Cats,
Dogs,
Men,
Women,
Ninnies
& Clowns

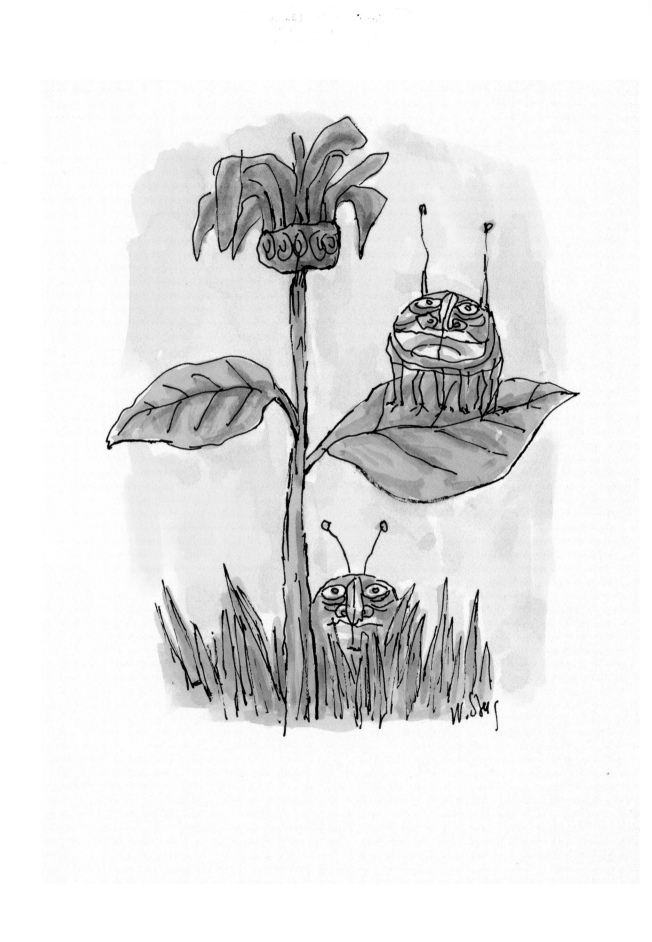

Cats, Dogs, Men, Women, Ninnies & Clowns

THE LOST ART OF
WILLIAM STEIG

Jeanne Steig

INTRODUCTION BY ROZ CHAST
AFTERWORD BY JULES FEIFFER

ABRAMS COMICARTS, NEW YORK

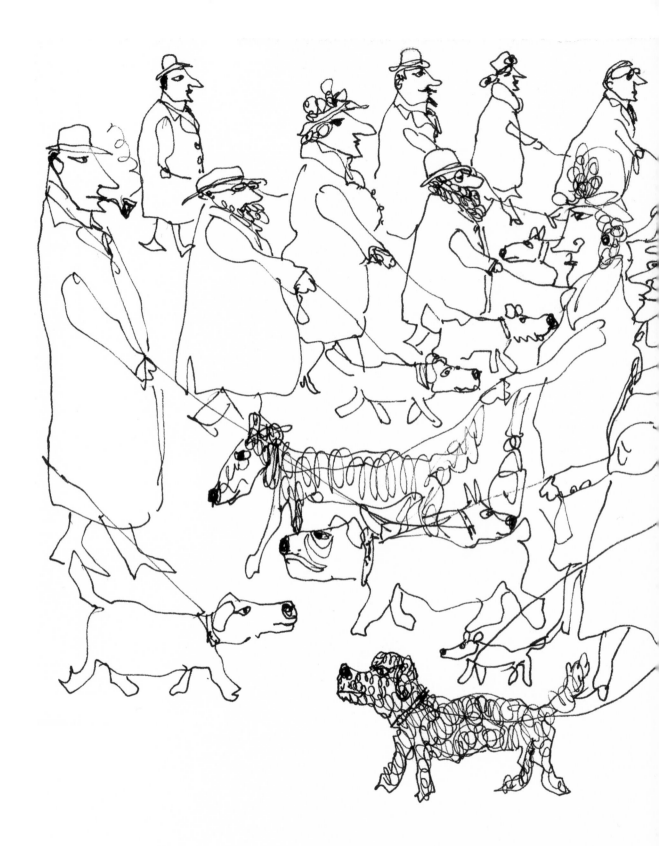

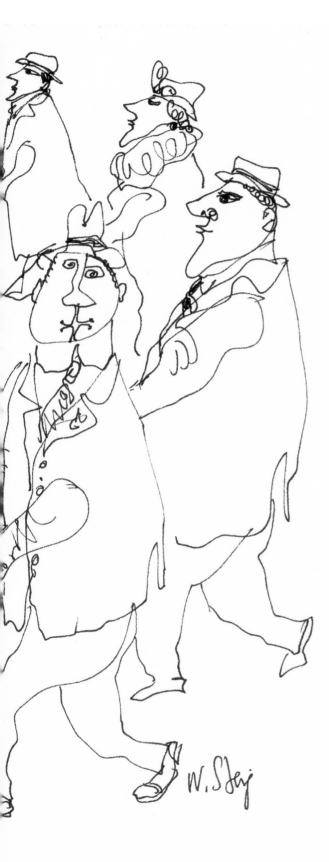

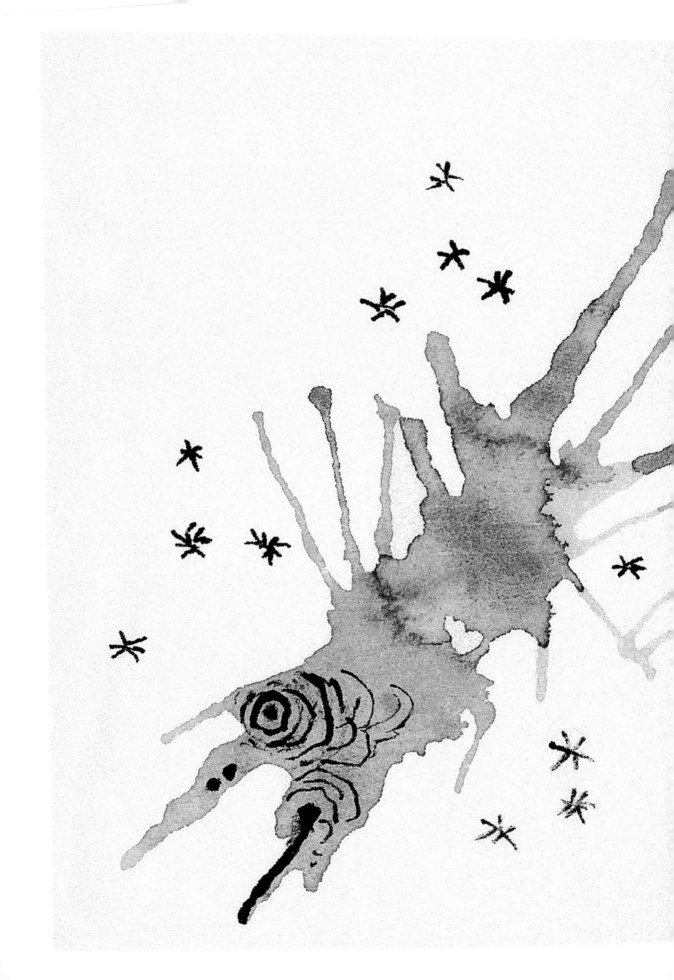

For Bill,
one of your odder ducks

W.S.

CONTENTS

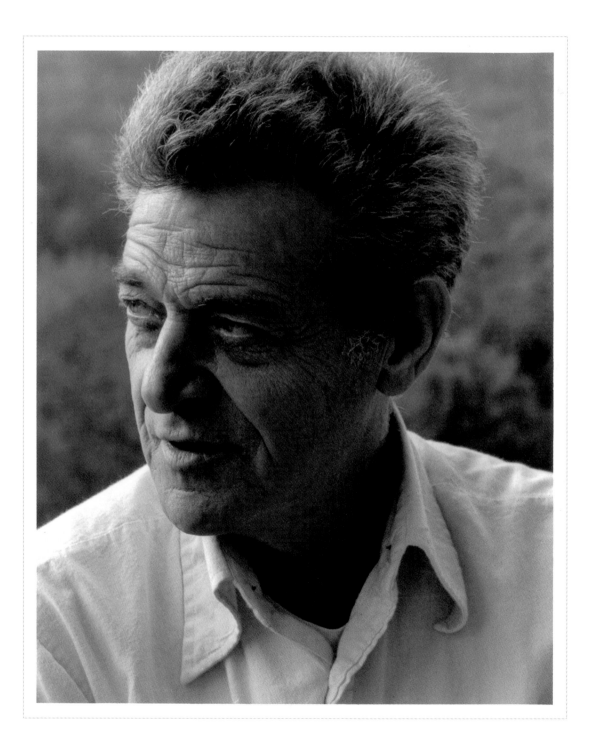

INTRODUCTION

I first noticed William Steig's covers and cartoons around 1970, when I was a teenager and would page through my parents' *New Yorkers*. His drawings didn't look like the rest of the cartoons in the magazine. They didn't have gag lines, but there was usually a descriptive title of some sort under the drawing. Also, the subject matter of his cartoons was different. There were no boardrooms, no cocktail parties with people saying witty things to one another. His men and women looked as if they were out of the Past, although I wasn't completely clear as to what era of the Past they were from. Steig's drawing style was decorative and loopy and loose. His cartoons weren't traditionally "cartoony." Sometimes the drawings made me laugh, and sometimes they didn't, but I always wanted to look at them. At first I wasn't sure I loved these drawings, but I was attracted to them. They were funny, but not in a setup/punch line way. I had a sense that these cartoons were made by someone who had had to create his own language, both visual and verbal, with which to express his view of the world.

The four hundred or so previously unpublished drawings in this book will take you into that world. There are hundreds of men, women, and children, and plenty of animals, both real and imaginary. The people may be cowboys, farmers, knights on horseback, damsels in distress, gigantic ladies and teeny-tiny men, grandmas, clowns of indeterminate gender, average joes, families, old couples, young couples, artists, deep thinkers, fools, loners, lovers, and hoboes, among other things. Some drawings are straightforwardly funny, and others are mysterious and abstract and more about pattern and color.

William Steig's drawings seem to flow effortlessly from his mind to his pen and onto the paper. I doubt he ever looked at a blank sheet and thought, "I have nothing worthwhile to say today," or "I can't draw a car as well as Joe Shmoe, so why don't I crawl back into bed and wait for the day to be over." Steig gave himself permission to be playful and experimental, and to follow his artistic heart, wherever it led. One of the many wonderful things about looking at his drawings is their inspirational message, especially

to his fellow artists: Draw what you love and what interests you. Draw it how *you* want to draw it. When we are children we do this instinctively. But somewhere in our passage from childhood to adulthood, the ability to be truly and fearlessly creative is often lost. To quote Pablo Picasso, who was Steig's favorite artist, "All children are artists. The problem is how to remain an artist once we grow up." I'm not saying that looking at Steig's drawings will solve all of anyone's art problems. Just that giving yourself over to his work is a step in the right direction.

William Steig was a prolific artist who produced more than fifty books, from early collections like *Small Fry* (1944) to children's books like *Sylvester and the Magic Pebble* (1969) and *Shrek!* (1990), which he wrote and illustrated in his later career. Unlike many artists who find a style early in their lives and then spend the rest of their careers perfecting it, Steig changed his style over the years. His earlier work from the forties and fifties is fairly conventional, and the people in his cartoons look like traditional cartoon-style people. The drawings of his middle years are more abstract. His style is more angular and geometric. And in his last decades, his line becomes very fluid and playful, and there is an explosion of color, especially in his children's books.

William Steig, who was a follower of Wilhelm Reich, was deeply interested in psychology. Much of Steig's work looks at society from an outsider's point of view, observing with humor and compassion the compromises we make when we grow up and try to conform to society's expectations. His earliest collection (and one of my favorites) was *About People* (1939). Each page contains a drawing representing a different emotional state, with a caption written underneath in his handwriting. Some drawing/title combinations are fairly obvious, like the man sitting in a chair calmly smoking a cigarette. Behind the chair is a huge octopus with four tentacles wrapped around the man. The caption is simply "Poise." But some of the drawings are not of people at all—they are more graphic and abstract, like the one of a roughly drawn spiral, and in the center of the spiral is a black blot with a tiny white dot in the middle. The caption is: "Father's Angry Eye."

These are not your typical cartoons, and especially not typical of cartooning at the time. They're funny in a kind of offbeat way. They're also about something otherwise intangible, like actual emotions. Steig's interest in psychology continued with *Persistent Faces* (1945), which features visual types like "Hostess," with her alarmingly twinkly eyes and teeth, and the worried man's face that is captioned "Straw in the Wind."

Another one of my favorite collections is *The Agony in the Kindergarten* (1950), which he dedicated to Wilhelm Reich. It's filled with drawings of children and accompanying statements like "I need that kid like I need a hole in the head," and "Stop asking so many questions." Perhaps Steig's most famous cartoon of this period is "Mother loved me but she died," from *The Lonely Ones* (1942). These demonstrate Steig's ear for language, and also demonstrate his ability to look at life through a child's eyes with the empathy of an adult who remembers what it was like to be a child.

Over the years, Steig's drawing style became looser. There was almost no subject that he could not incorporate into his world. His cats, dogs, men, women, ninnies, and clowns continued to tumble from his pen until the very end of his life. He also started to work with color more and more. Steig was an exceptionally gifted colorist, and he used color in an instinctive and expressive way. His colors are often luminous. Even when the goings-on are terrifying, as they often are in *Rotten Island* (1984)—my favorite of all of his children's books—his palette might be dark, but it's never depressing. His dark colors are about a *gleeful* darkness, the darkness children feel when they know their most trusted adult is going to tell them a spooky story. The color isn't overfussed or second-guessed or muddified. Steig loved pattern. He was not a minimalist. Rugs, sofas, chairs, wallpaper, ladies' dresses, and men's shirts were all little mini canvases where he could make up designs—diamonds or flowers or spirals or something that looks like an upside-down banana peel. Even a sky could be patterned with lines or bricklike shapes or decorative cloud puffs.

Since I first saw his work in 1970, back when I was a teenager and worrying about my life and whether I would ever get out of my parents' Brooklyn apartment and what would happen if I did,

13

I've found more and more to love about Steig's work. His humor is never trite, and he never shoots fish in a barrel. The cartoons aren't tied to specific current events that are forgotten a week later. They are eternal because they are about the human condition.

Sometimes I think of the Cartoon World as a big house with a Magazine Panel Cartoon Wing, a Newspaper Daily Strip Wing, a Graphic Novel Wing, an Underground Comics wing, a Superhero Comics wing, an Animation wing, and lots of other wings I don't know about yet. Steig's drawings throw open a bunch of windows and let in some fresh air, for which I am deeply grateful. He saw the world of human beings as absurd, hilarious, terrifying, mystifying, and definitely worth observing closely and writing and drawing about.

In the preface to his collection *Dreams of Glory* (1953), Steig writes, "We can laugh at the pretense and pose and foolishness of an irrational ideology and at the same time feel pity and love—for a living being—that should be ingredients of all humor."

Thank you, William Steig, wherever you are, for your wonderful, inspiring art. May it continue to elucidate what all of us "Lonely Ones" feel.

Roz Chast
Connecticut
January 2011

ROZ CHAST is a cartoonist whose work has regularly appeared in the *New Yorker* for more than thirty years. Her cartoons have also been published in *Scientific American*, the *Harvard Business Review*, *Travel & Leisure*, and many other magazines. She is the author of nine collections, including *Theories of Everything: Selected, Collected, Health-Inspected Cartoons by Roz Chast, 1978–2006*. She also illustrated *The Alphabet from A to Y, with Bonus Letter Z!*, the bestselling children's book by Steve Martin. She lives in Connecticut.

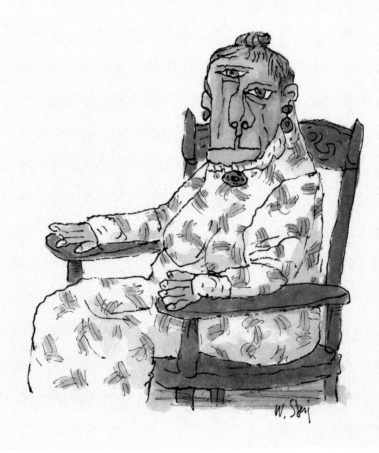

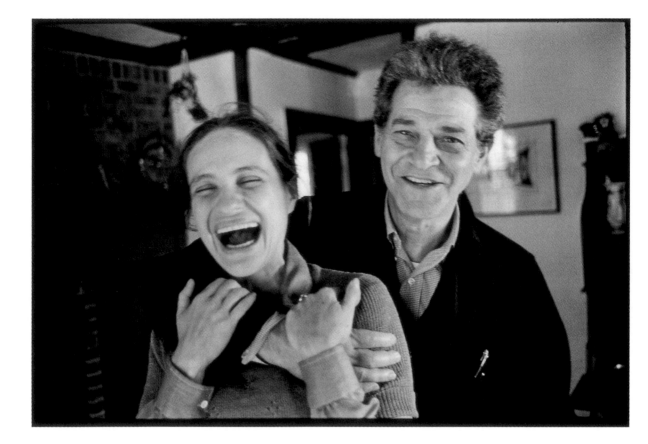

PREFACE

William Steig worked, as it amused him to say, "with the Eternal Verities." Eternal Verities, even the funnier ones, are not always matters of burning interest. As a result, many of the drawings in this collection are work the *New Yorker* rejected. Bill never did the topical drawings favored by that venerable magazine. He made this art for his own pleasure (and for yours, if you have any sense). He was a somewhat modest man, and understood that his humor wasn't for everybody, though he couldn't always see why. Some of the pieces included here are also alternative versions of work that was published—a look from another angle.

Back in the days when dentists could afford *New Yorker* subscriptions, you might sit holding your jaw in an office and watch other victims leaf through ancient, dog-eared copies, smiling grimly over the cartoons. Sit long enough, and you'd even hear an occasional "Haw!"

Bill had a high percentage of "haws," and he did it mostly without the aid of any captions: a great rarity, even today, among cartoonists. The humor was in his ridiculous, hapless sense of the world gone slightly awry. Exactly the sort of fateful misadventure that caused you to await your dentist, perhaps. The humor wasn't gag humor; it was there in the art itself. And it was not something you could easily describe. Both the humor and the meaning were tied to an existential understanding of life. Yes, true enough, we are each alone in a cruel and uncaring universe. But aren't we noble for putting up with it? Isn't this cockamamy world endlessly entertaining?

Bill held in his heart that one great question: "What's going on here?" With every drawing he made a leap toward revealing at least the question. And sometimes, he even provided an answer.

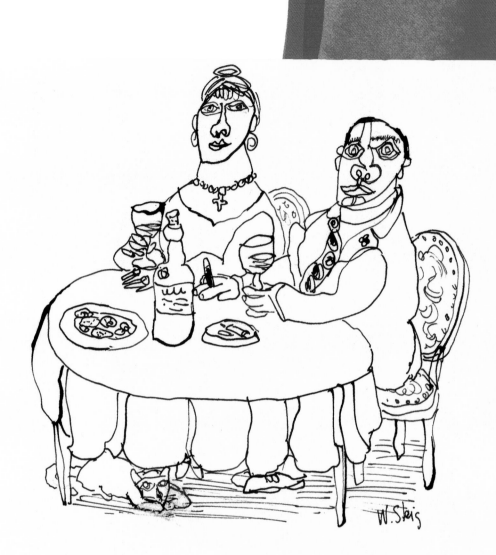

LADIES & GENTS

The meanest thing Bill could call someone was "bourgeois." He came from a family of ardent socialists, and he was strict. I sometimes suffered from that. When I made him a helping of deviled eggs, to which he was highly partial, I gussied them up with cocktail onions. He'd clear the plate, then point out that they, and I, were "extremely bourgeois." Needless to say, aristocrats and kings took a terrible beating in his work, and he drew them often.

Anyone was a fit subject for Bill, alone or in company, rich, poor, or just "a guy off the block." He'd draw them in love, in anger, and more often than not, in bewilderment. Self-examiners, highfliers, the lonely, the lewd. Beautiful women were always a pleasure to draw, and he was a wonder at portraying children. In his early books, *The Lonely Ones*, *The Agony in the Kindergarten*, and *Dreams of Glory*, Bill fashioned a way of saying the things he saw about people, adults and children, that had never been pictured before. He liked best to draw faces. His variations were inexhaustible. He never drew anybody he knew but every one looked familiar.

Bill was terrific company. He specialized in asking questions, which made his visitors adore him. That could be a problem, as Bill was not really crazy about visitors. He wanted to draw people, and wasn't much for hanging around with them. He asked questions, much of the time to avoid being questioned himself. He might tell a joke (rather badly, but with gusto), or he'd amuse guests by reciting the names on the spines of a set of encyclopedias kept in his family's Bronx apartment: A–Ban, Ban–Can, Can–Cry, Fis–Hgs, Hgs–Lar, Lar–Man, Man–Pla, Pla–Sal, Sal–Sto, Sto–Tho, Tho–U, U–Zim. The grandeur of that string of words was always new for him.

Bill once said, "For some reason, I've never felt grown up." He may have behaved like a highly responsible fellow, but that was a cover. The man who knew how to write for children "so that you don't write *Moby-Dick*" had never lost touch with his childhood self. He was as playful as a child, and he loved to be with children. When we went to a party, as soon as the kids were put to bed, Bill was ready to take his leave.

As long as things were going his way, Bill was a happy man, not greedy, easy to please. We didn't fight often. We had both spent enough time in other relationships to know that a good fight was not what we needed to keep things exciting. We had something better. We found that a bit of contention, most of the time, was good for a laugh.

Bill was sometimes sentimental, in a non-slushy sort of way. He used to refer to us fondly as "a couple of cats," or perhaps more romantically as "two rolls on a plate." But of course we did fight now and again. Bill felt he couldn't work with anyone "extra" around. He didn't want company, anyone's company, for more than a day or two. When we lived in the country, one of my many relatives came for a visit. She brought presents: fresh halvah, one of Bill's favorite sweets, and other delightful gifts. She was good company. Bill got along nicely with her, but the day she departed was surely not one day too soon. No sooner did the door close behind her than Bill fell into a rage. My relatives, those benighted bourgeois, "had nothing better to do with themselves than fly all over the world bringing presents." I then fell into a fit myself, stormed out to the car, and took off for New York City. Half an hour later I started to laugh, and I laughed my way right back home. I should also point out that I had forgotten my purse, and it was getting too late to drive all that way in the dark.

When I got home I found Bill in his studio, just where I'd left him. He looked up, beaming, and asked whether dinner was ready. He hadn't realized I had left him. And I never bothered to do it again.

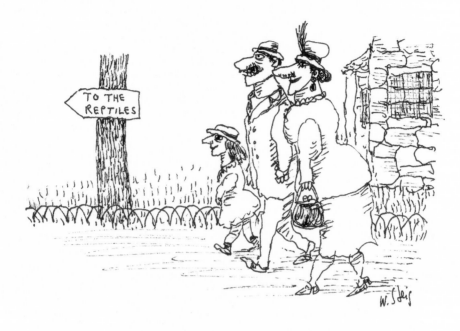

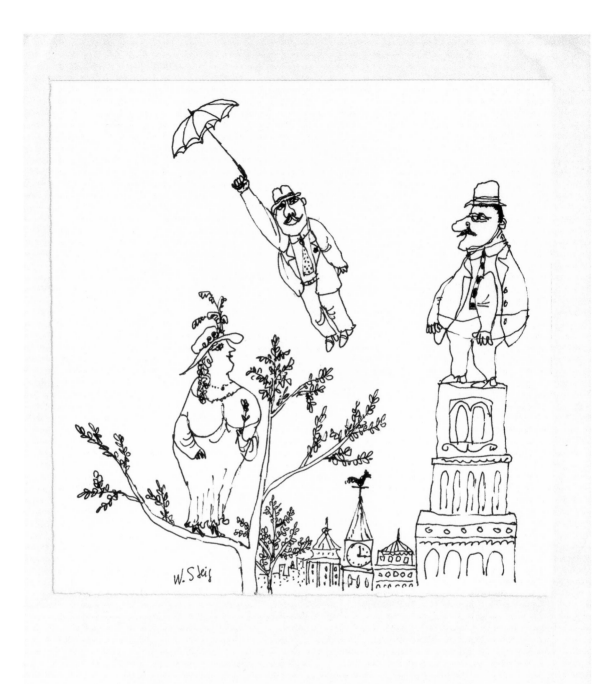

SPRING

above: Spring

opposite, top: For Claude

opposite, bottom: "Yes, the vertical stripes do make you look slimmer."

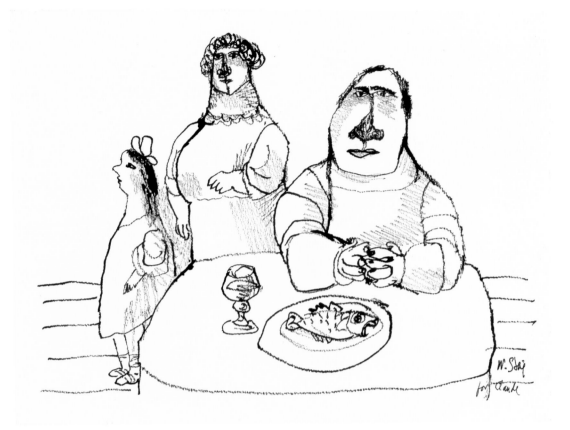

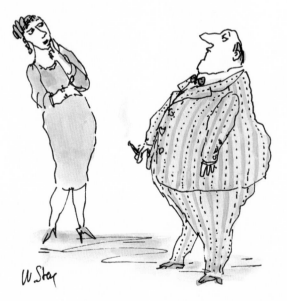

"YES, THE VERTICAL STRIPES DO MAKE YOU LOOK SLIMMER."

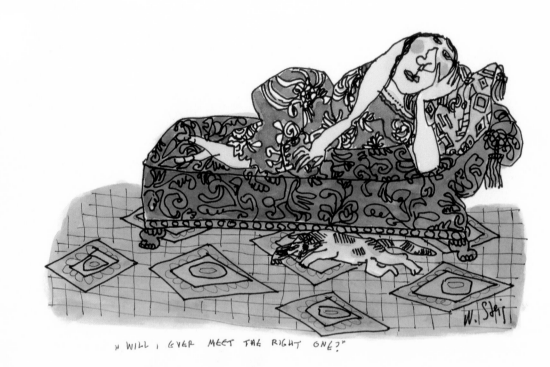

"WILL I EVER MEET THE RIGHT ONE?"

above: "Will I ever meet the right one?"

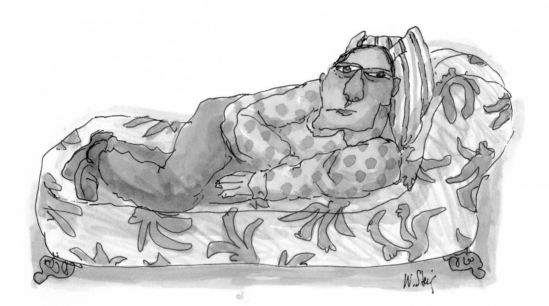

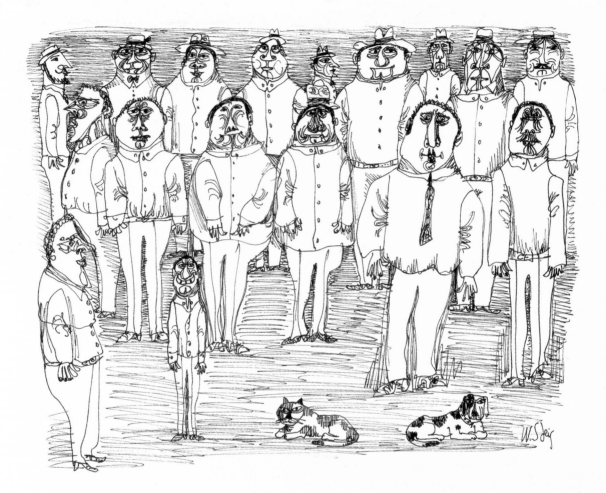

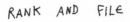

RANK AND FILE

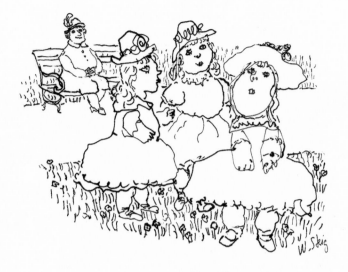

FRIENDS

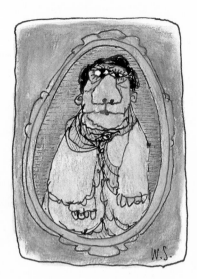

ONE ISN'T AS GOOD-LOOKING
AS ONE SHOULD BE

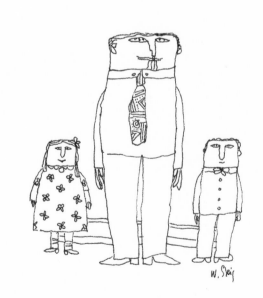

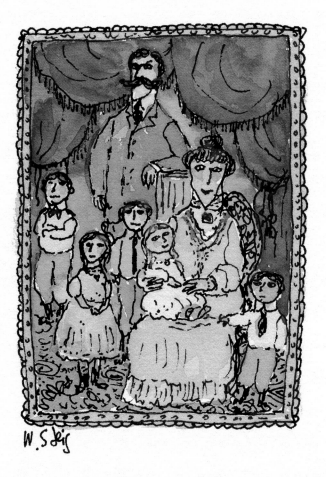

opposite, top: One Isn't As Good-Looking As One Should Be

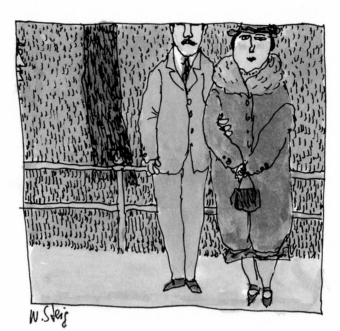

SNAPSHOT

above: Snapshot

opposite: Glad Day (Romantic)

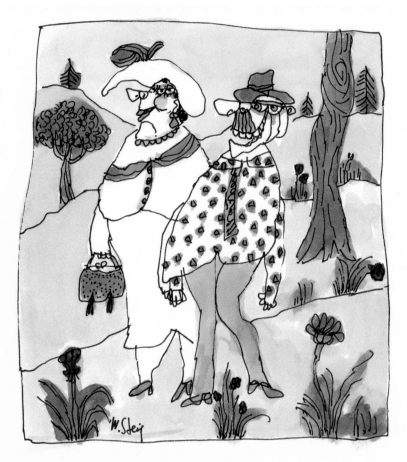

ROMANTIC
GLAD DAY

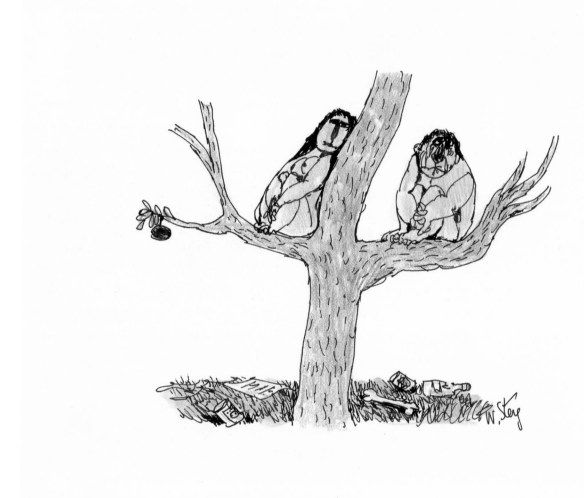

opposite, bottom: Expulsion from the Garden

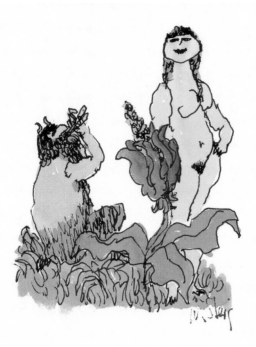

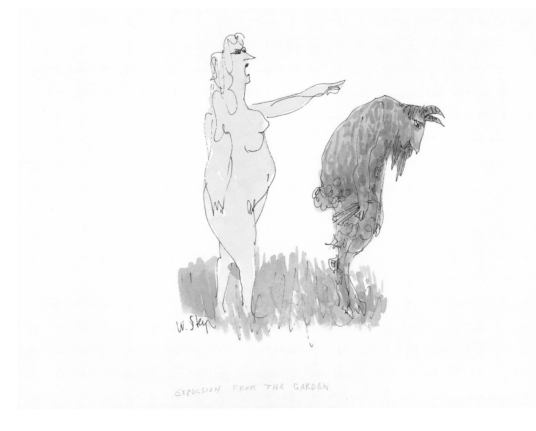

EXPULSION FROM THE GARDEN

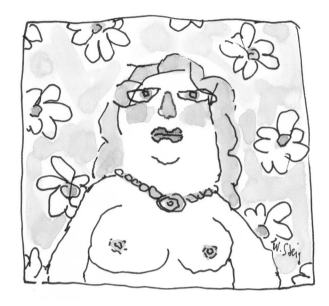

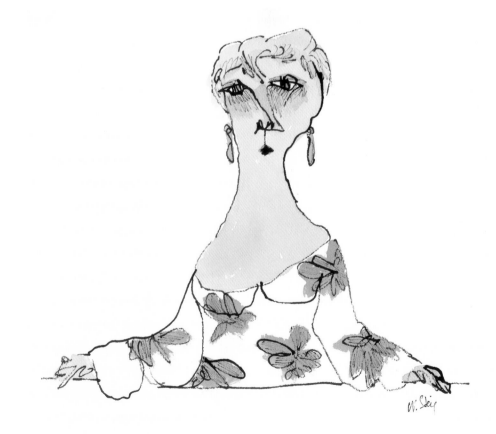

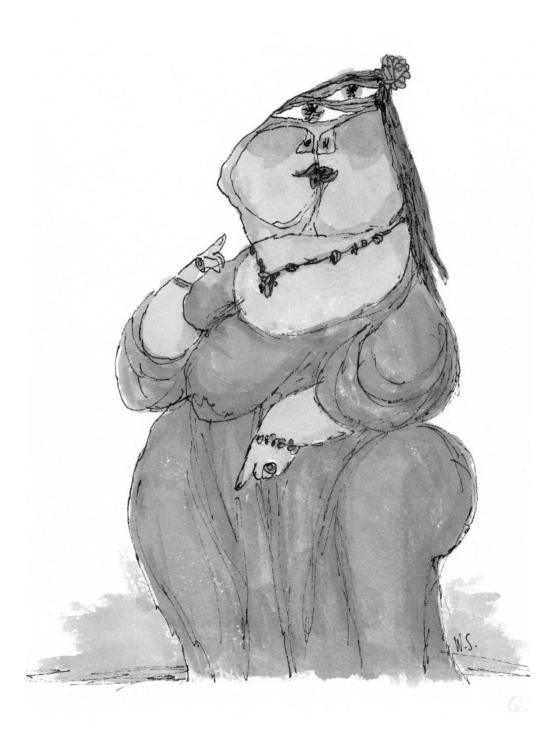

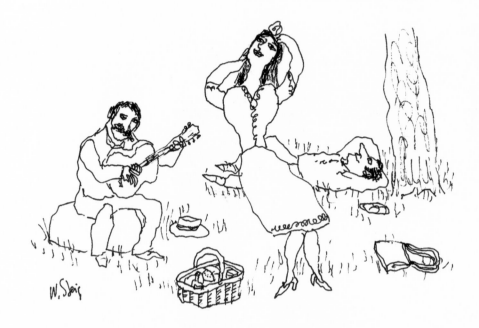

A LITTLE FLAMENCO.

above: A Little Flamenco

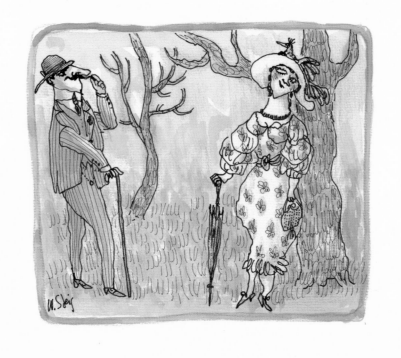

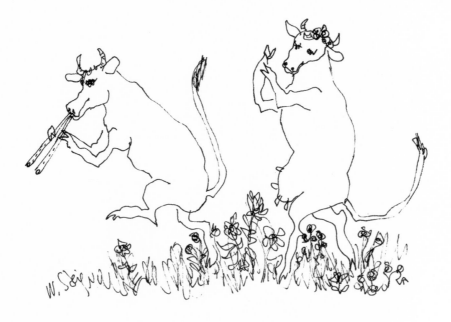

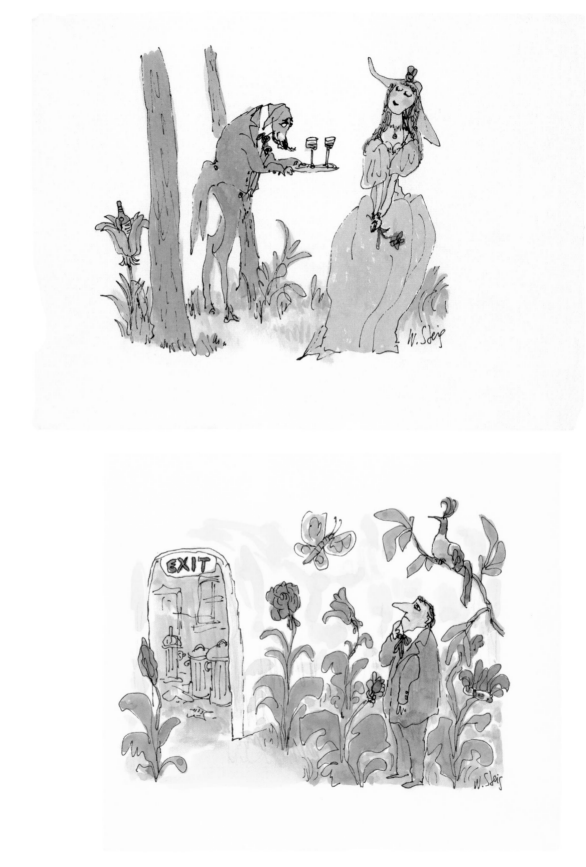

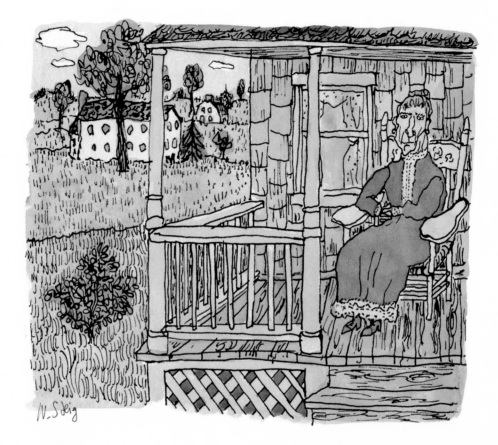

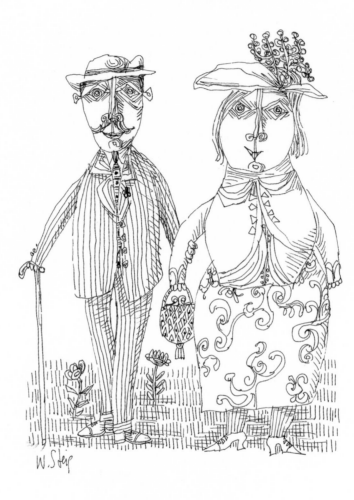

COUPLE

above: Couple

opposite, bottom: Railroad Station

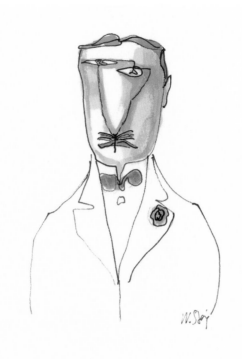

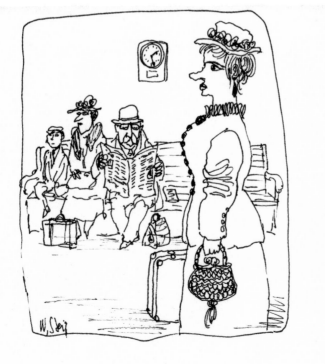

RAILROAD STATION

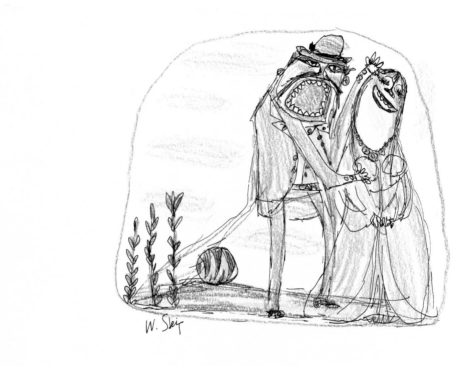

W. Steig

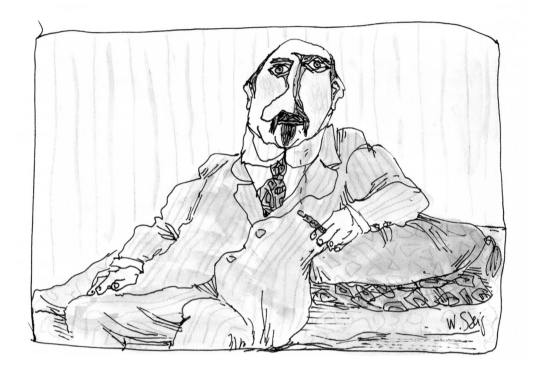

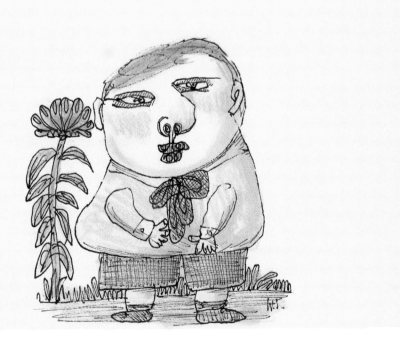

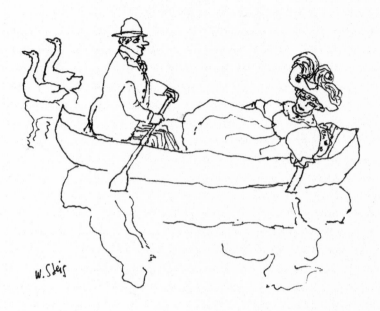

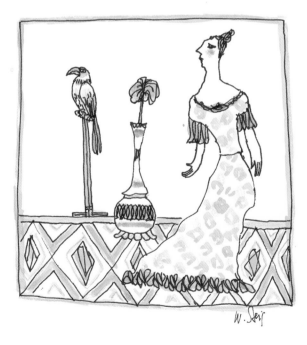

HURT FEELINGS

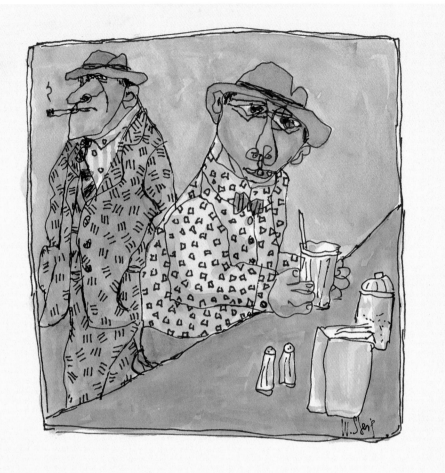

opposite, bottom: Hurt Feelings

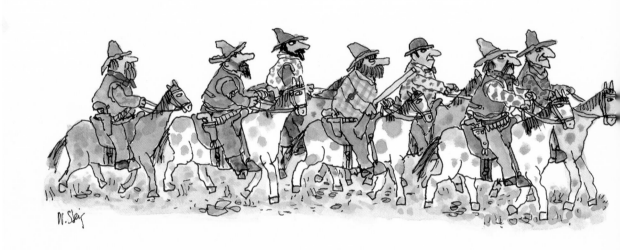

POSSE

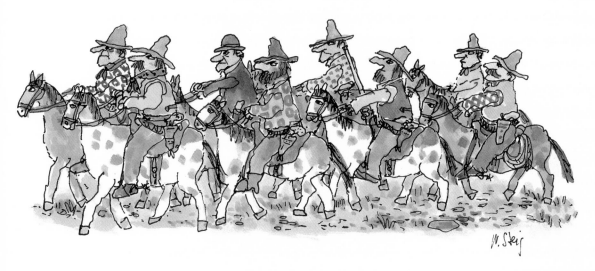

POSSE

opposite and above: Posse

opposite, bottom: Equestrienne

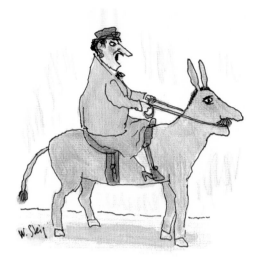

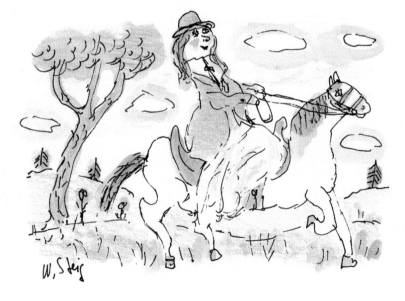

EQUESTRIENNE

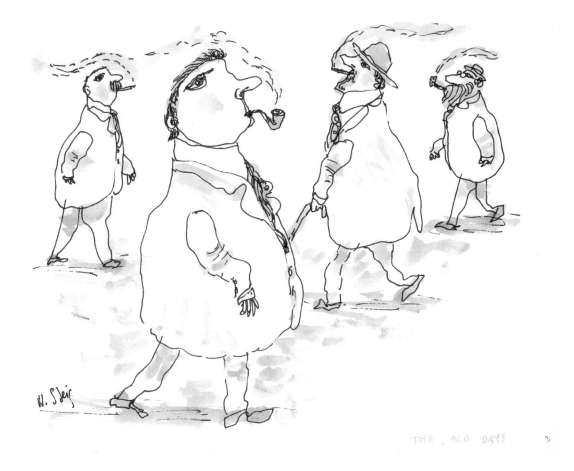

THE OLD DAYS

above: The Old Days

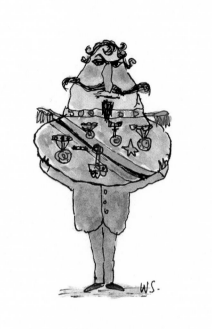

EGOMANIAC

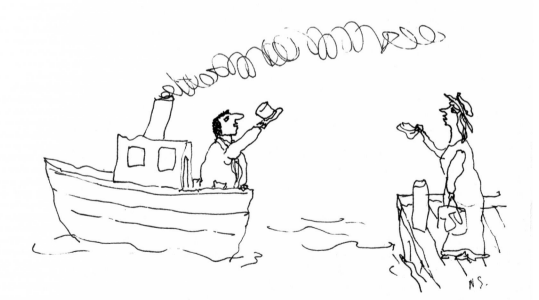

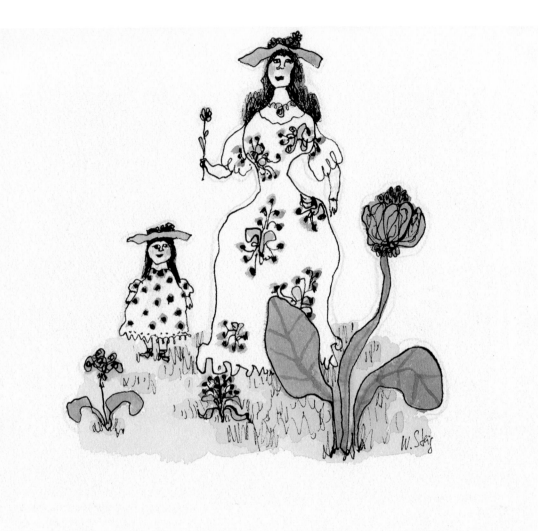

opposite, top: Egomaniac

WOMEN ARE EMOTIONAL

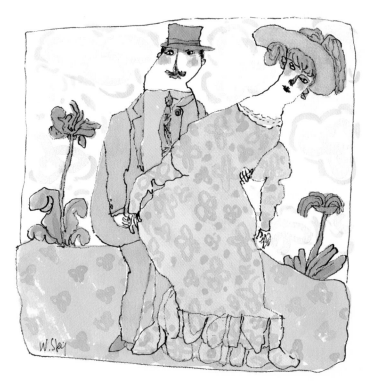

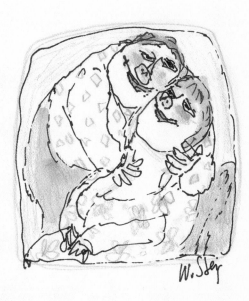

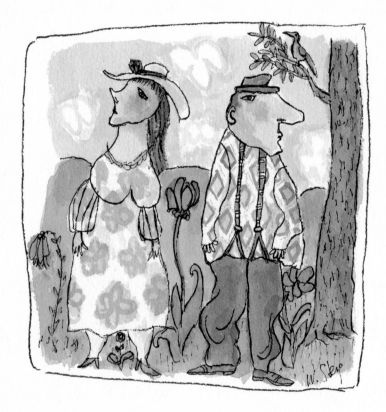

SHY LOVERS

above: Shy Lovers

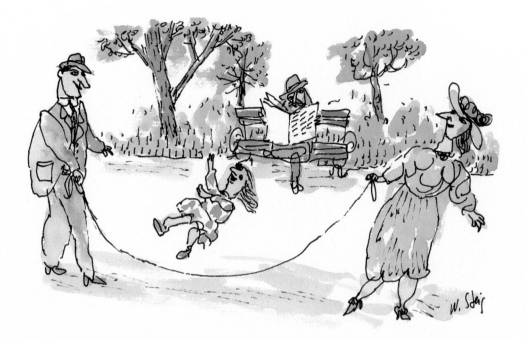

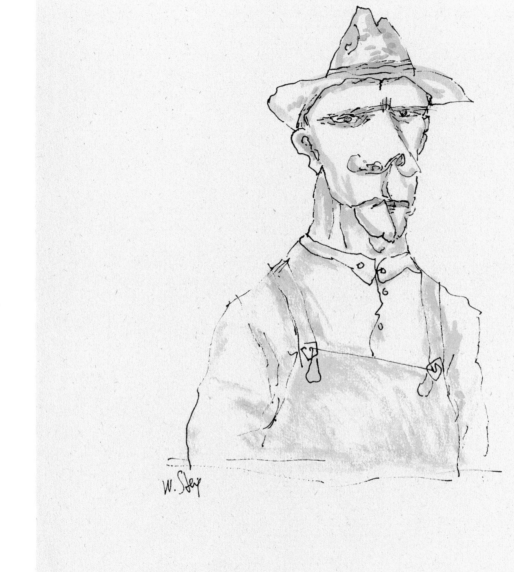

W. Steig

opposite, bottom: The Appalachian Trail

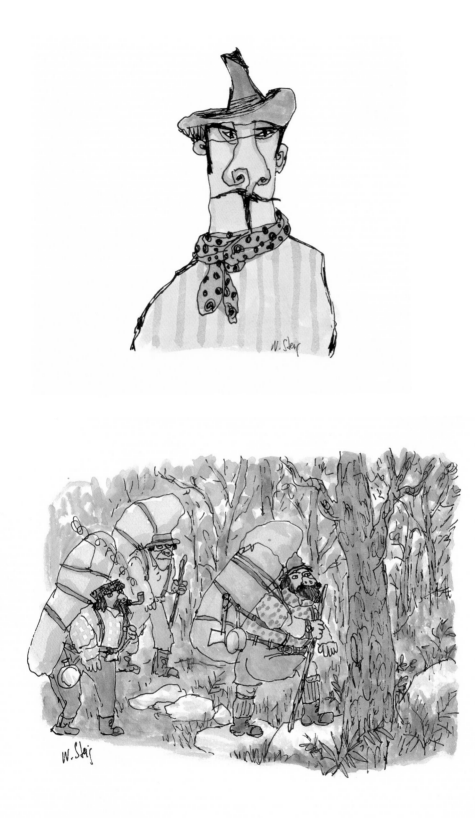

THE APPALACHIAN TRAIL

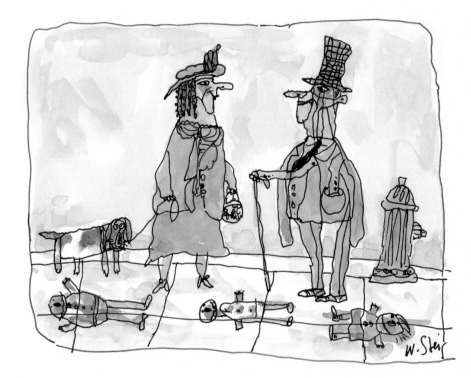

HOLIDAY

above: Holiday

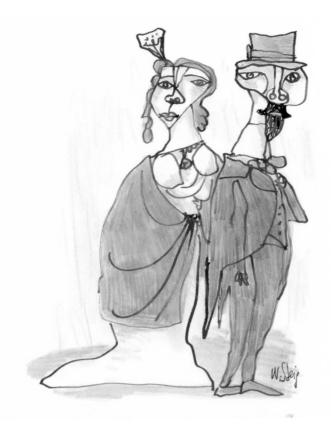

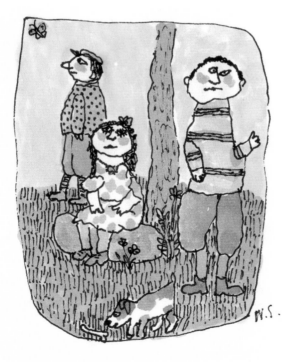

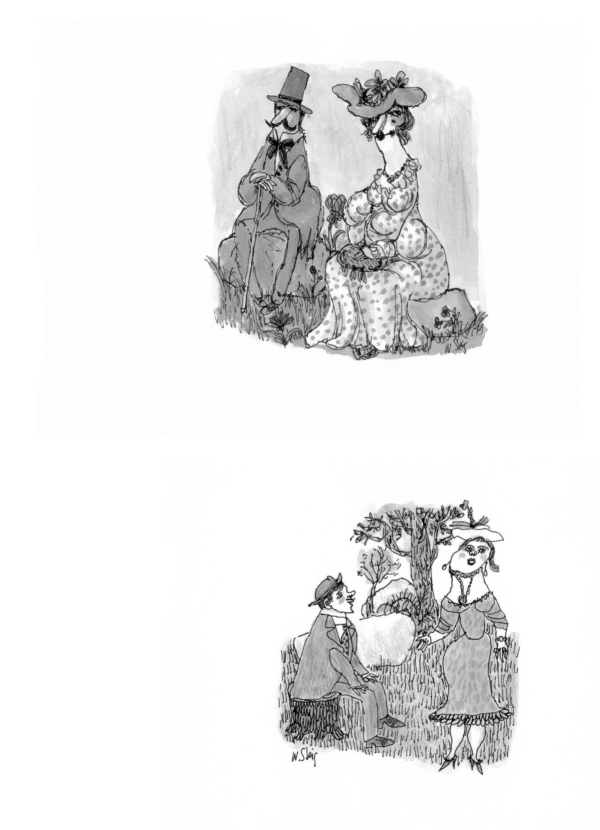

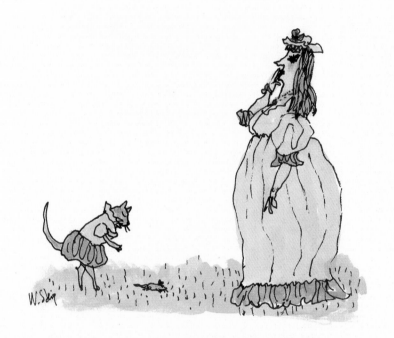

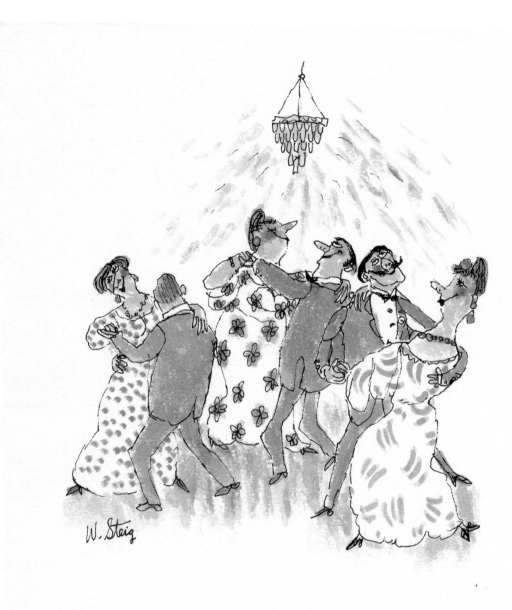

W. Steig

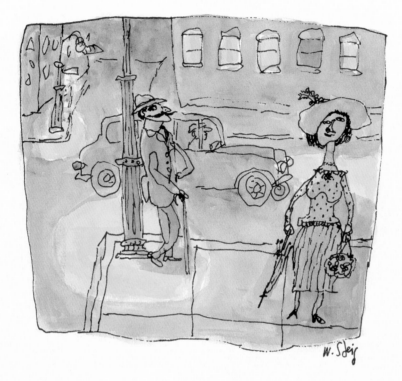

THE WITCHING HOUR

above: The Witching Hour

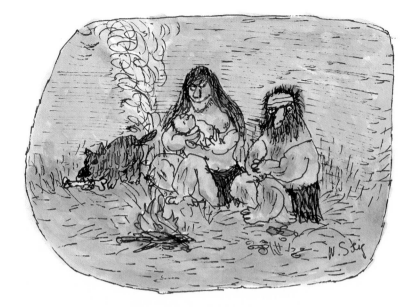

THE WAY IT WAS

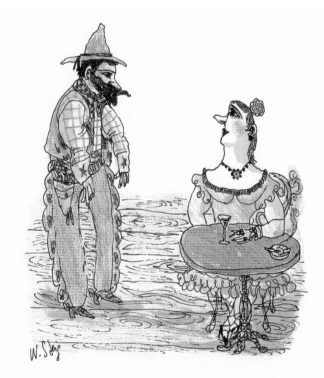

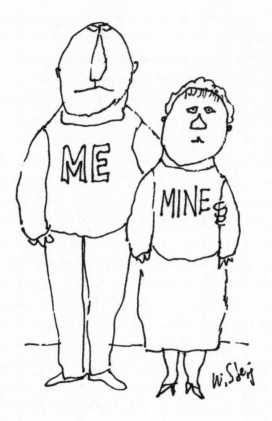

opposite, top : The Way It Was

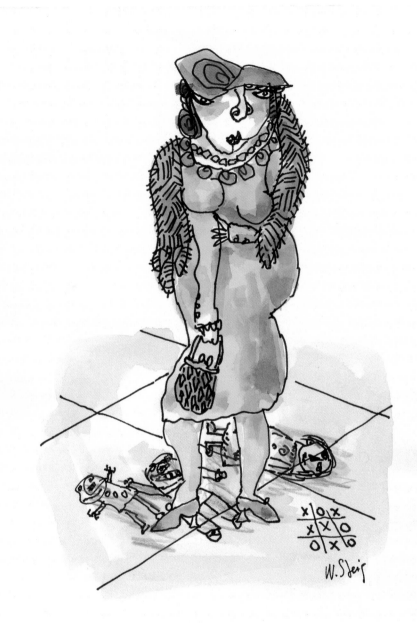

PHILISTINE

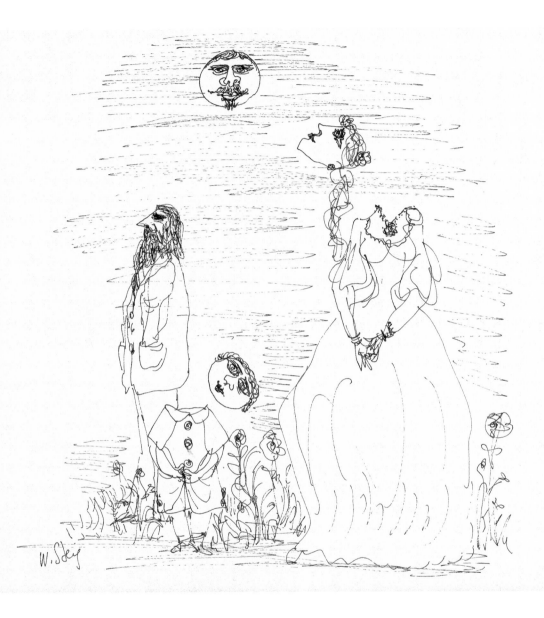

opposite: Philistine

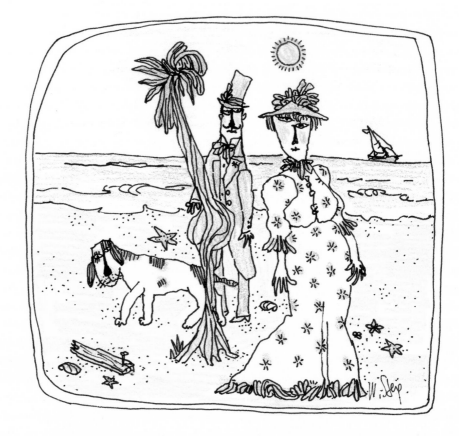

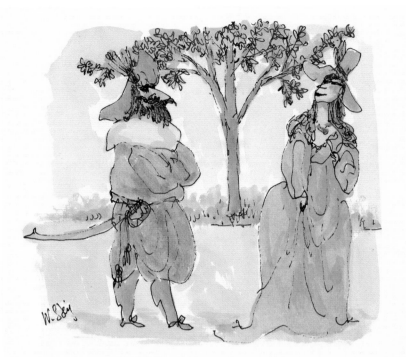

LOVE AT FIRST SIGHT

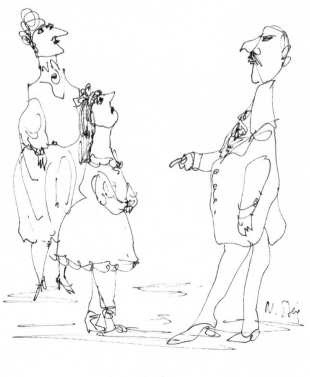

The Authoritarian

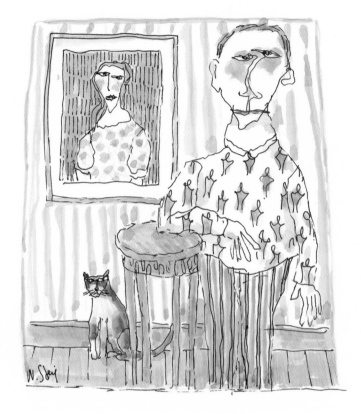

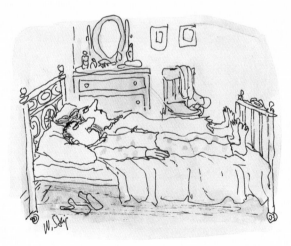

FRIENDS?

NOT SPEAKING

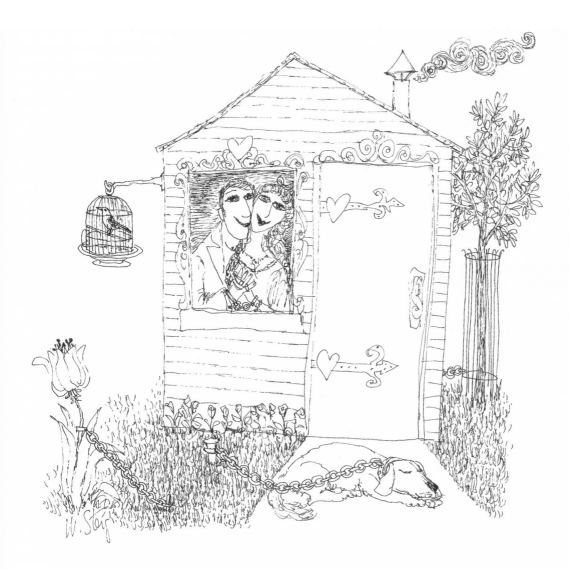

opposite, bottom: Not Speaking (Friends!)

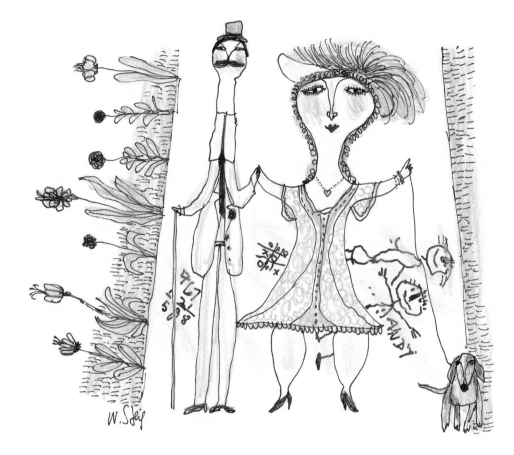

GRAFFITI

above: Graffiti

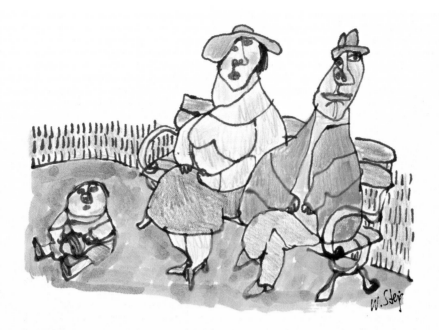

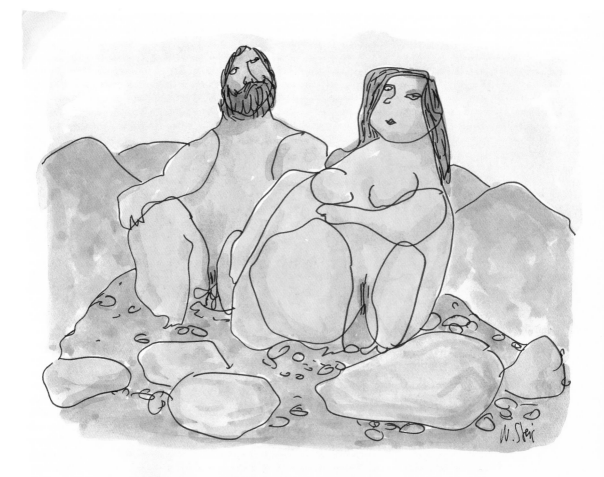

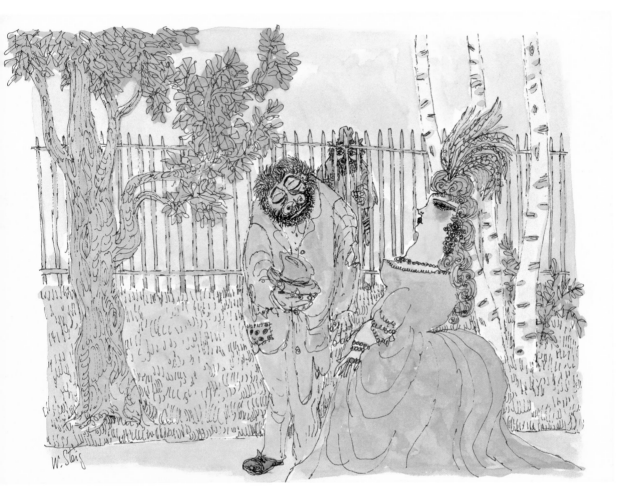

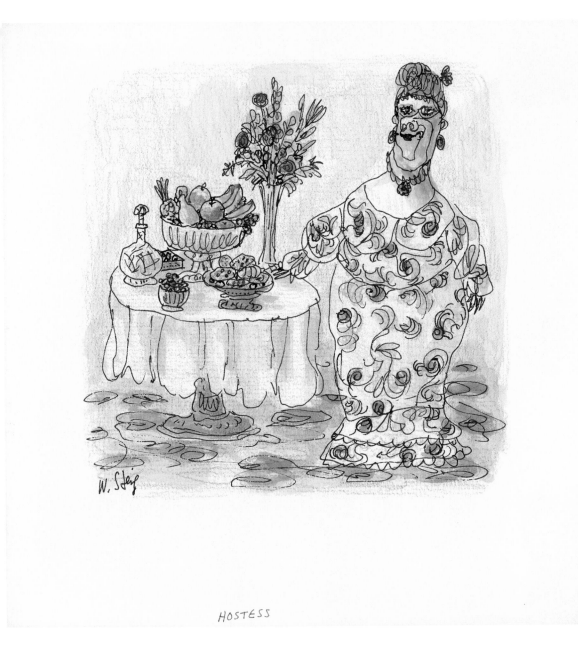

HOSTESS

above: Hostess

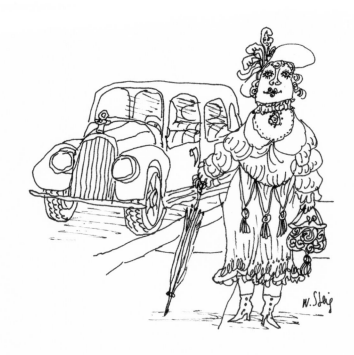

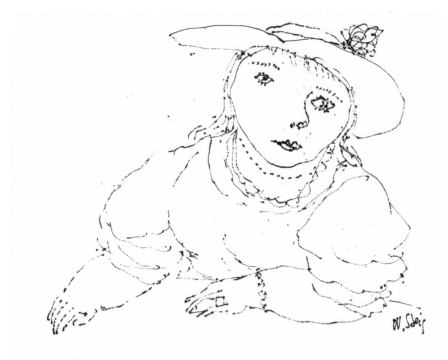

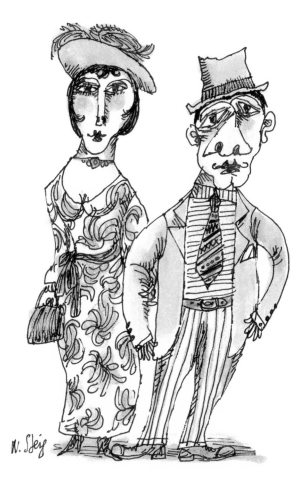

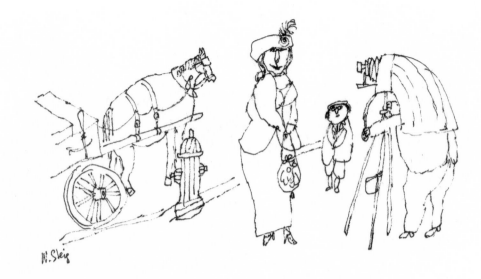

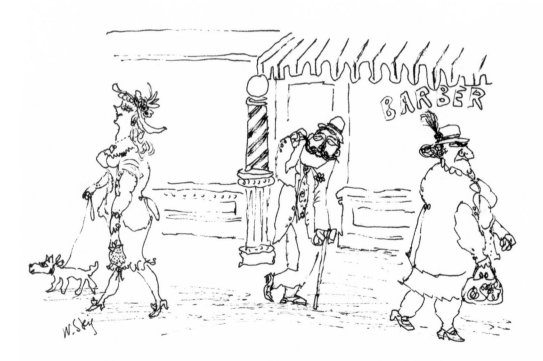

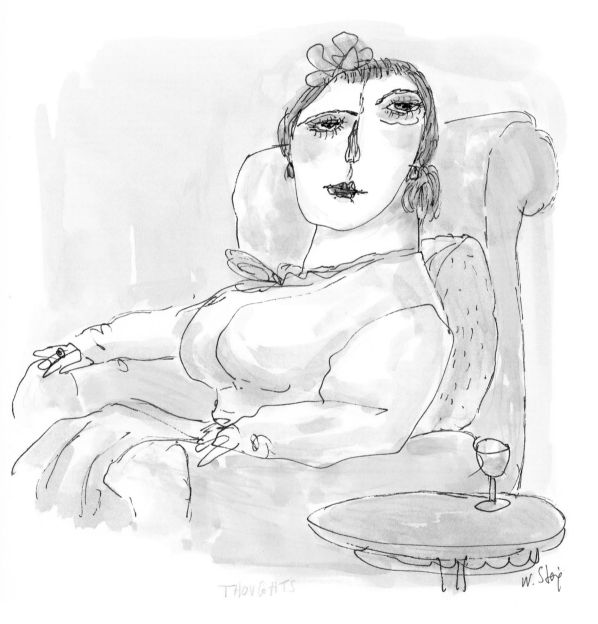

THOUGHTS

W. Steig

above: Thoughts

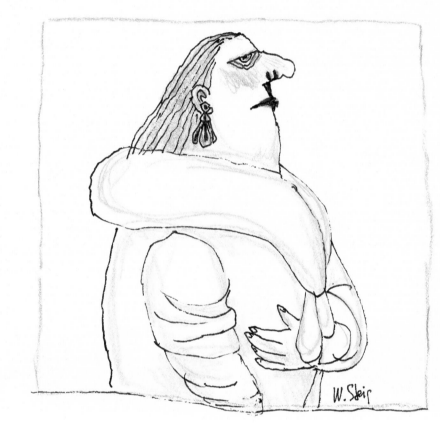

opposite, bottom: Lost Soul

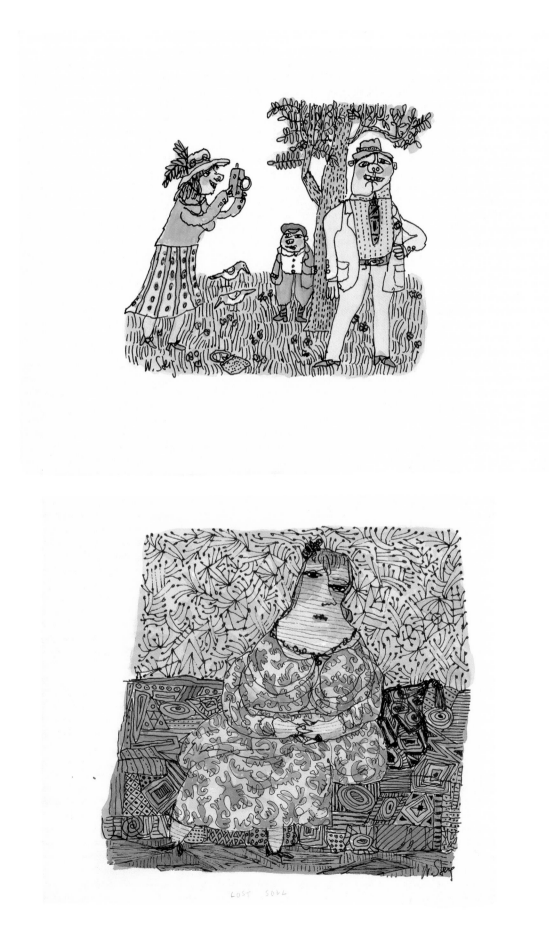

LOST SOUL

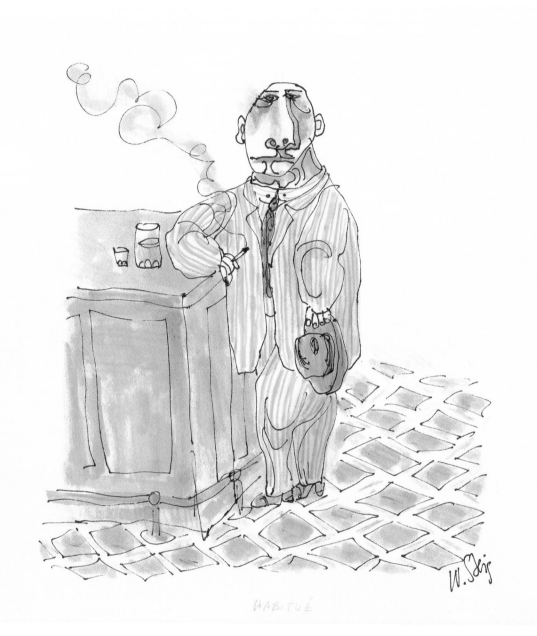

HABITUÉ

above: Habitué

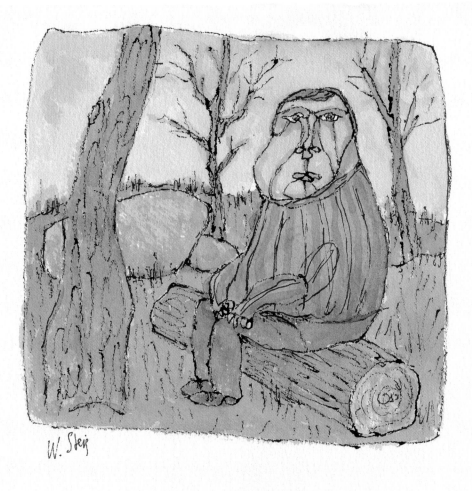

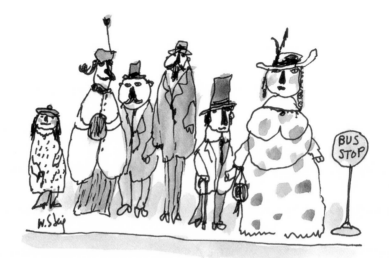

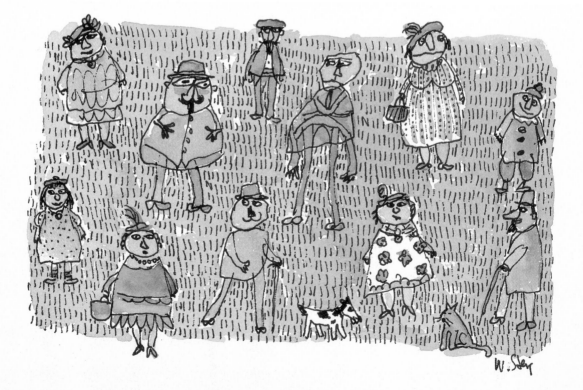

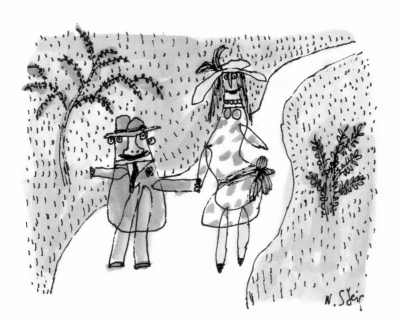

A PARK IN A FOREIGN ~~TOWN,~~ CITY.

above: A Park in a Foreign City

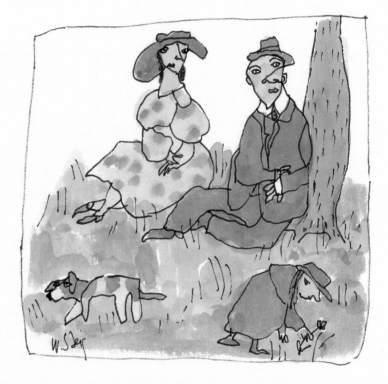

opposite, bottom: Coffee and Some Memories

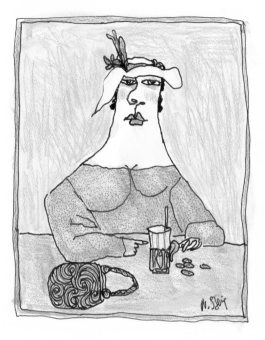

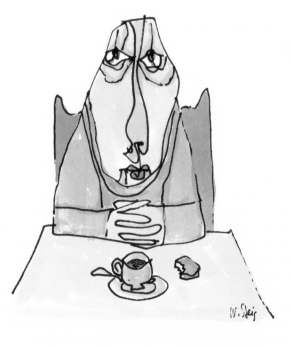

COFFEE, CAKE
AND SOME
MEMORIES

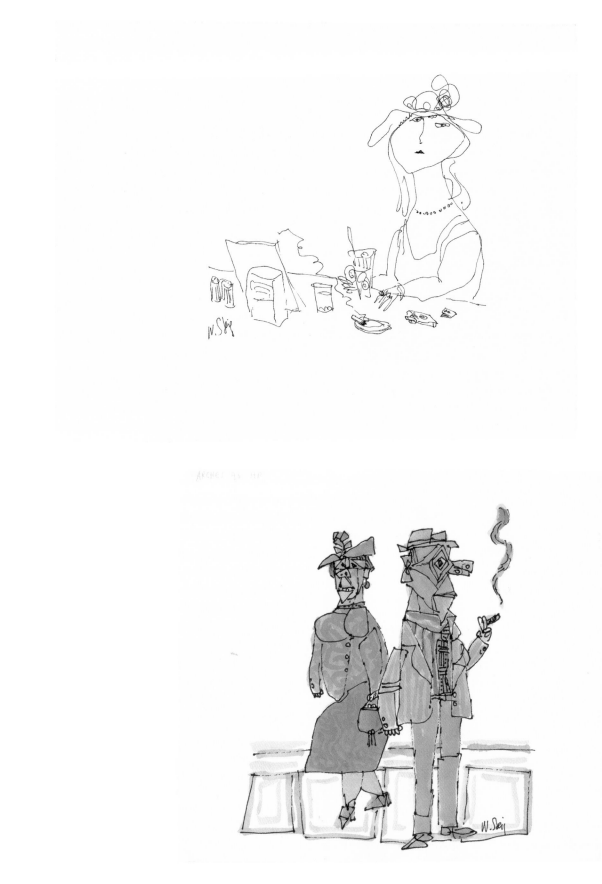

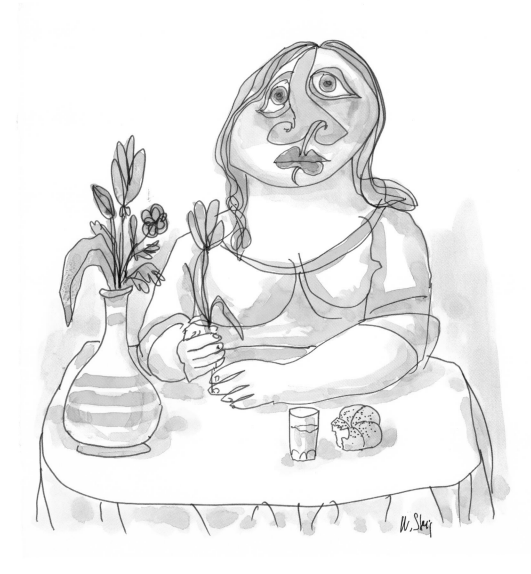

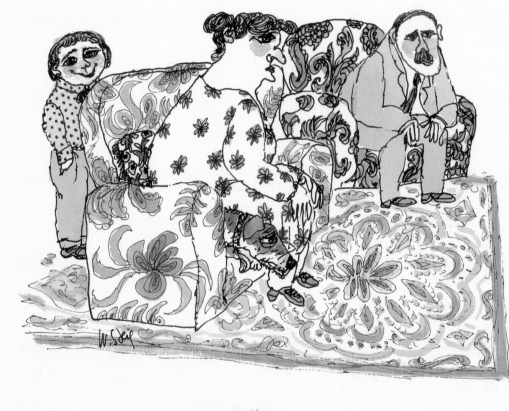

BAD BOY

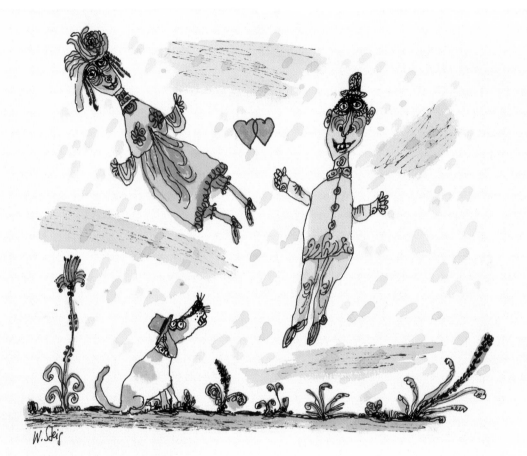

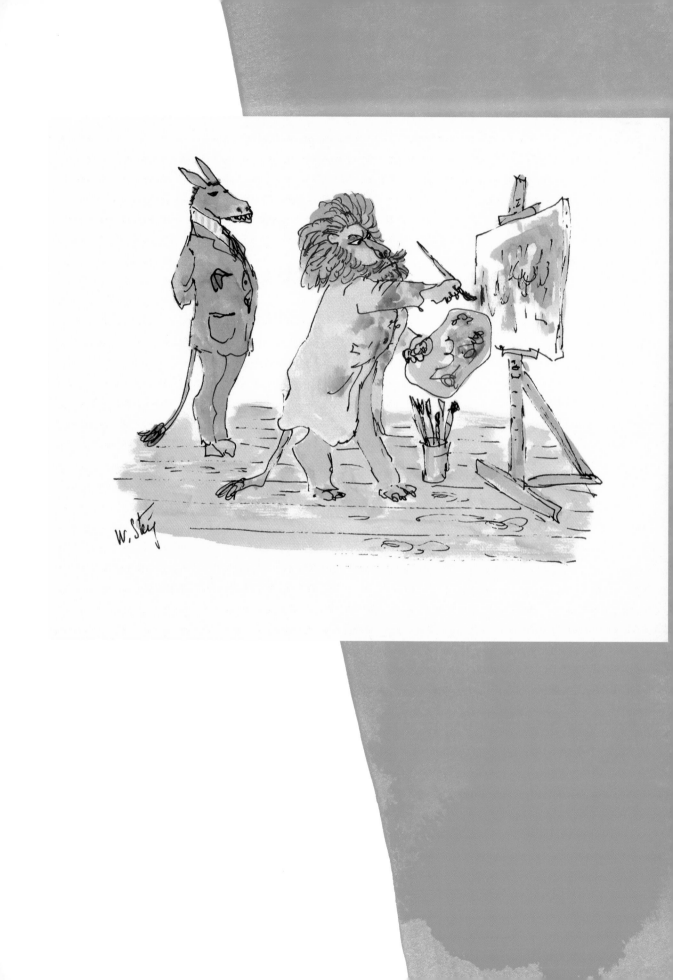

ART

Just about everybody in Bill's immediate family was an artist. His parents were accomplished unschooled painters. Most of his brothers were artists, too. Henry thought of becoming a dentist, but the family wouldn't hear of it, so he became a fine jeweler, and was thus able to work with small bits of gold in another context. Irwin, the only nonartist, was, in his teens, a reviewer of vaudeville, and became a writer of important books on chess. Each of Bill's four wives was, or became, an artist. Bill was tremendously encouraging. I think he felt that everyone had artist potential—you had to discover what kind of artist you needed to be and get on with it. "Art is the only life," he frequently said.

Bill would try anything. He had a short but productive wood sculpture period, during which he made, among other things, dignified ladies with elegant hats full of nails, and noble, ridiculous birds—I've seen only those two, but he had a show of them in Greenwich Village, and sold everything. Nelson Rockefeller was much taken with them, and bargained for a discount on half a dozen.

When I first met Bill in 1968, I fell into a deep writer's block. He felt sorry for me, and advised that it was not healthy to sit around all day writing, though that is exactly what he was doing himself, as he had just taken up writing books for children. "You'd be better off making things," he said. I'd always wanted to do that, I responded—but what things? With what? "Whatever you've got around," he answered. He'd observed that I did have an awful lot of fairly odd stuff around. I found more in the street, and that was the start of my doing exactly what I still love to do: making art out of trash. How did he know that? "Well," he said, "it stood to reason."

In Bill's drawings, artists are often depicted as animals, just as animals are often the subjects of artists. Art was not a profession Bill

regarded with reverence. Art was a part of nature, shared by dogs, cats, clowns, and roosters. Animal artists were stand-ins for humans, by way of variety. Art expressed whatever was important about life, and in Bill's case he expressed it comically. Comic art is not any easier than dignified or lugubrious art; perhaps in some ways it is more difficult. The artist must point at something odd about human nature, and smile kindly at it.

Bill once did a *New Yorker* drawing of a terrified snowman. A snowman is always funny—he's made of nothing but ice, coal, and a carrot, and he's bound to melt. The caption beneath the drawing reads, "The Snowman Realizes Who He Is." That's tragicomedy at its profoundest: a merciless joke, both tender and grave.

Bill disliked cuteness—that devil whose other name is sentimentality. In order to avoid cuteness, it is necessary to move in the direction of craziness. If you don't go far enough, you look like you've stepped in chewing gum. If you go too far, you seem unhinged. Bill went far. And it always worked. His favorite artist was Picasso, whom he loved with a grand passion, and Picasso went very far indeed.

Artists of all sorts—photographers, sculptors, writers, musicians—were treated in Bill's drawings with the same rueful love he accorded the rest of the world. Dancers escaped, for the most part, with their dignity intact, but it must be said that Bill refused to attend the ballet. He always came down with a terminal case of the giggles, and was forced to leave, his shoulders heaving.

Bill read the most recent authors, and reread the old ones. He loved Beethoven's quartets, he loved jazz, and he was crazy about the blues. Well, blues are funny and sad, so it stands to reason.

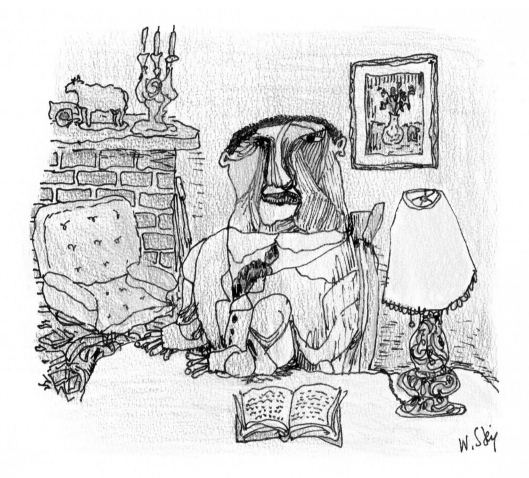

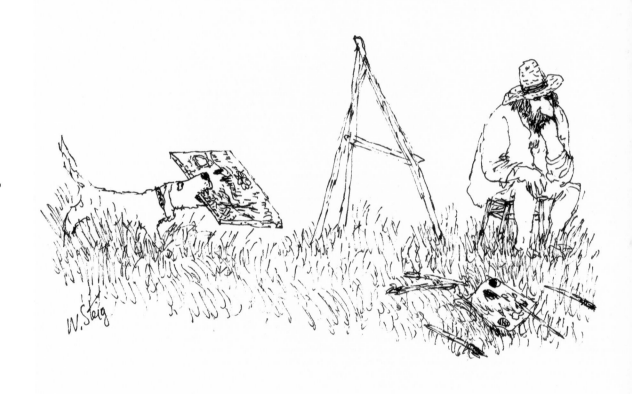

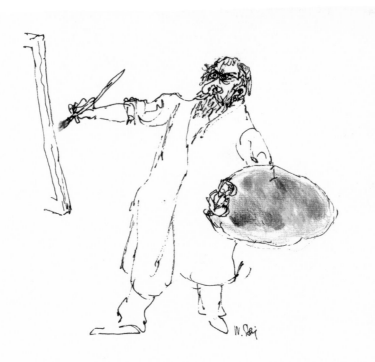

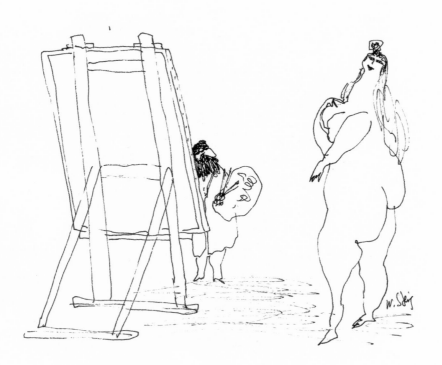

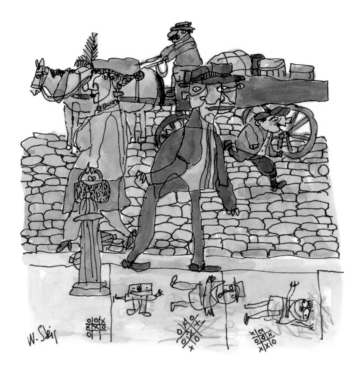

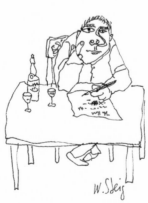

POET AND PAINTER

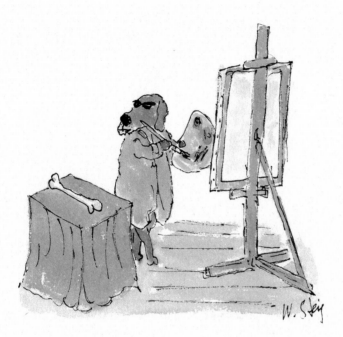

opposite, top: Tic-Tac-Toe

opposite, bottom: Poet and Painter

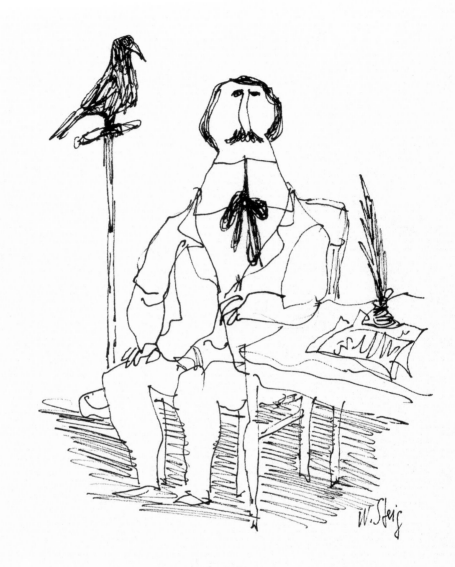

EDGAR ALLAN POE

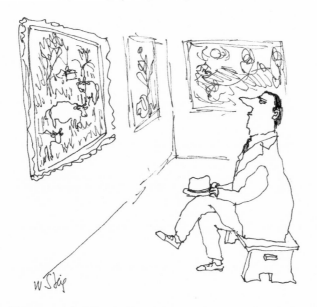

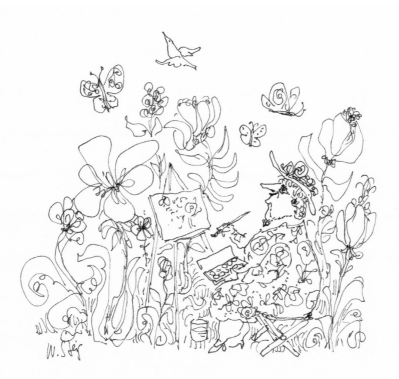

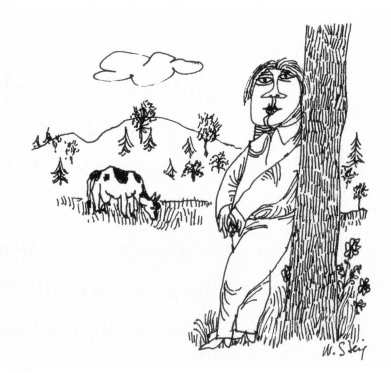

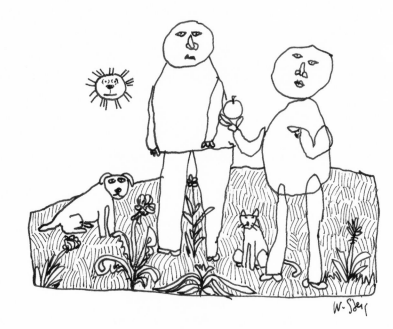

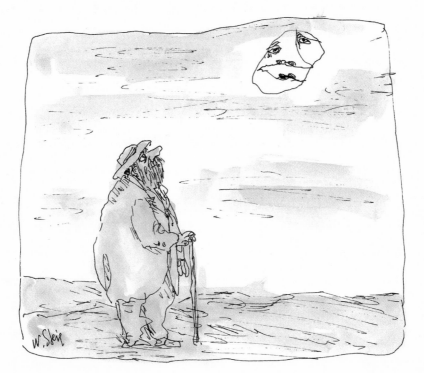

UNRESPONSIVE MOON.

above: Unresponsive Moon

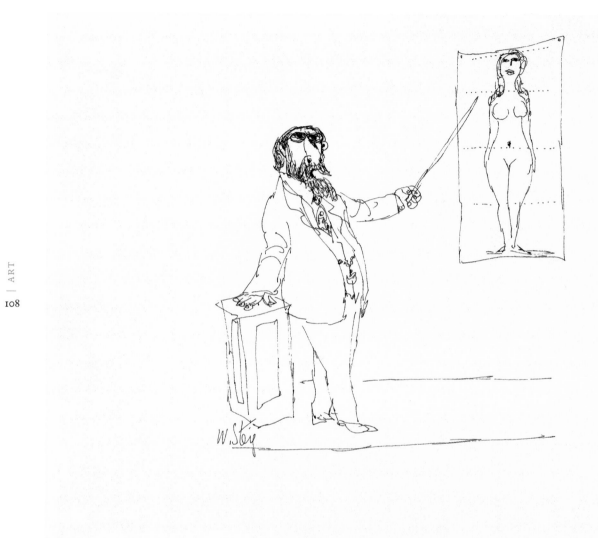

opposite, top: Tourist

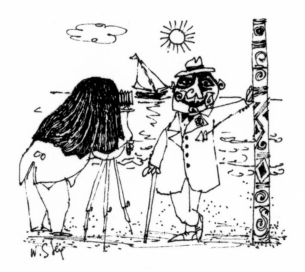

TOURIST

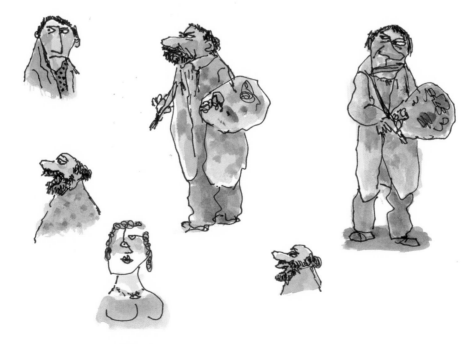

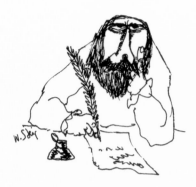

"Varlet, Knave, Jackanapes"

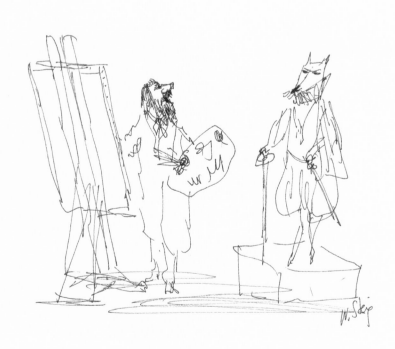

"How did you get to be known as "The fox"?"

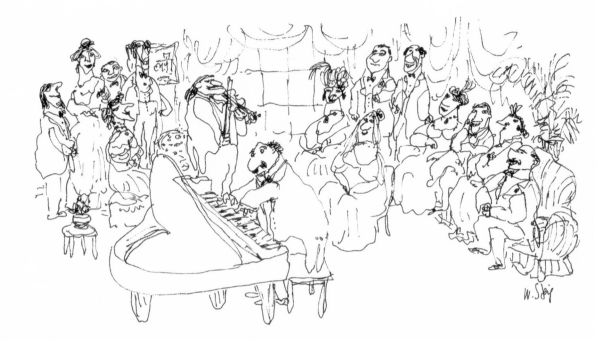

MUSICALE

opposite, top: "Varlet, knave, jackanapes . . ."

opposite, bottom: "How did you get to be known as 'The Fox'?"

above: Musicale

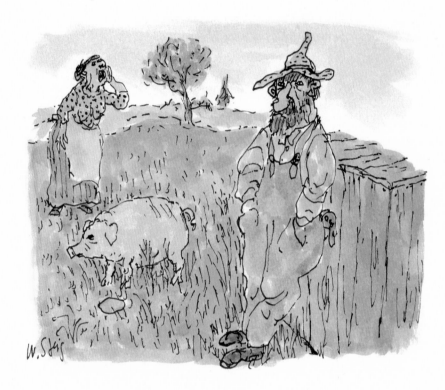

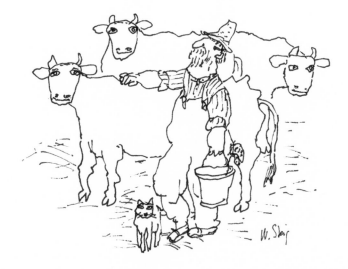

SYMBIOTIC RELATIONSHIP

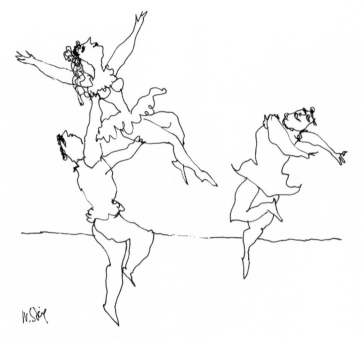

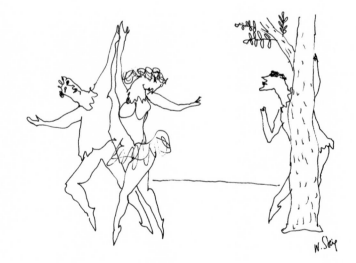

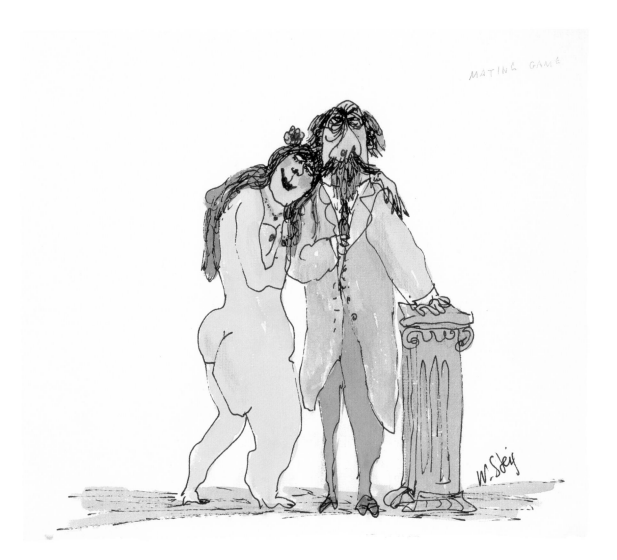

MATING GAME

above: Mating Game

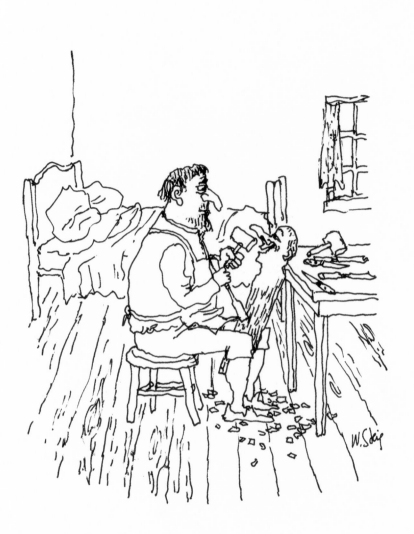

W. Steig

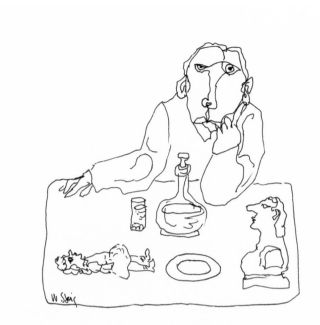

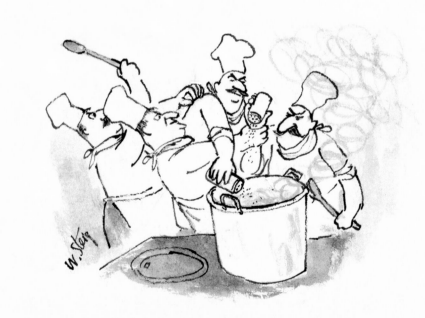

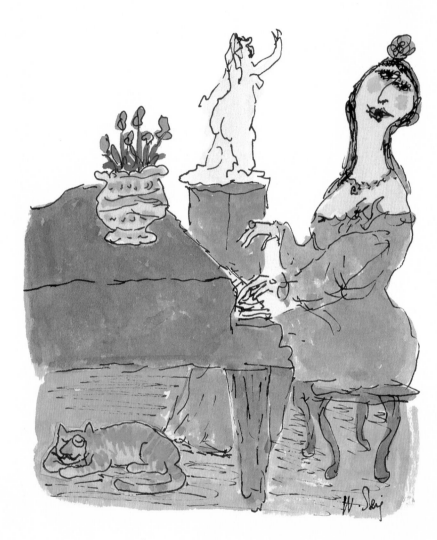

HIS FAVORITE SONATA

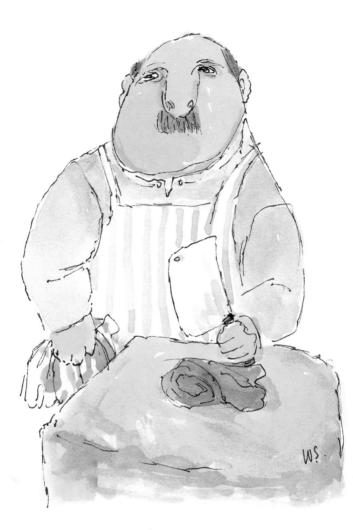

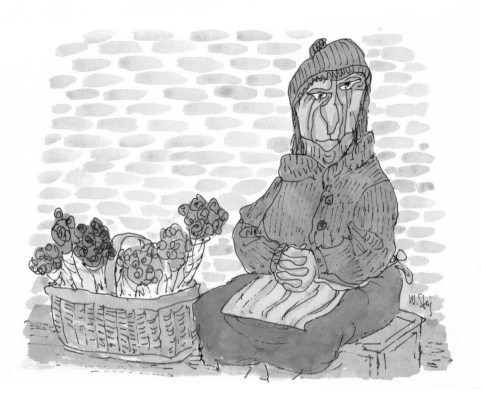

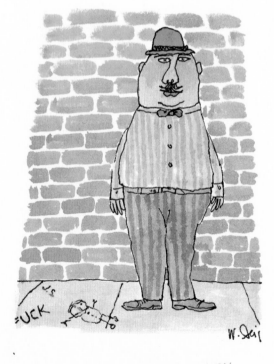

FIRST PHOTOGRAPH IN HIS NEW COUNTRY

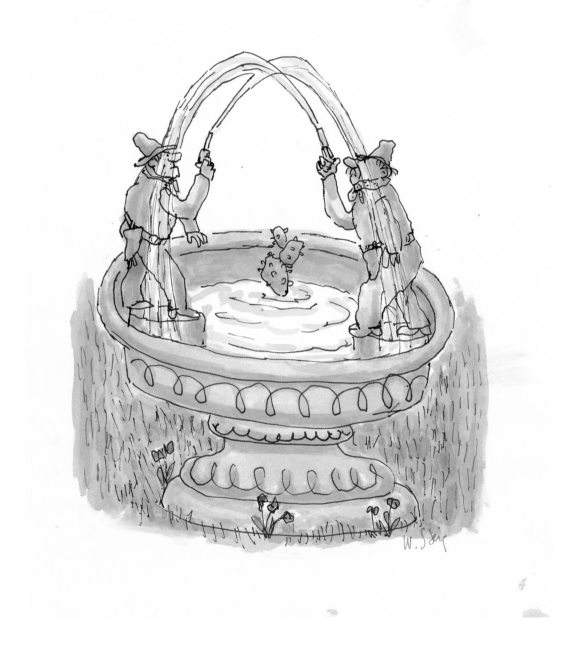

opposite, bottom: First Photograph in His New Country

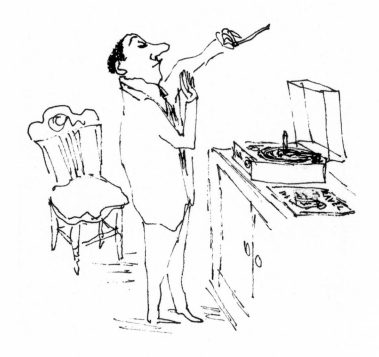

SYMPHONY CONDUCTOR

opposite: Symphony Conductor

opposite, bottom: Cézanne

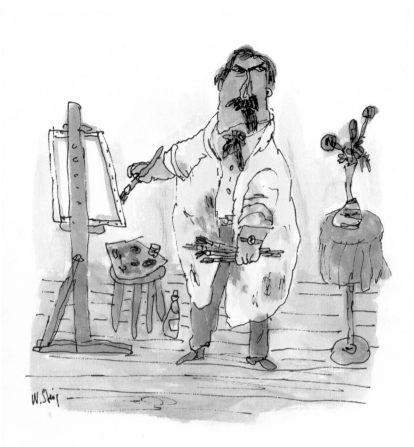

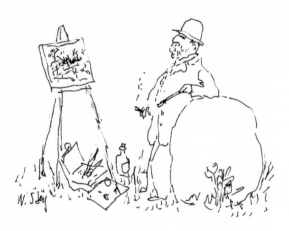

CÉZANNE.

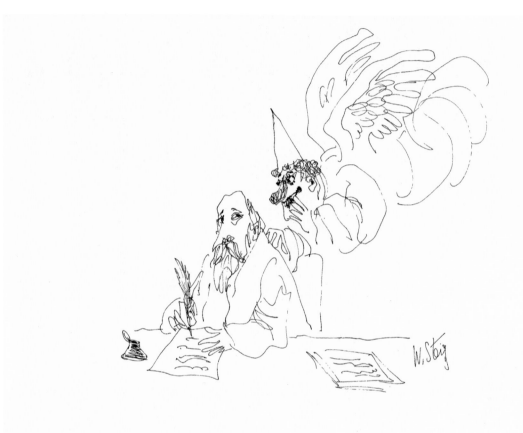

" Out, out, brief candle, life's but a walking shadow, a poor player
that struts & frets his hour upon the stage & then is heard no more —
'Tis a tale told by an idiot — — . "

above: "Out, out, brief candle, life's but a walking shadow, a poor player
that struts and frets his hour upon the stage and then is heard no more —
'Tis a tale told by an idiot …"

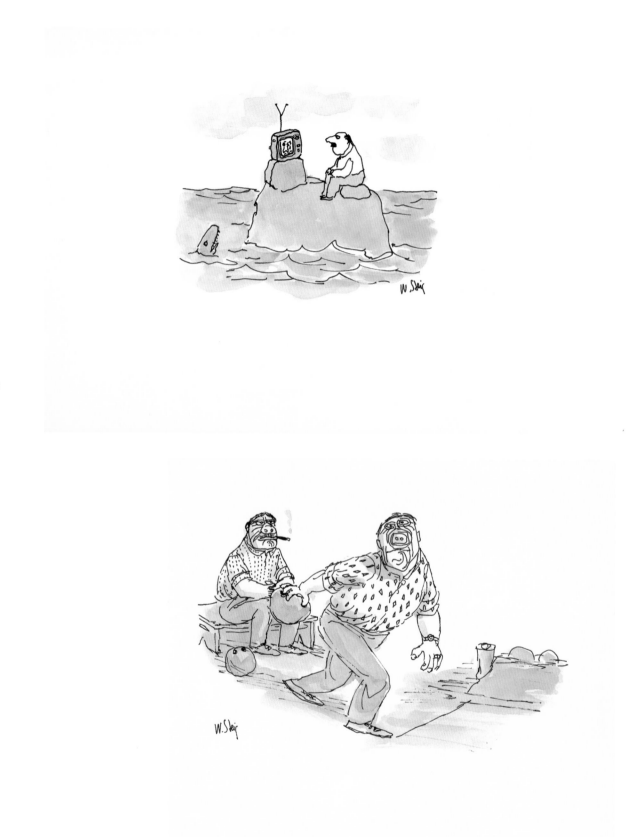

FINAL FRAME

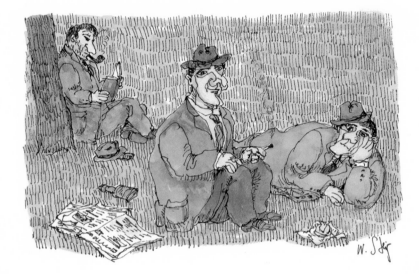

BIVOUAC

opposite, bottom: Final Frame

above: Bivouac

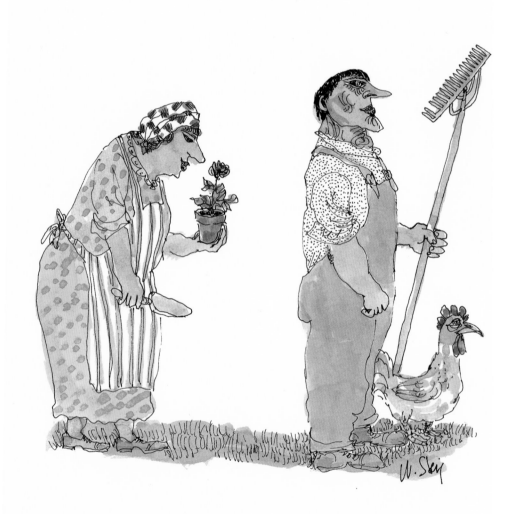

opposite, top: Rare Butterfly

opposite, bottom: Suitor

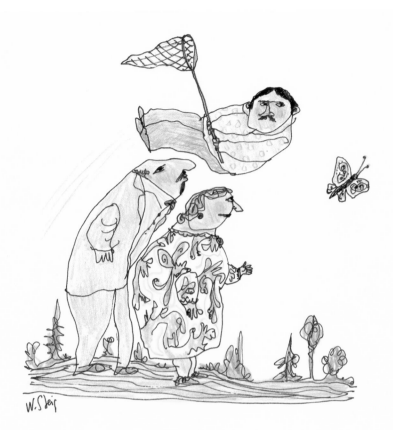

RARE BUTTERFLY

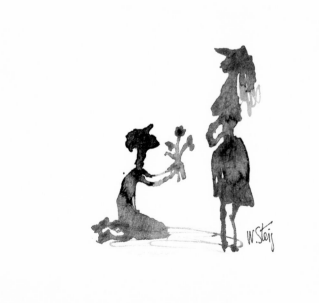

SUITOR

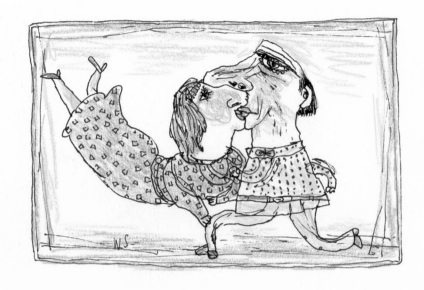

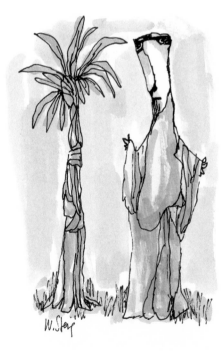

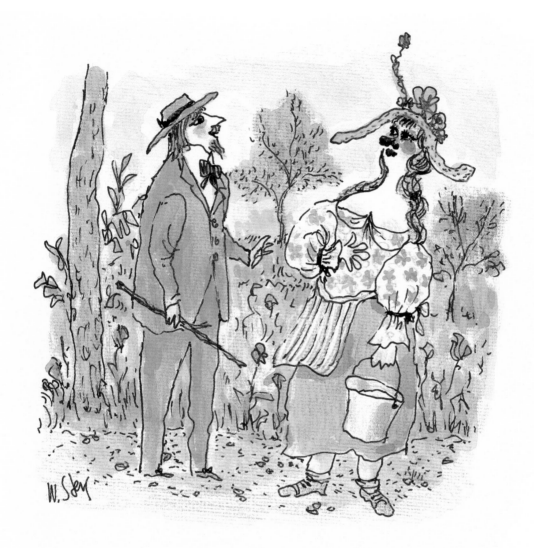

POET AND PEASANT

above: Poet and Peasant

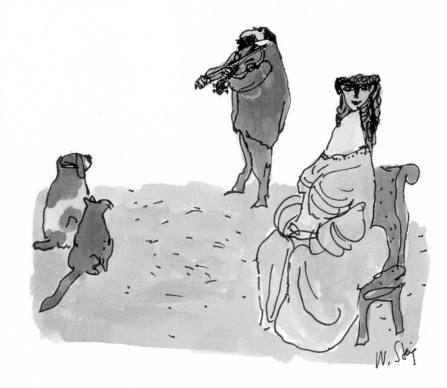

RONDO CAPRICCIOSO

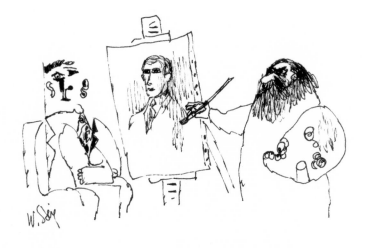

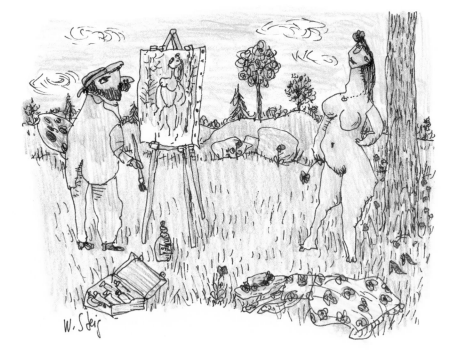

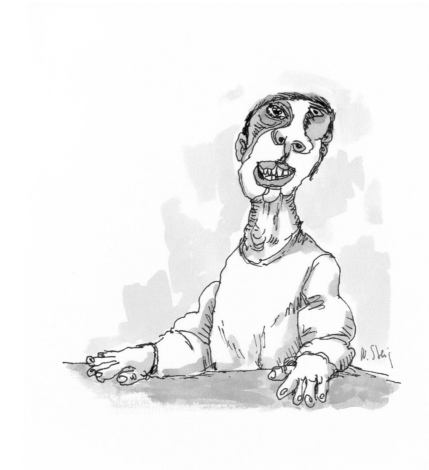

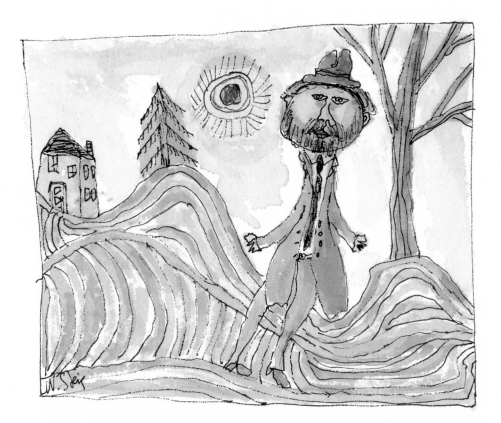

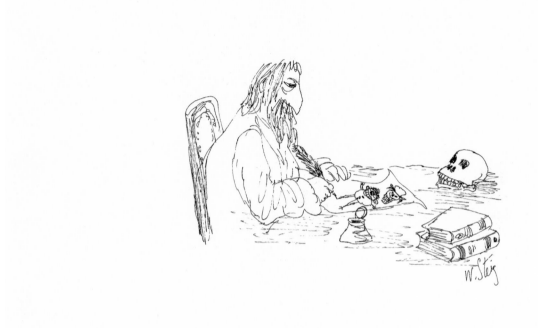

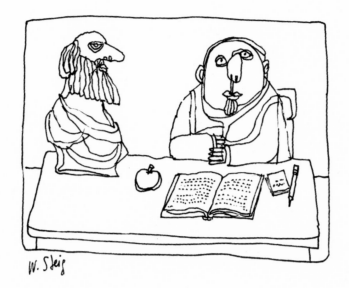

TWO SCHOLARS

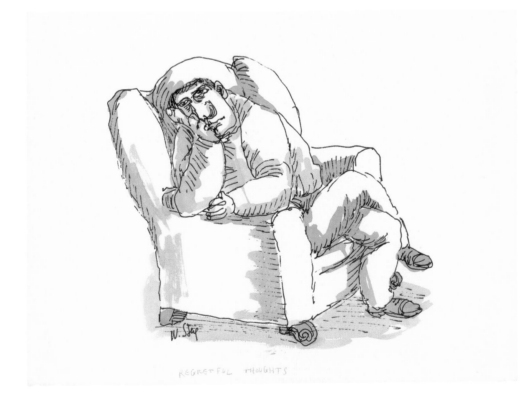

REGRETFUL THOUGHTS

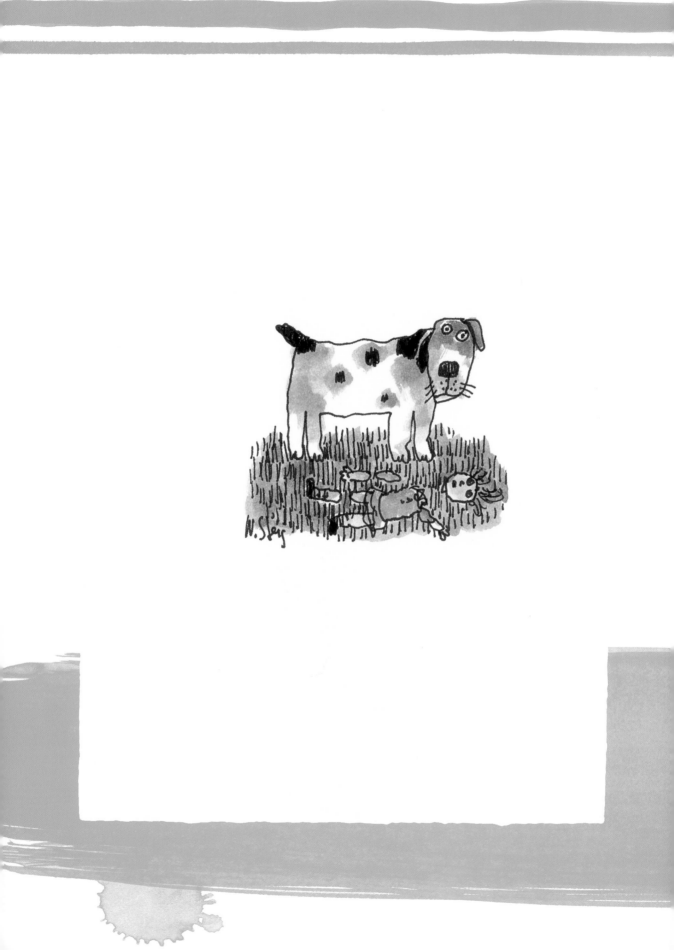

DOGS

Pearl was a dashing white bluetick-redbone coonhound cross. We called her Pearl after a doll Bill had once invented. The doll arrived in raggedy clothes with a spiffy makeover outfit her new owner could dress her in once she was "adopted." Our Pearl didn't need any improvements. She vibrated with energy and passion, and she loved everybody, except for one mean-spirited old carpenter who hated dogs, and was proud of it. The first time Pearl saw him she let out the only growl we'd ever heard from her, and she went after him before one of his legs was halfway out of his pickup truck. He, in turn, vowed to shoot her first chance he got. He never did shoot her, and she never did sink a tooth in him, but she drove him crazy, frequently making off with his cap, and often his sandwich as well. She was a wonder to have around, and we missed her awfully when her madcap nature moved her to jump off a stone wall just the other side of a curve and into the path of an oncoming car.

Our next dog, Kasha, was an all-American mutt with an up-curving tail and a thick brown coat. She was sensitive, a homebody, and a true companion. When she was a pup, she volunteered for a long walk with our son-in-law, but they encountered a gathering of wild turkeys, which gave Kasha an awful turn, and he had to carry her, quivering, out of the woods to the safe fields beyond. Once, Bill put on a recording of wolves, thinking it would amuse her. She was not amused, and instead turned tail and dove under a sofa, not to

be seen again for hours. She had a particular passion for swimming after us when we rowed in our little pond. Her prize was permission to clamber into the boat, shake herself dry, drench the rest of us, and ride around like a proud, frumpy queen. Kasha lived a long, hearty life, and made a fine old lady. She never lost her passion for extraordinary smells, and would bound in, coated with essential skunk or goose leavings, to roll on our bed and share that delectable nasal experience, almost to her final days.

A dog, for Bill, was a natural pal to man- and womankind. His drawings are full of them. They appear, for the most part, in human company, sharing whatever mood their owner seems to be suffering. But every now and again Bill turned one of them loose, and a dog may be seen passing by with others of his kind, or off by himself to send out a heartfelt howl at the moon.

Dogs were always of interest to Bill. In his children's books, they were sometimes bad guys, but more likely than not they were fine, enterprising fellows. When Bill finished writing and illustrating *Dominic*, he realized that its eponymous canine hero was patterned after his own father, Joe: impetuous, energetic, and full of curiosity about the world. That same description might serve just as well for Bill himself. He wondered about everything. You can find it in his drawings: a friendly kind of sniffing. A nosing around for answers.

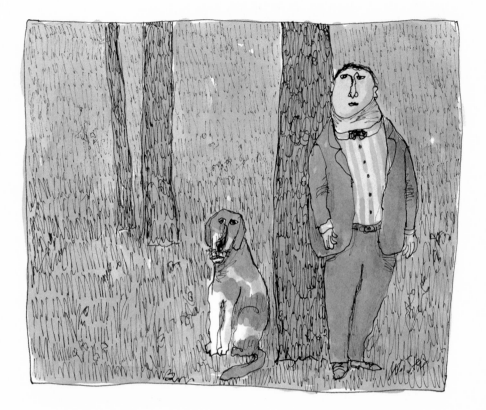

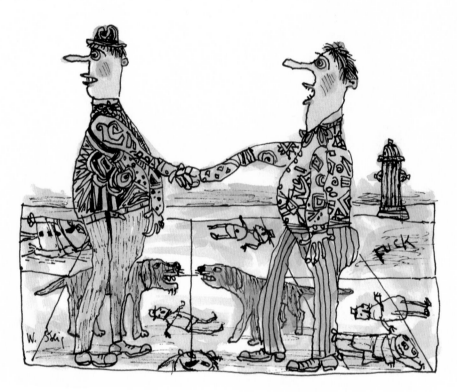

opposite, top: Dog Day

opposite, bottom: "He has no business blocking our path. Tell him!"

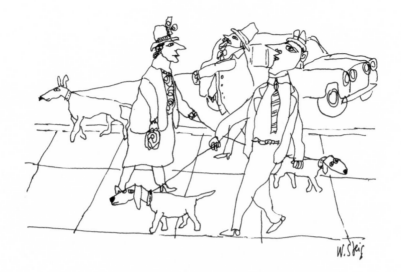

"He has no business blocking our path. Tell him!"

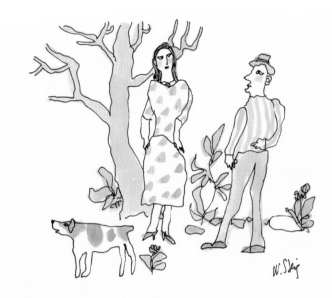

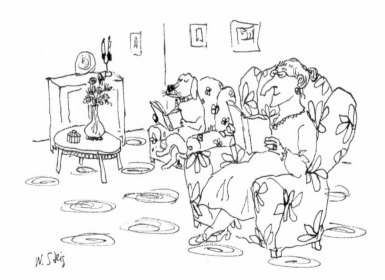

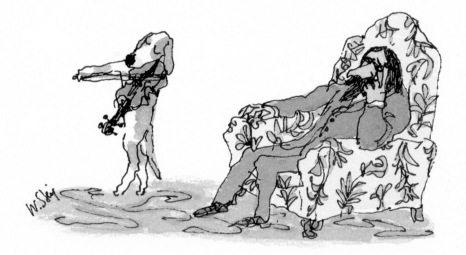

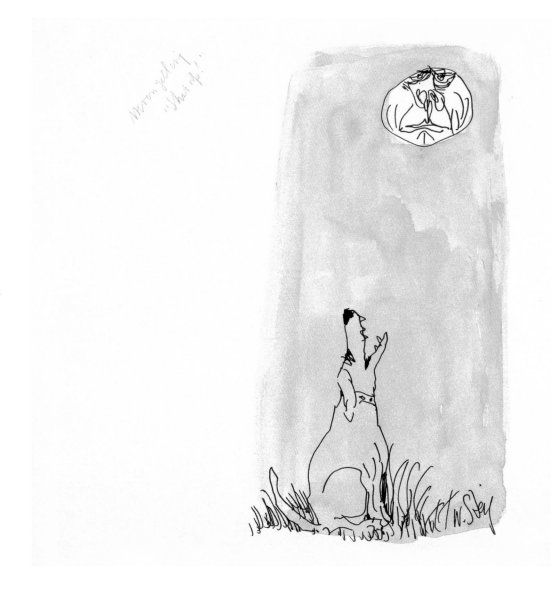

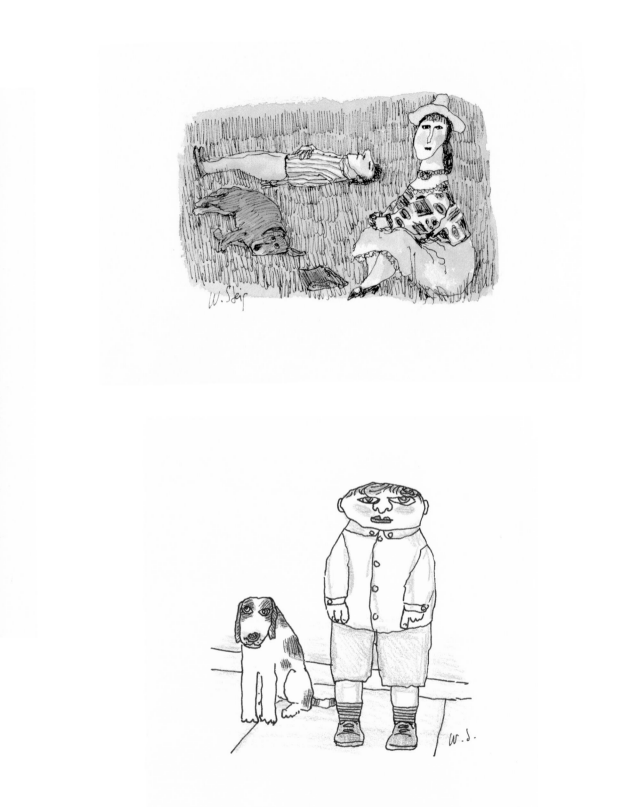

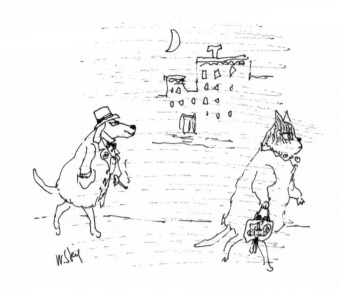

BUDDIES

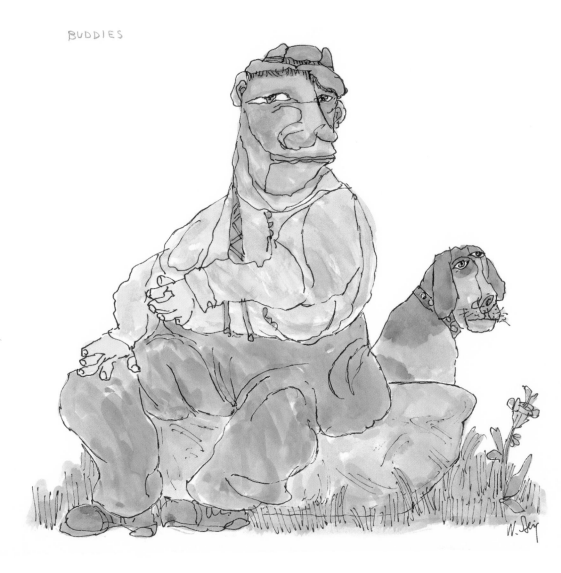

above: Buddies

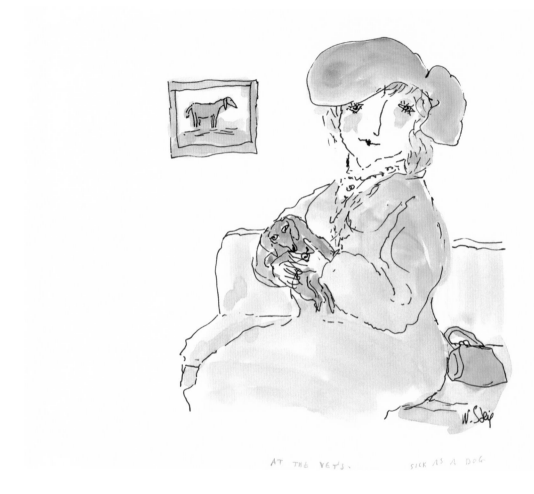

AT THE VET'S. SICK AS A DOG

above: At the Vet's (Sick As a Dog)

opposite, bottom: "No, dumbbell, leap!"

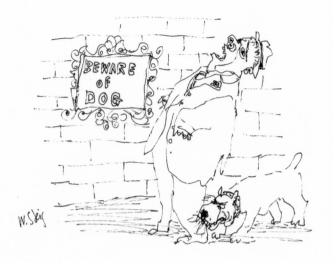

"NO, DUMBBELL, LEAP!"

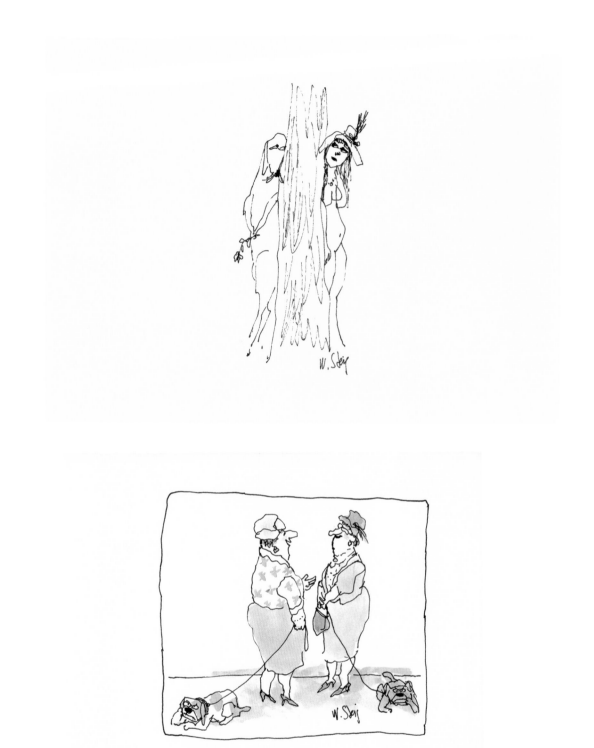

YACKETY - YACKETY

Two dogs

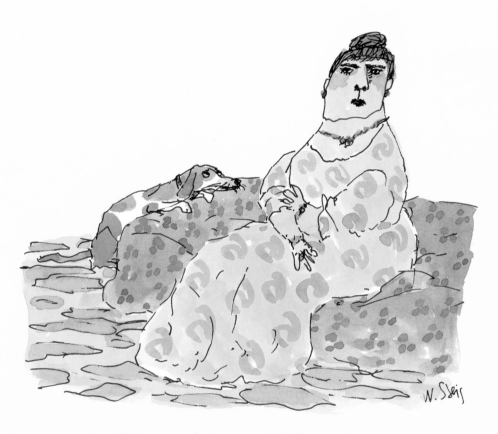

BAD DOG

N. Sbeis

opposite, bottom: Two Dogs (Yackety-Yackety)

above: Bad Dog

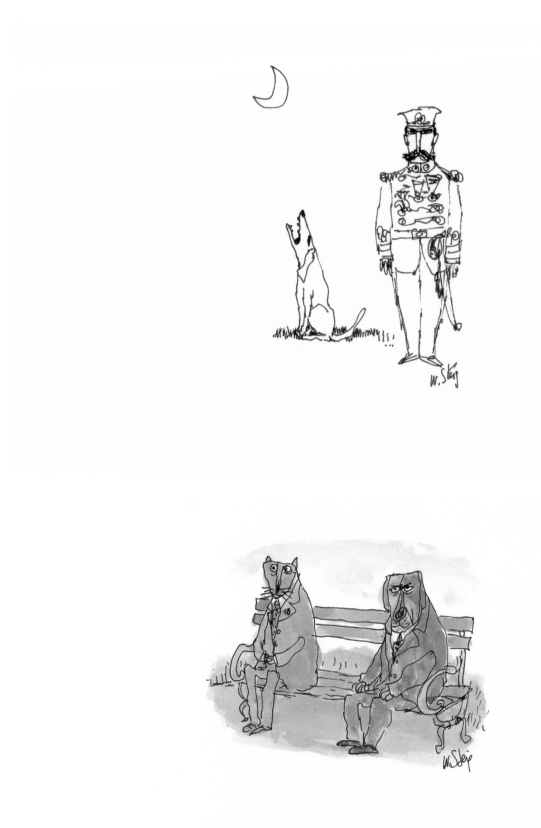

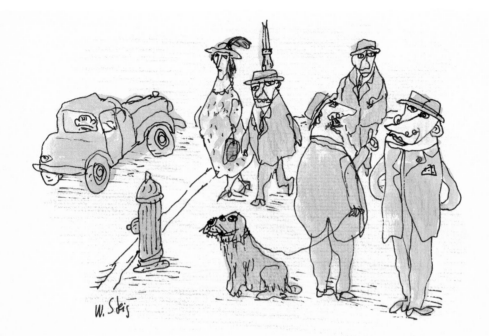

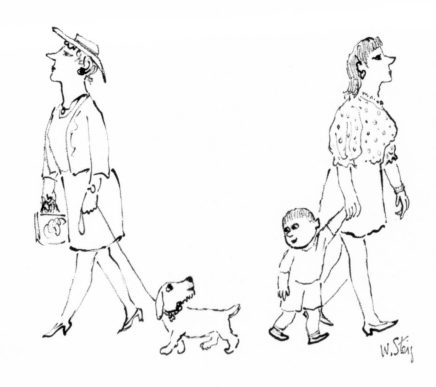

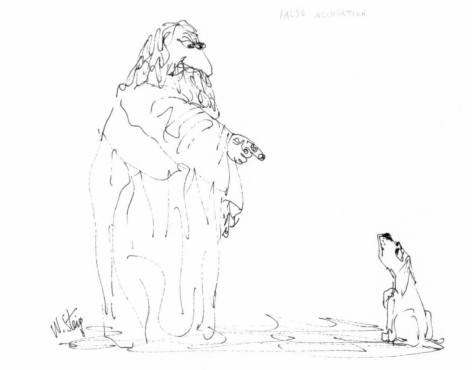

FALSE ACCUSATION

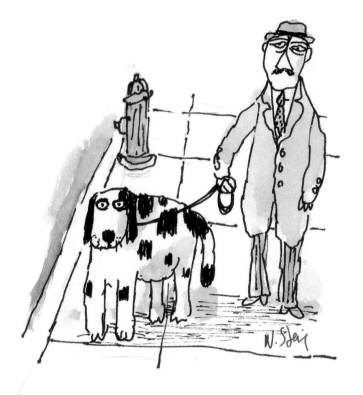

opposite, bottom: False Accusation

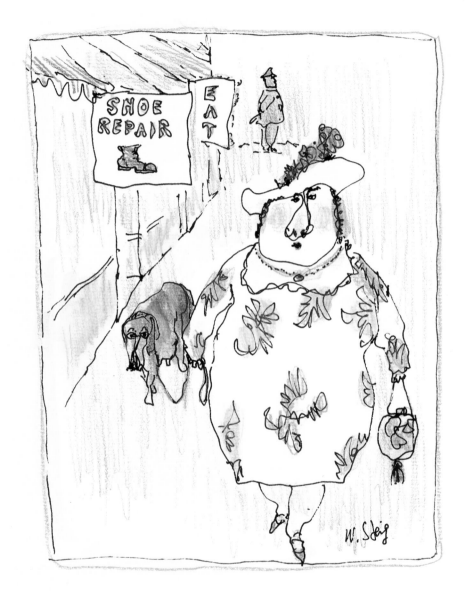

Within the illustration: SHOE REPAIR · EAT · W. Steig

opposite, top: Man, Wife, Cat, Dog

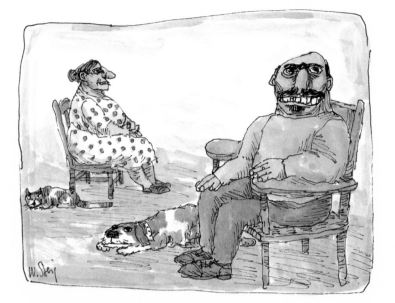

MAN, WIFE, CAT, DOG

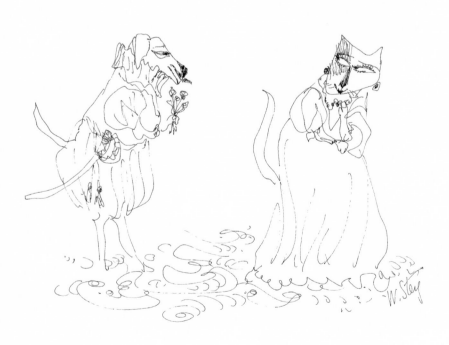

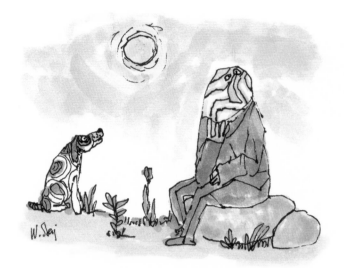

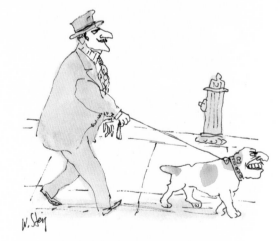

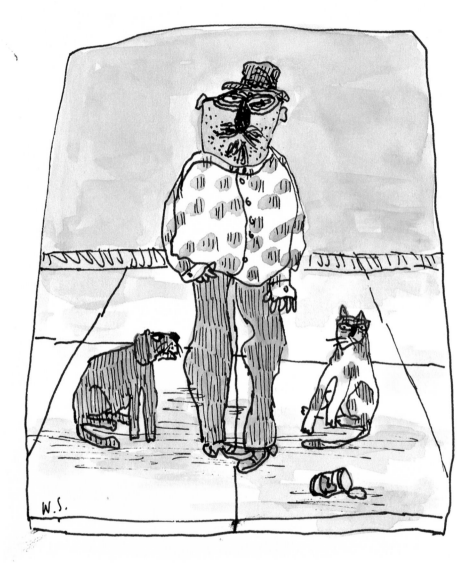

CATS

"A cat is a criminal," declared Bill Steig, "always." Nothing personal. It was just a literary call. Bill's respect for cats did nothing to change his mind. He liked drawing them. He loved having them around; they amused him. He felt tenderly toward them, but as a fictional character a cat was a villain.

Long before I knew him, Bill lived in the country and had a cat named Slotkin, a feline hero, the archetype of a cat to which none other might ever compare. When Bill had to move back to New York City, Slotkin was reluctantly tendered to a neighboring family so that he would be spared apartment life and could continue to enjoy his country freedom. A year later, when Bill paid a visit to the old place, he was informed that Slotkin had decamped shortly after having been put up for adoption, and taken a job in the small country store, chasing rats and greeting the locals. Bill dropped by to say hello. Slotkin turned his back, arched his tail, and stalked off. Bill always admired that cat, and I believe it was Slotkin's orneriness Bill found so endearing.

We had a series of cats when we moved to the country: Alan, a yellow kitten with baseball mitt paws who climbed into Bill's lap and refused to be rejected, was the first. He was a rascal, and showed his color early on by walking over a palette full of paint and inscribing much of the furniture with turquoise paw prints. Not long after that, he figured out how to open the drawer where his catnip stash was located. "That *is* a cat," said Bill. "Smart. Independent." Independence was also important to Bill.

When Alan died, we found another, almost identical cat, whom Bill insisted should also be named Alan. Alan II was a mighty

hunter, a cat of charm and dignity, but not, according to Bill, as smart as he might have been. Bill never condescended to animals any more than he did, in his books, to children. If you were dumb, you were dumb. Alan II moved to Boston with us, where he retired to a life he viewed looking through a window from the comforts of a couch. But he also passed many hours in philosophical thought before the washing machine, or staring solemnly at a crack from which, perhaps, a mouse might emerge.

When Alan II died of extreme old age, we adopted a pair of twin kittens. We'd gone to the shelter for one, but those kittens were so intertwined that we felt compelled to take both of them. We named them Mo and Easy. Easy was greatly enamored of Bill and once in a while, in a fit of passion, he would jump on the back of his chair and pull gently at Bill's fine field of hair. It was an act of affection, a grooming. But Bill did not go for it.

Cats populated Bill's drawings. Almost all of them are seen with people. Some are cosseted, some are taking their ease. Some are just going about their business while human life eddies around them. And a few of them are criminals.

opposite: L'Île d'Abel

L'île d'Abel

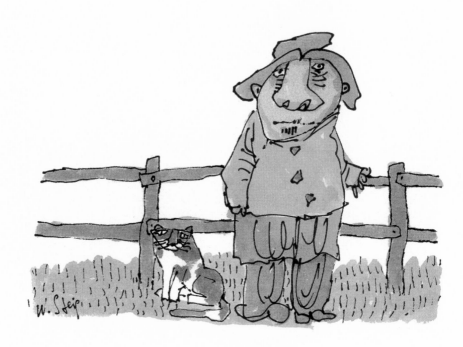

RUSTIC

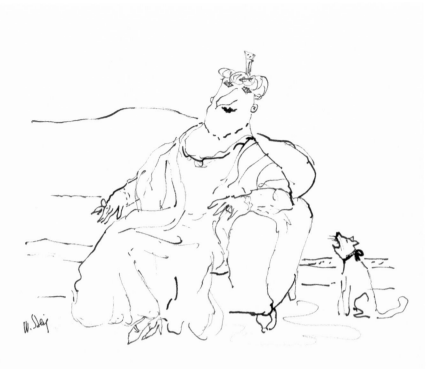

THE HUNGRY CAT

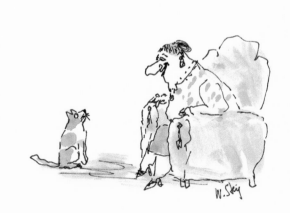

"GUESS WHO IDOLIZES YOU."

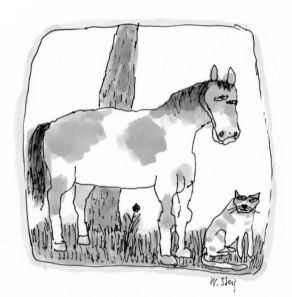

MIDNIGHT REVEL

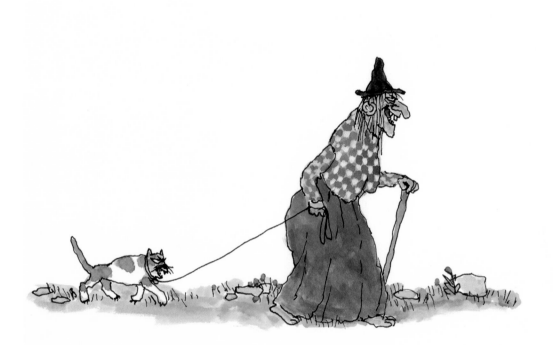

opposite, bottom: Midnight Revel

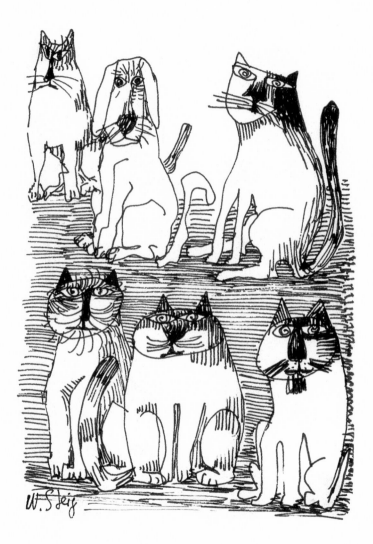

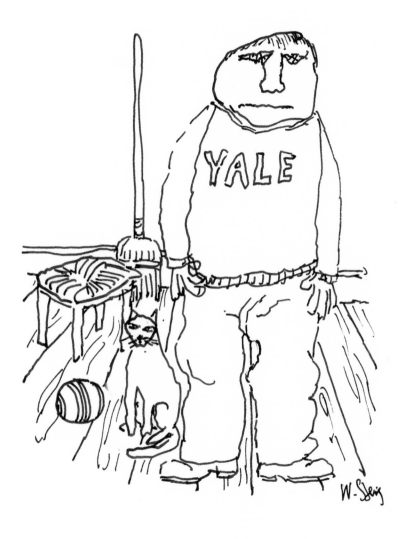

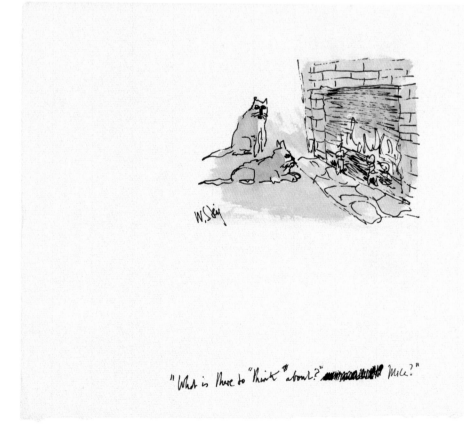

"What is there to "think" about?" ~~~~~~~ Mice?"

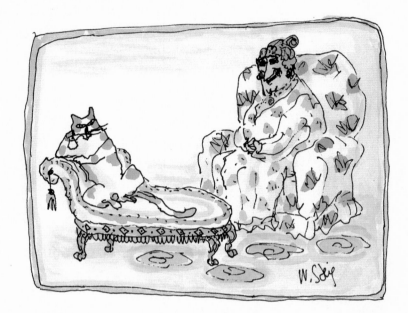

opposite, bottom: "What is there to 'think about'? Mice?"

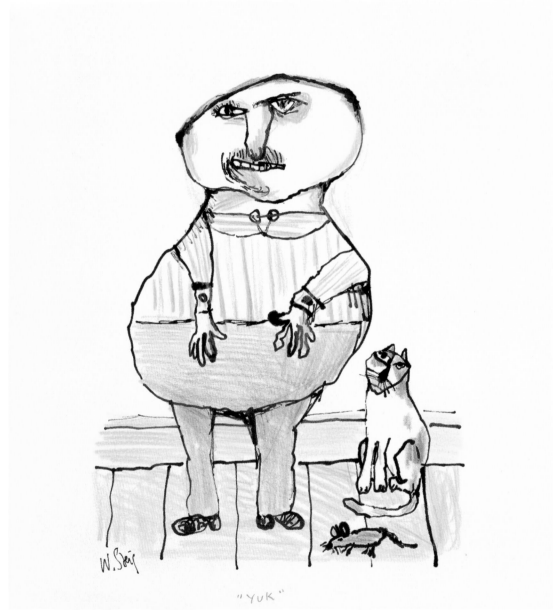

"YUK"

above: "Yuk"

opposite, bottom: The Shy Criminal (Malefactor)

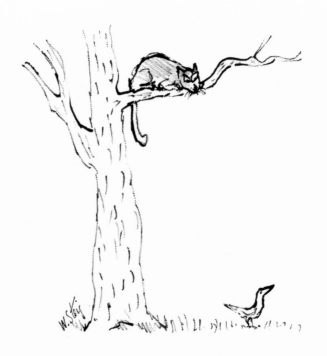

THE SHY CRIMINAL
malefactor

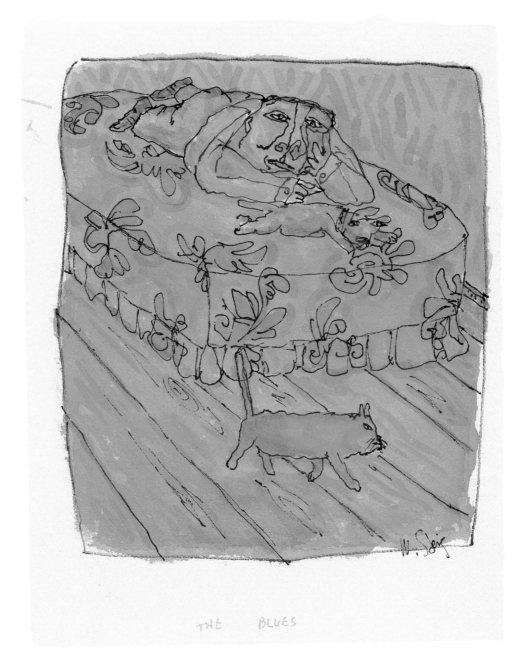

THE BLUES

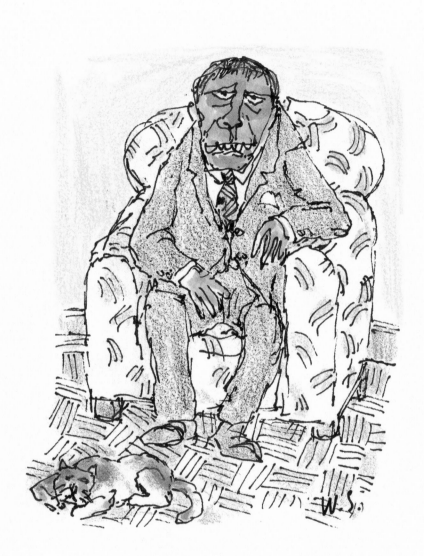

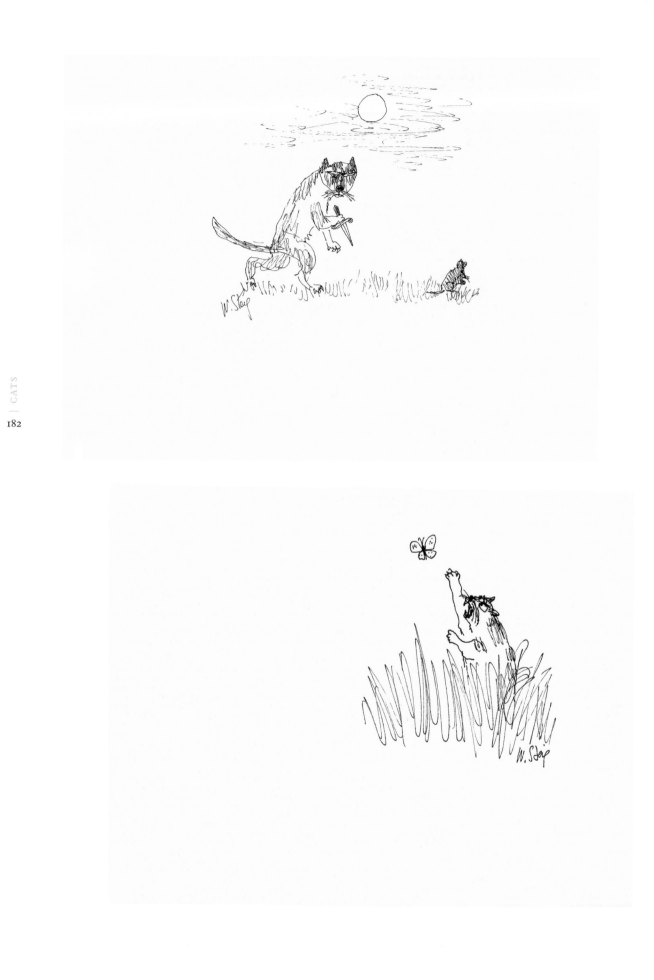

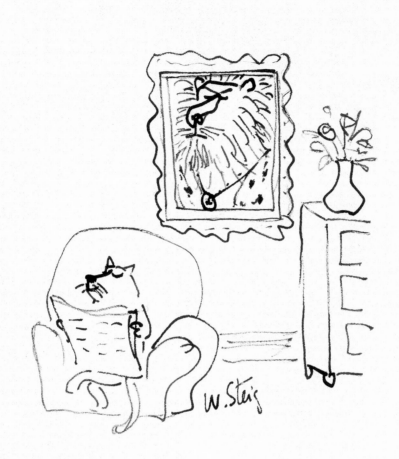

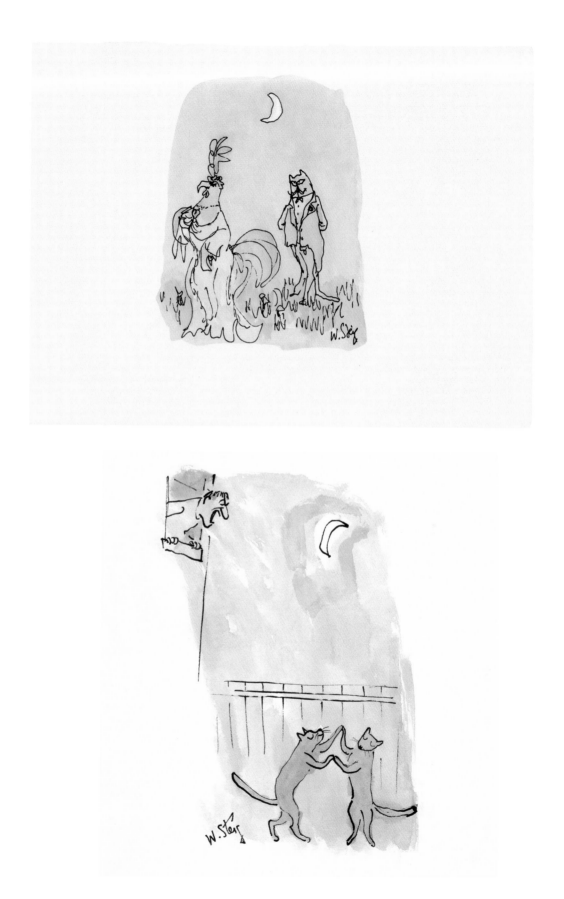

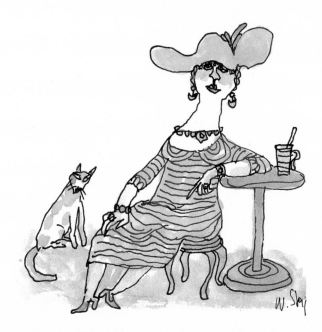

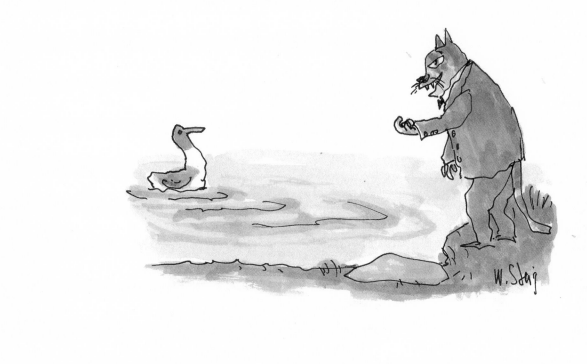

"Don't be so shy."

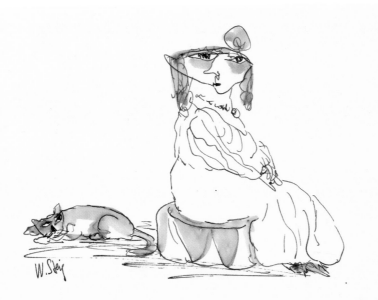

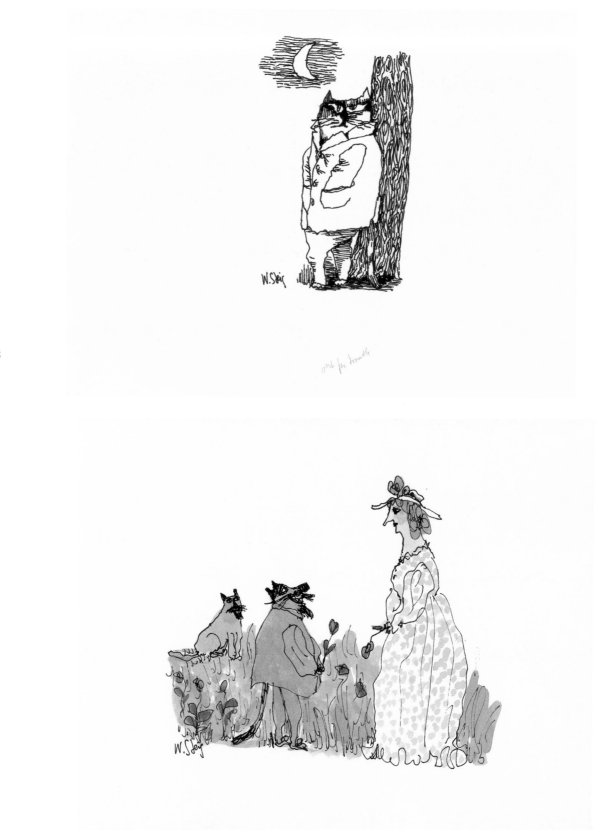

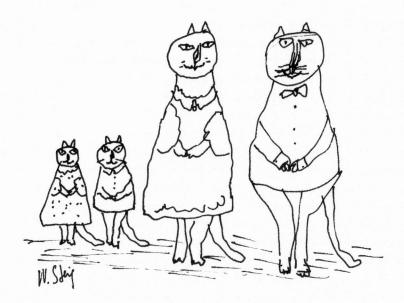

THE CATSES

opposite, top: Out for Trouble

above: The Catses

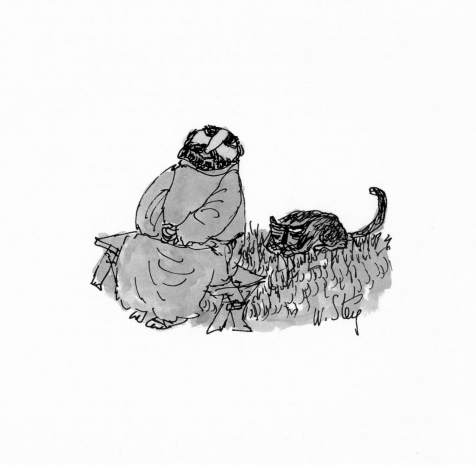

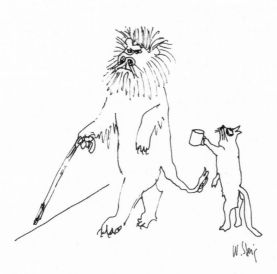

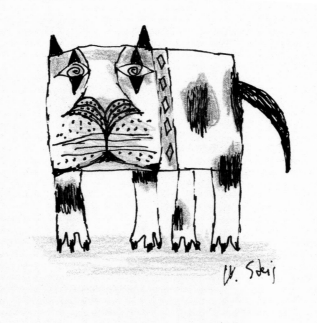

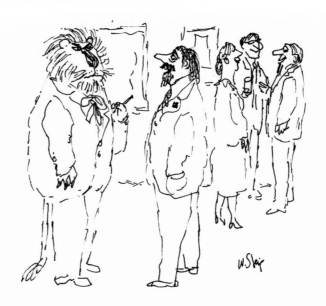

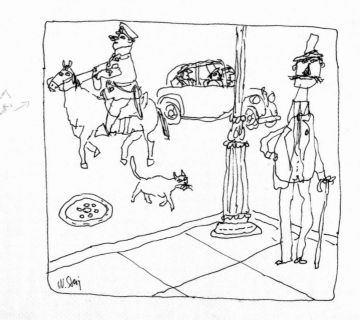

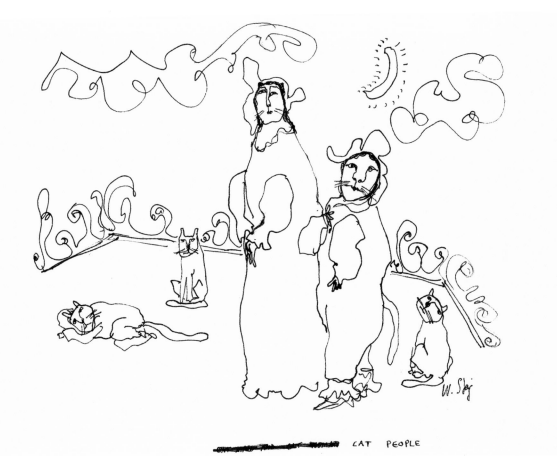

CAT PEOPLE

opposite, top: "Am I bothering you, sir?"

opposite, bottom: Someone Calling Him Cossack

above: Cat People

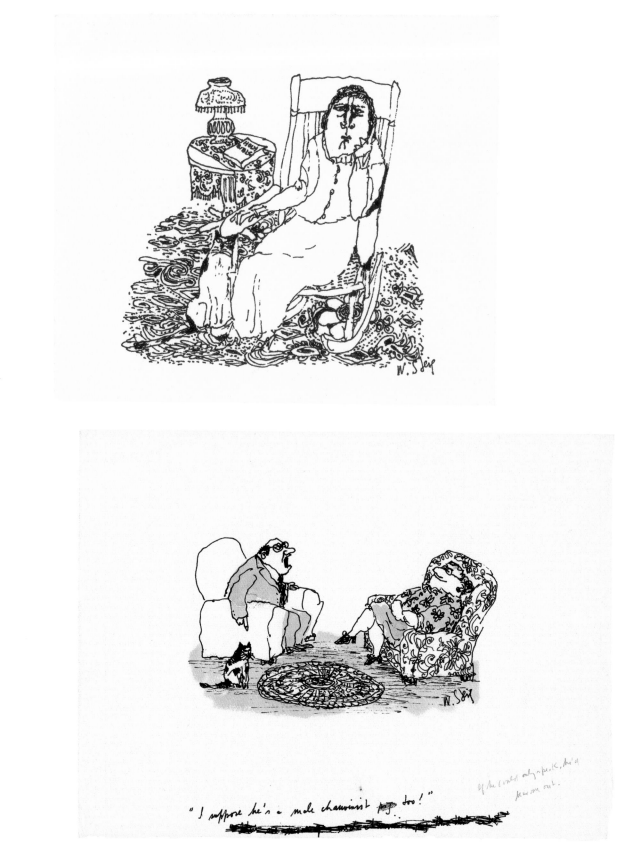

"I suppose he's a male chauvinist pig, too!"

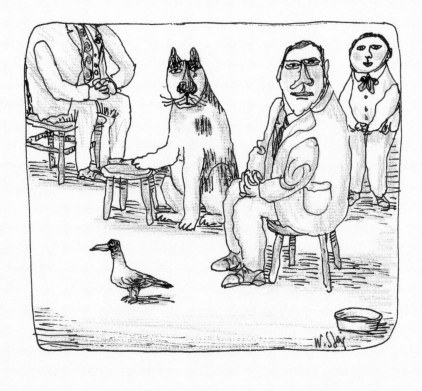

HOUSEHOLD PETS

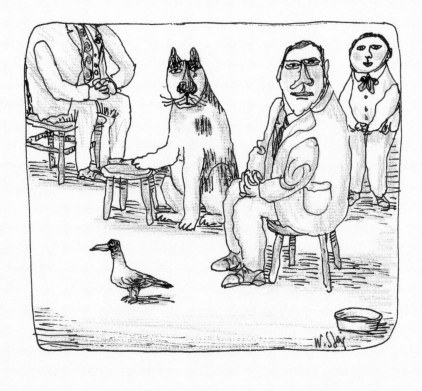

opposite, bottom: "I suppose he's a male chauvinist too!" (If He Could Only Speak, He'd Hear Me Out)

above: Household

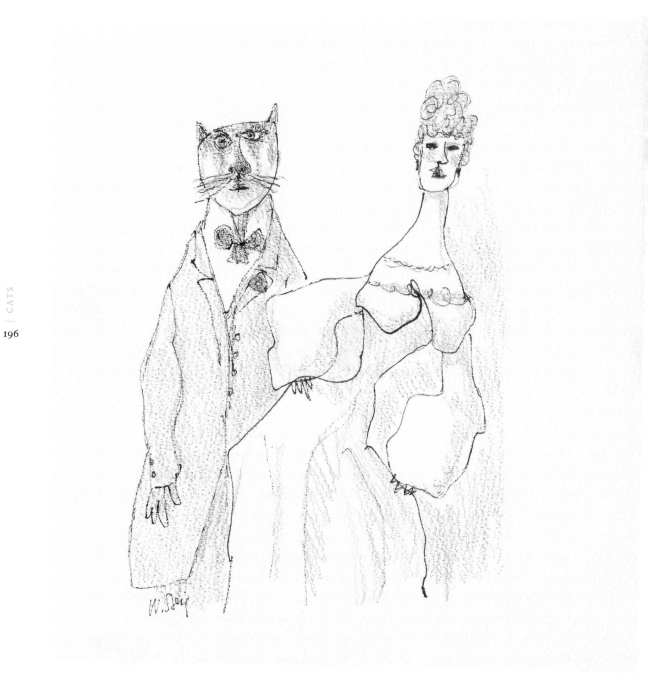

opposite, bottom: "Scat!"

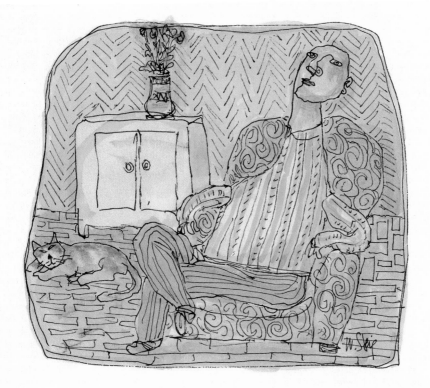

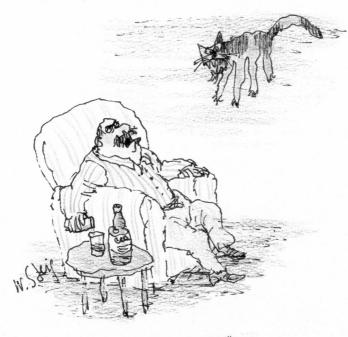

"SCAT!"

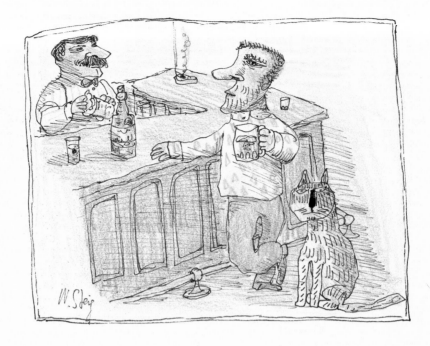

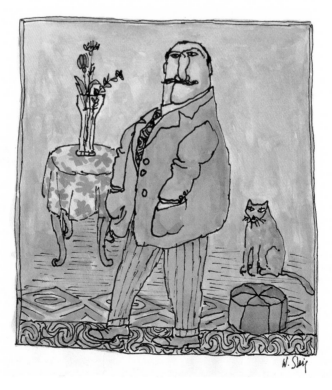

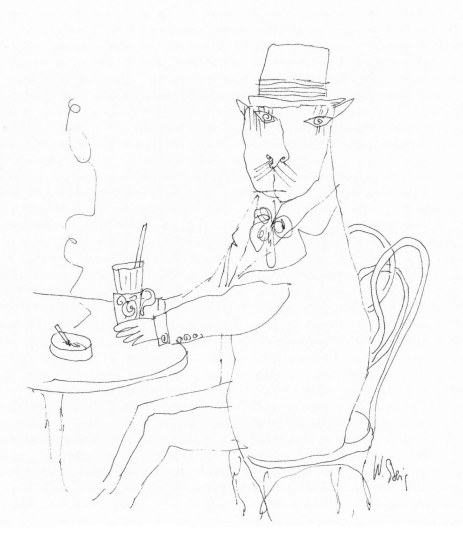

opposite, bottom: Student Cat

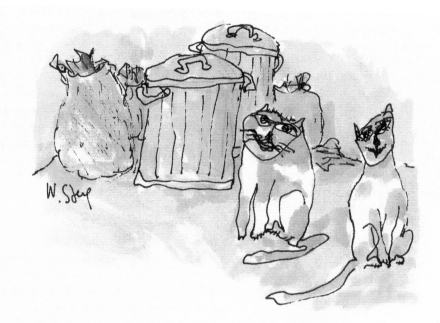

W. Steig

TRYST

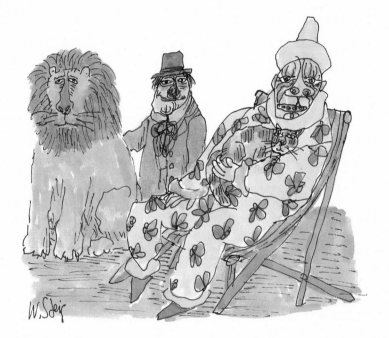

CAT LOVERS

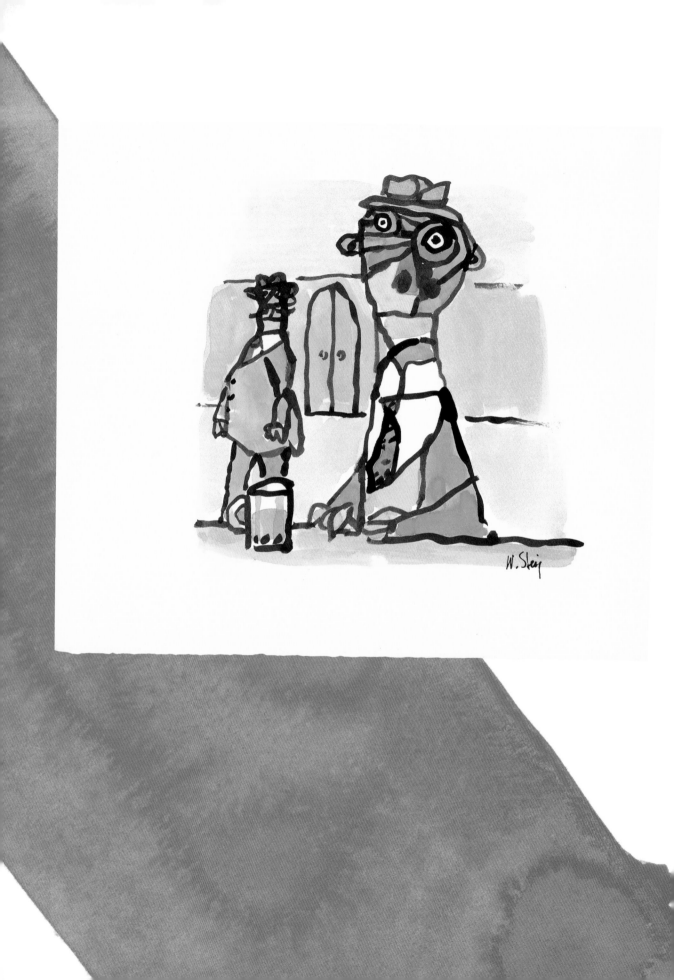

ODD DUCKS

Bill considered himself a doodler. Somebody once called him a "Divine Doodler," to his enormous delight. Bill would doodle on anything: he favored grocery lists. These were frequently garnished with jumbles of interlocked figures whose noses, mouths, and sundry body parts linked together like puzzle pieces. The subjects may have been desperate to part, or perhaps they were overjoyed by their weird intermingling; there was no telling. Bill was able to doodle invisibly. He could construct in his own head complex mandalas, though he would never have thought to use that term. This enabled him to appear to be fascinated by conversations which were of absolutely no interest to him. If you saw him looking intense at a party, it's a fair bet that's what he was up to.

When Bill sat down to draw without any thought of the *New Yorker* or a book he had in the works, he took off; and likely as not he'd land in a Steigian country, inhabited by some very odd ducks. There were themes he returned to repeatedly: ink blots, out of whose splashes extravagant creatures emerged; figures suggestive of insects, flowers, or puppets; rubbery fellows, some bulbous, some lean; maniac dancers; and often strange, brooding figures. These odd ducks were his freest and, I believe, among his most powerful works, in which energy and profound emotion are bound together like those impossible personages he depicted. In some ways they were his clearest look at the human race: some were dark spirits; some were wise innocents, almost angelic creatures. That's how Bill thought we were all meant to be.

Bill had a loose but meaningful relationship with a group of zany "spirits" who kept their collective eye on him and helped

him along. They hung around when he played solitaire, a game he greatly enjoyed, and they had no objection to his changing the rules if that seemed advisable. When he had a losing streak, Bill said they felt he should just keep at it. "How do you know they don't want you to get to work?" I'd ask. No answer. The spirits felt he knew what he was doing.

That nitwit game was exactly the thing Bill needed to be transported, to open himself to the art that stood in the wings. Work for Bill was a "given," a mysterious gift. He was an entirely intuitive artist, never the least bit interested in what someone else thought his work might mean. The Creative Process was not a subject Bill ever spoke of. It was almost as though he felt that was none of his business.

Art was serious play, and it went without saying that there should be no intrusions. For years Bill did advertising work; he had a good number of people to support and, while he hated doing it, he did it very well. When things got easier for him, he underwent a volcanic explosion during the course of an advertising meeting, and disengaged himself once and for all from that "bourgeois" arena. It was a great relief.

Children's book writing replaced advertising, and he wrote them with pleasure and ease, but he liked just plain drawing better than illustrating. An illustrator needs to know what he's up to. You follow the rules when you're making a book: the same character, dressed in the same way on every page. When Bill and I did a book together, I was restricted to very short stories so he was never compelled to repeat a character. That freed him from having to follow the rules. He couldn't abide by them. If you were so rash as to tell him a secret, he'd stop the next stranger he met on the street in order to pass it along. Bill Steig was one of your odder ducks.

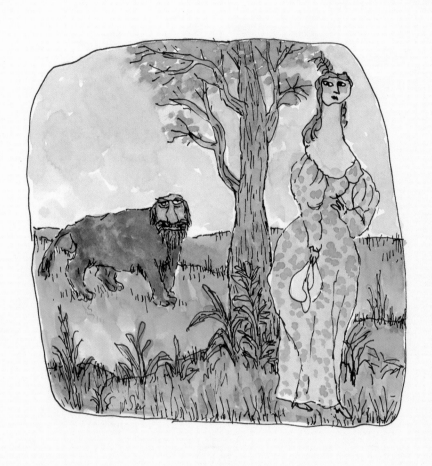

ADMIRER

above: Admirer

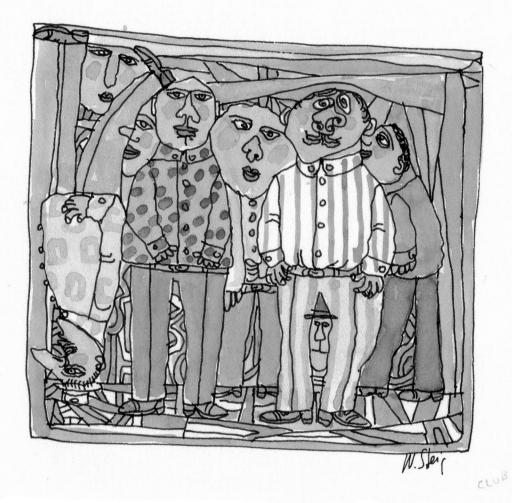

above: Club

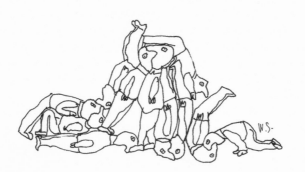

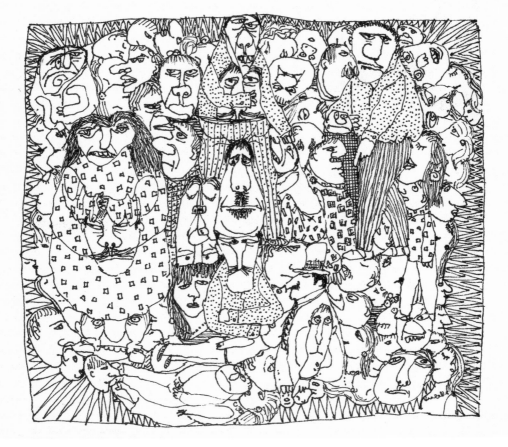

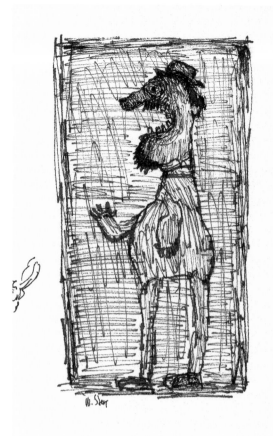

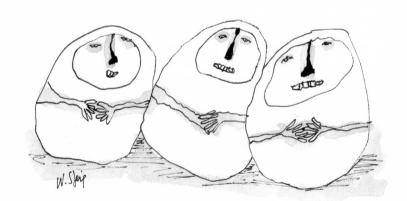

BAD EGGS

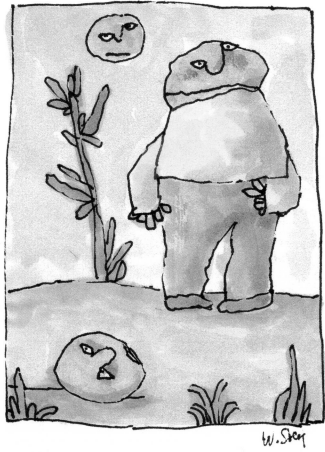

opposite, bottom: Bad Eggs

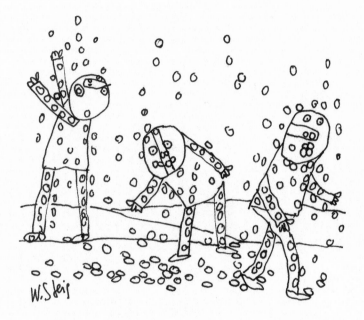

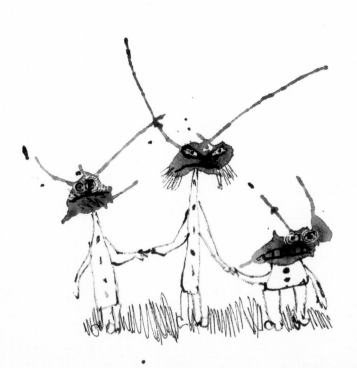

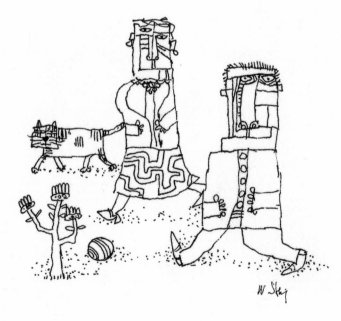

CAPITULATION.

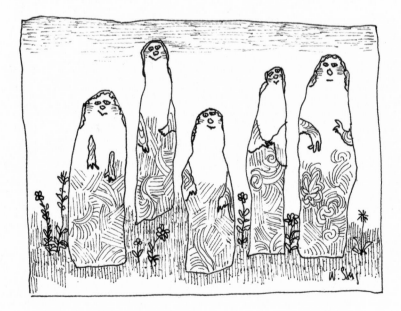

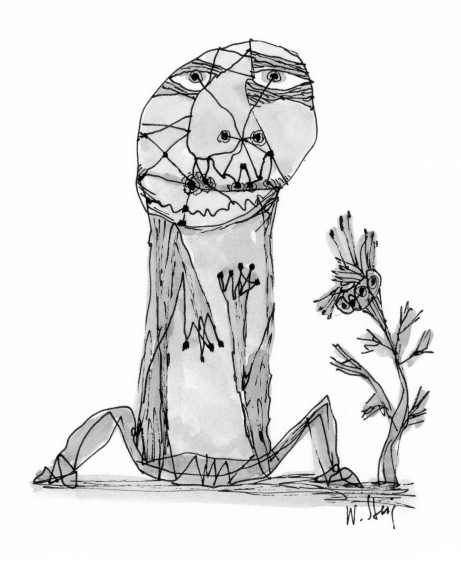

opposite, top: Capitulation

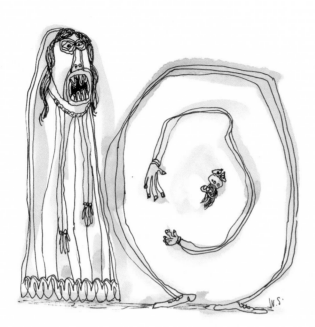

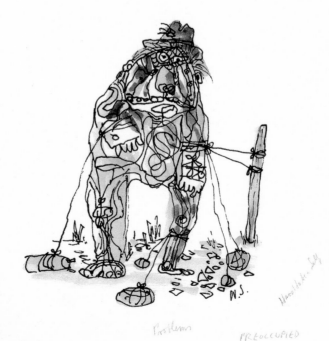

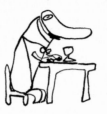

Lone diner

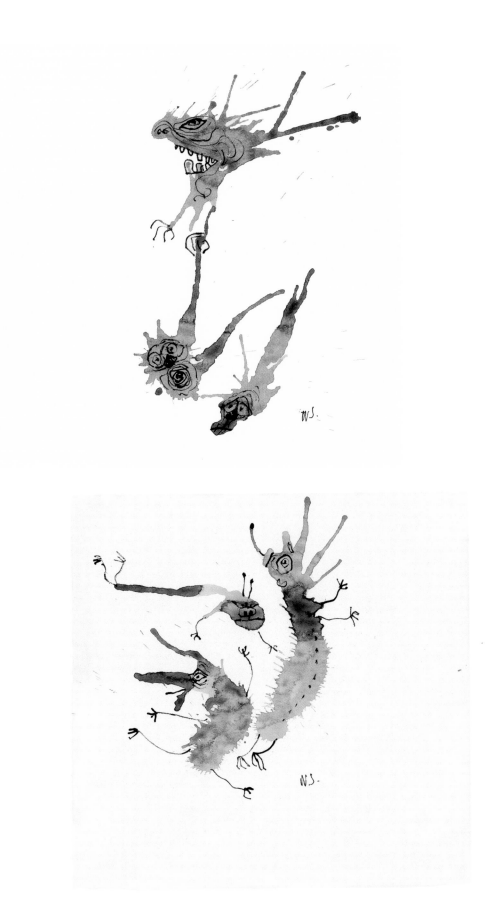

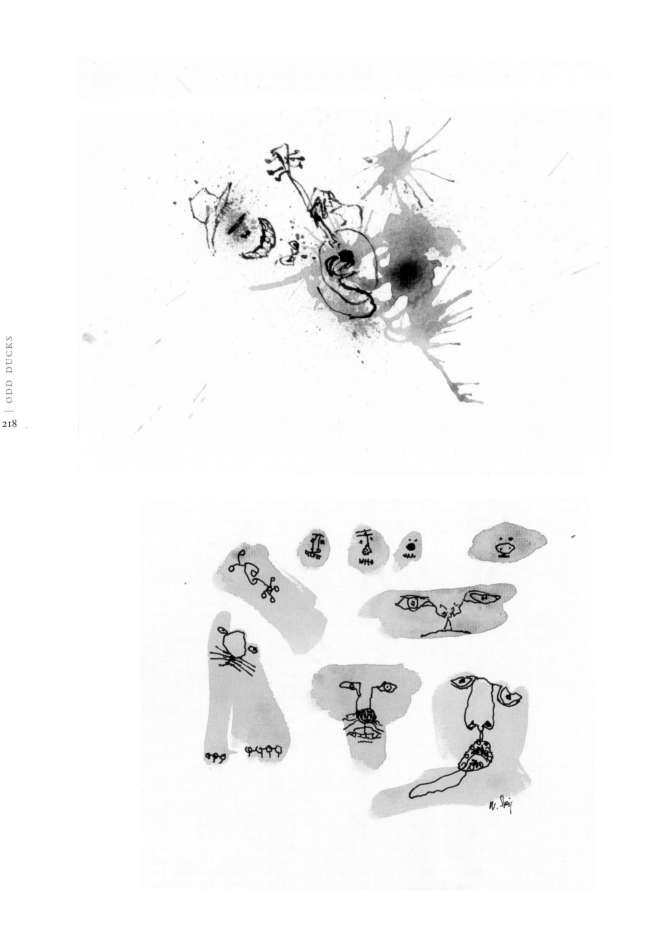

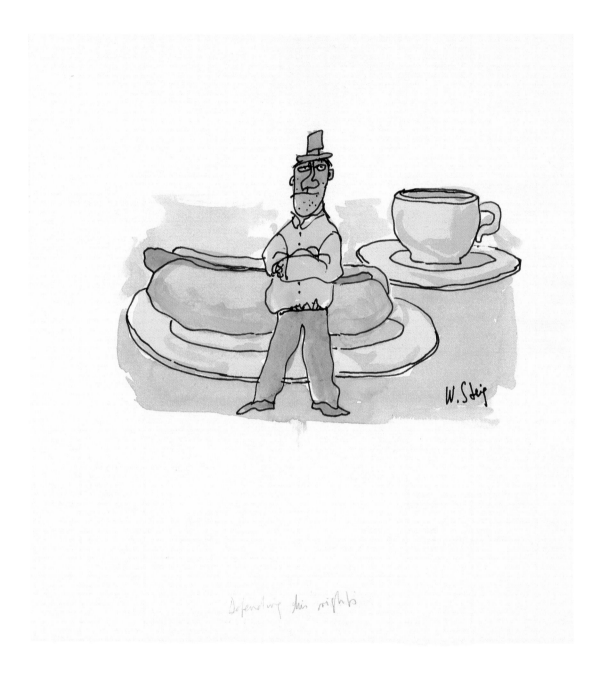

above: Defending His Rights

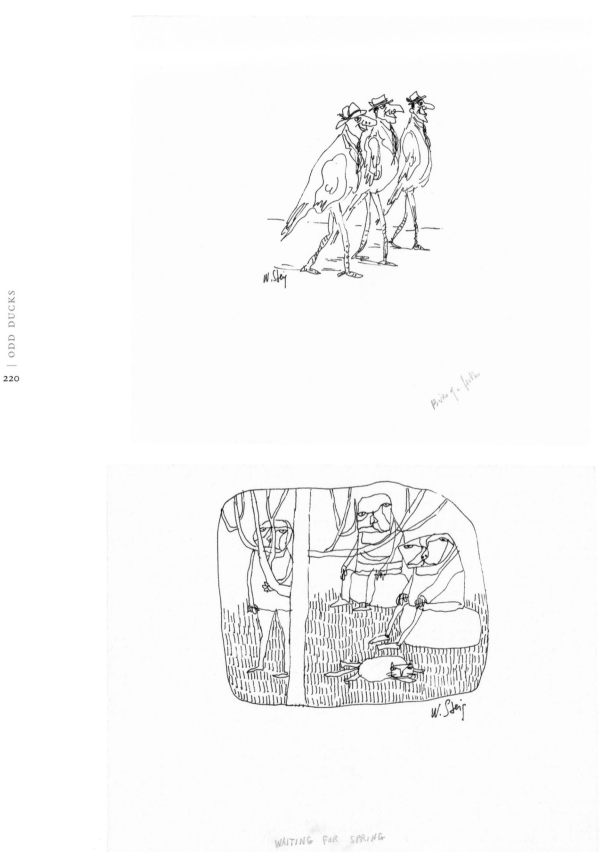

Birds of a feather

W. Steig

WAITING FOR SPRING

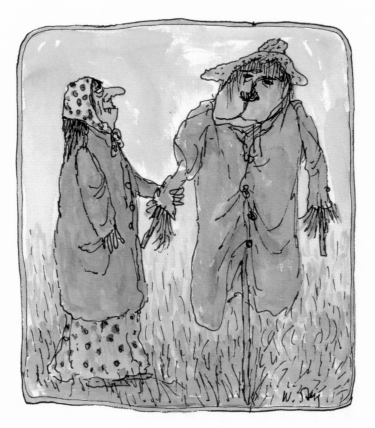

opposite, top: Birds of a Feather

opposite, bottom: Waiting for Spring

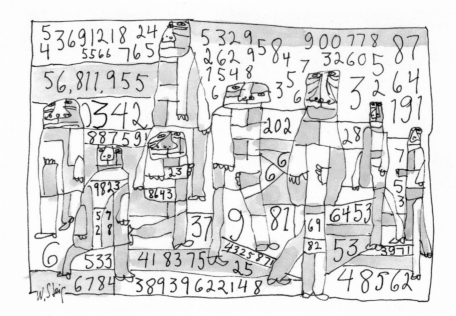

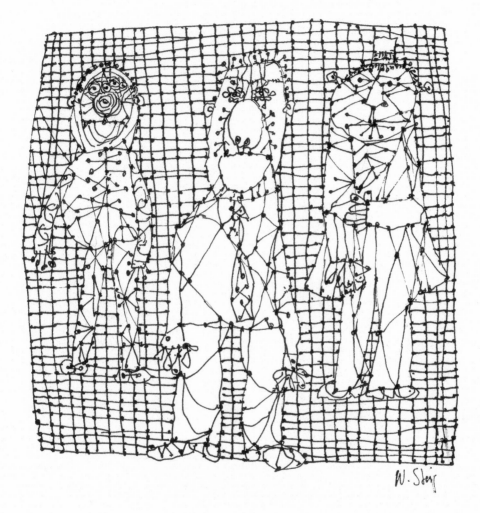

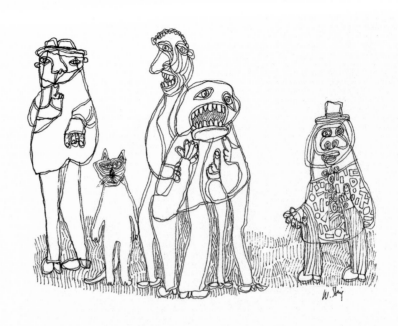

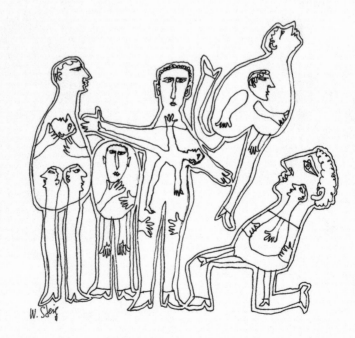

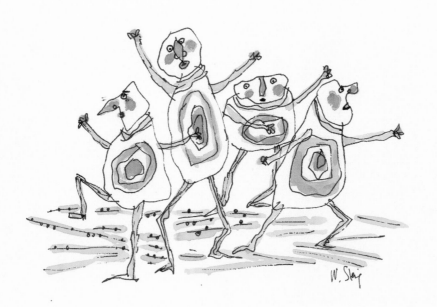

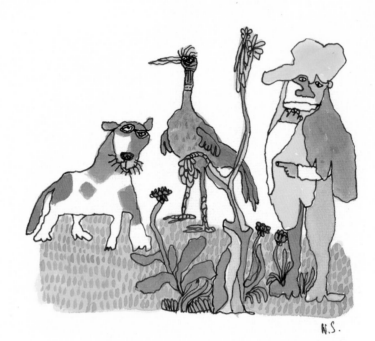

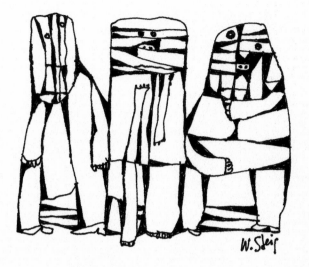

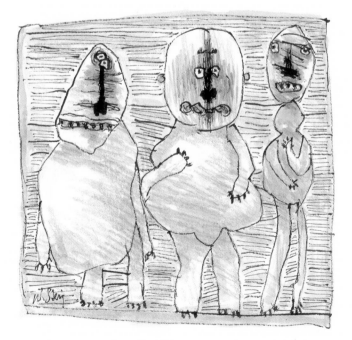

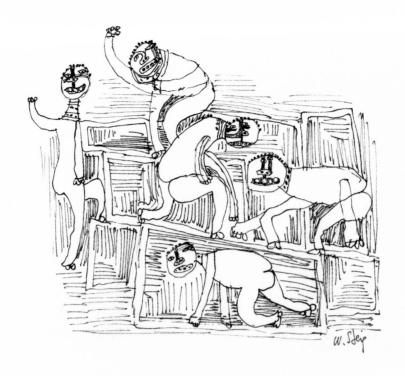

BOARD GAME

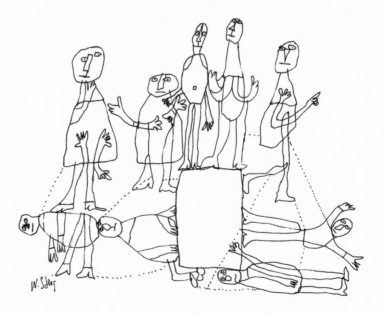

DIAGRAM

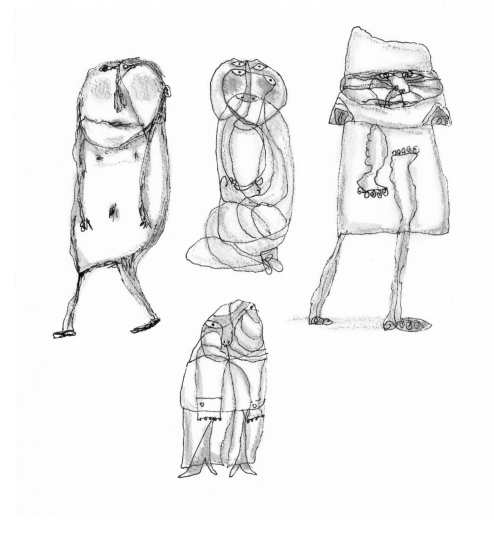

opposite, top: Board Game

opposite, bottom: Diagram

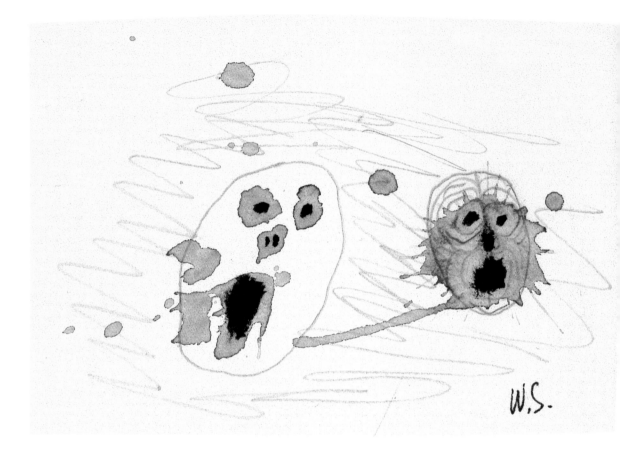

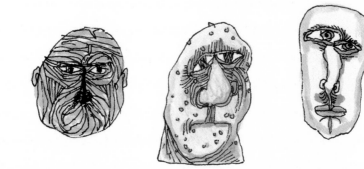

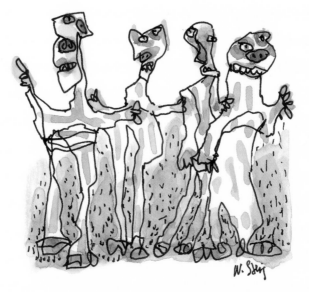

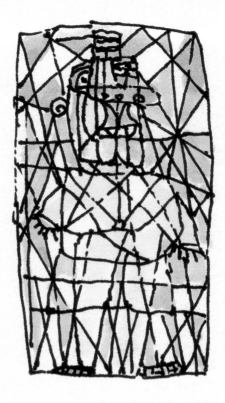

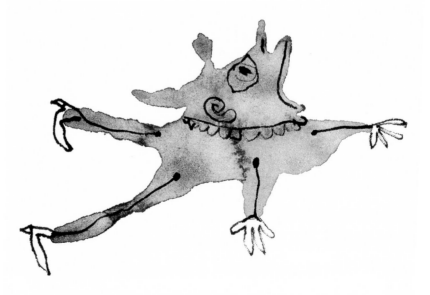

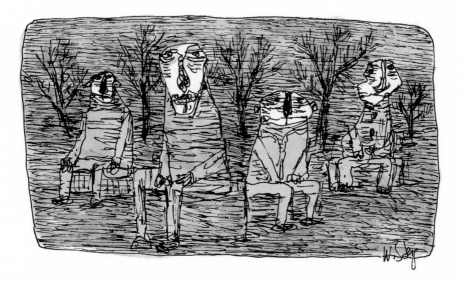

above: In the Gloaming

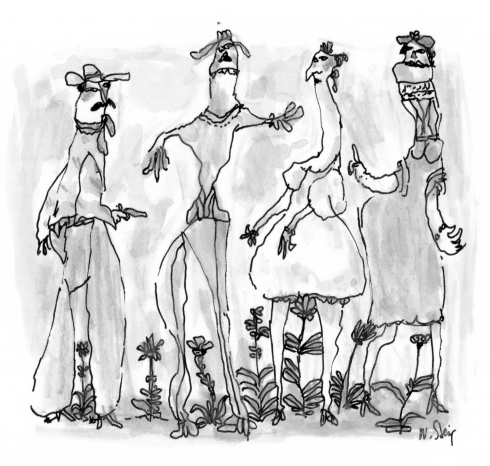

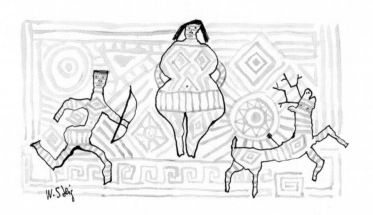

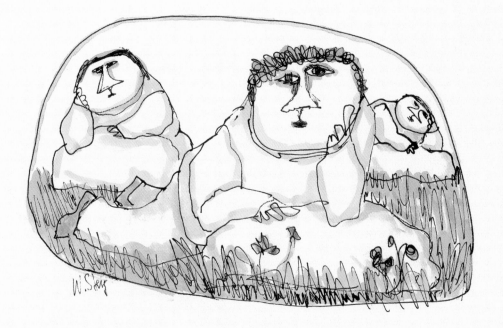

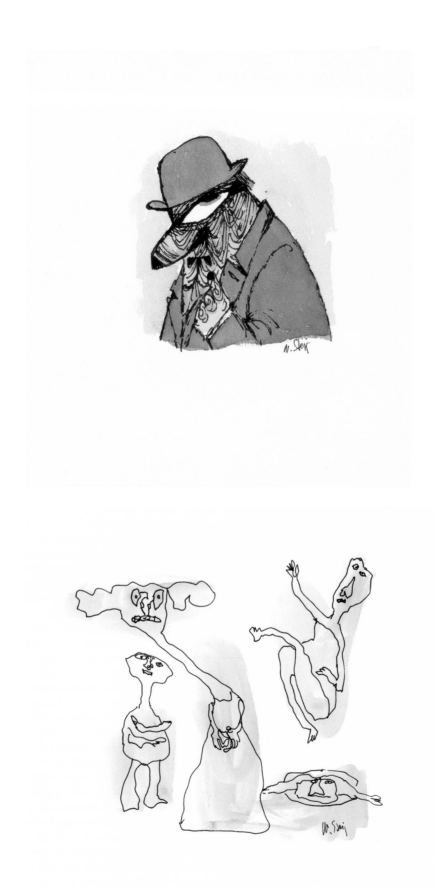

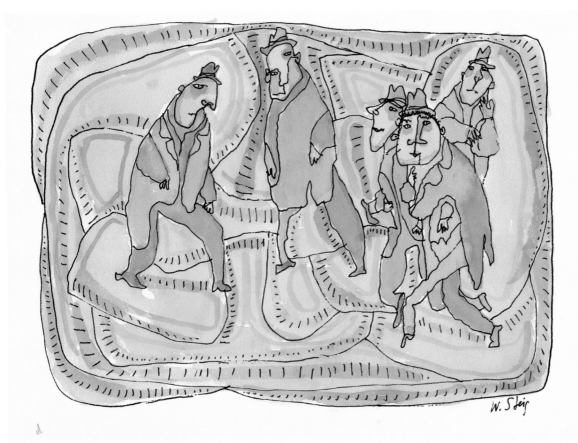

TIPPYTOES

W. Steig

above: Tippytoes

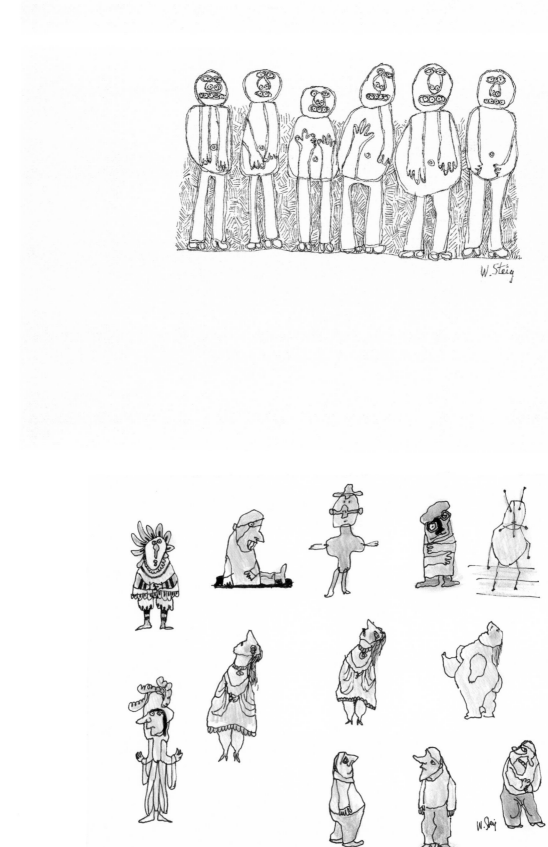

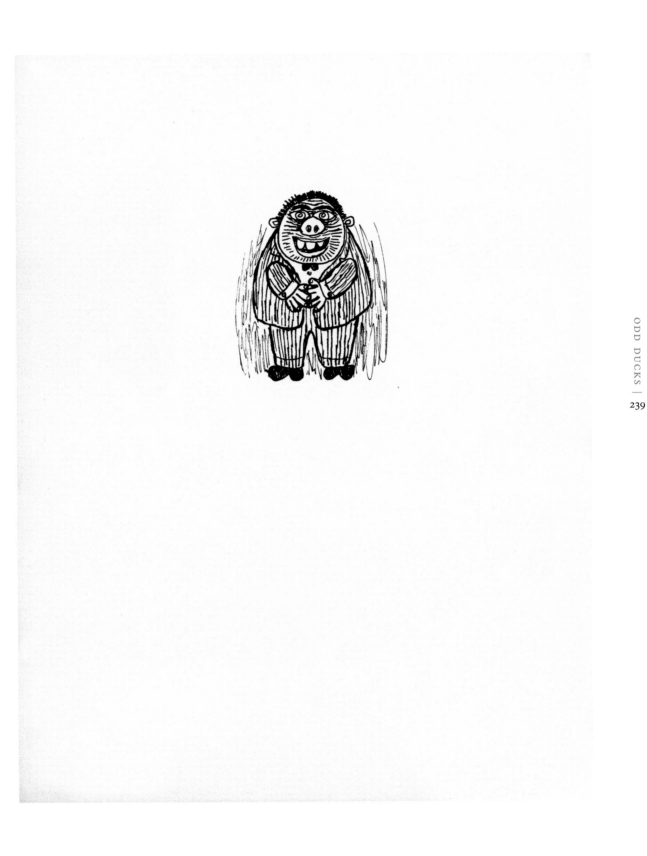

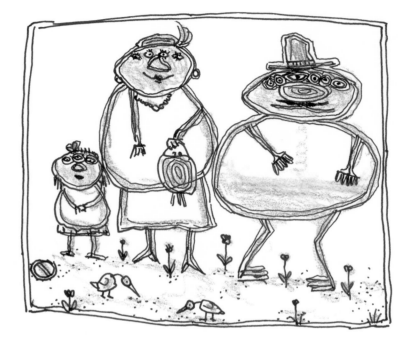

opposite, bottom: Tuckered Out

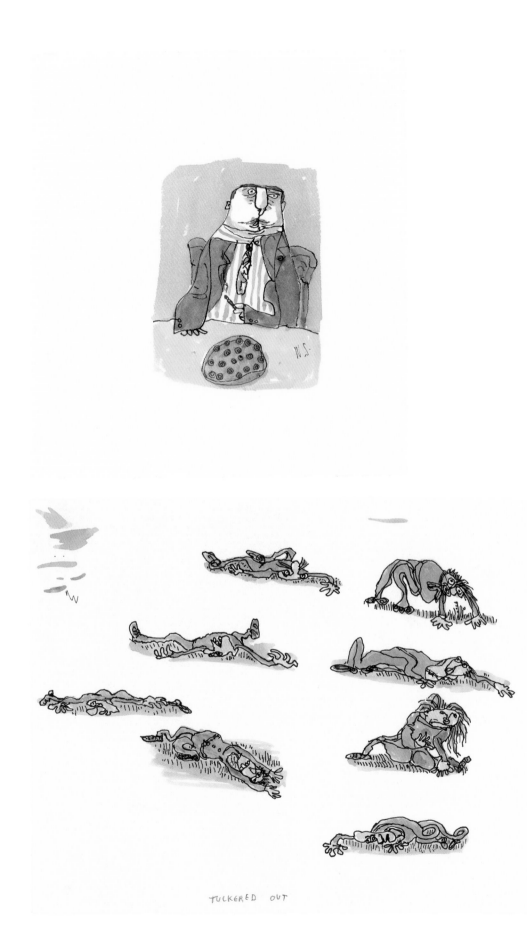

TUCKERED OUT

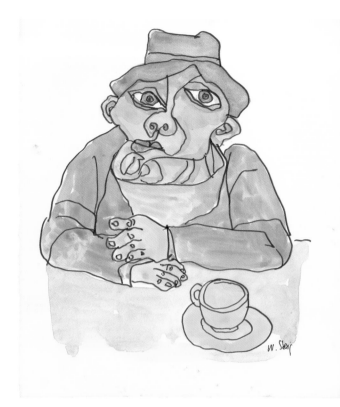

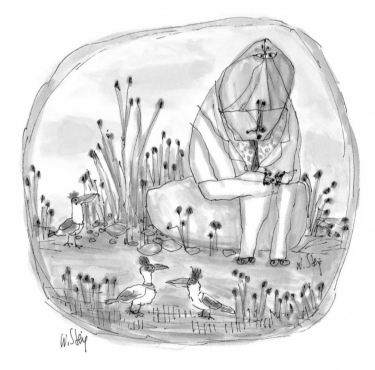

REFUGE VACATION

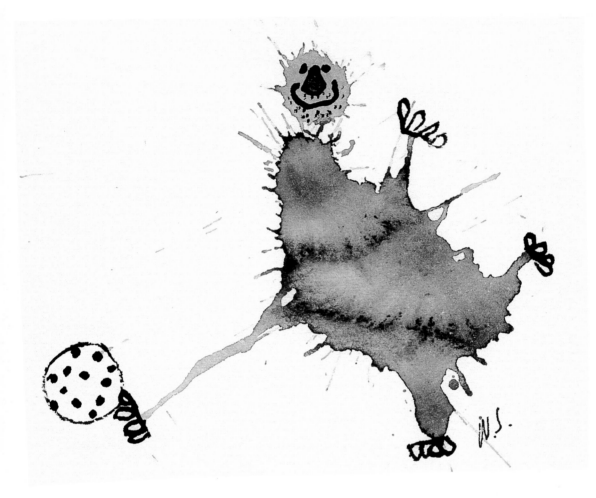

opposite, bottom: Refuge (Vacation)

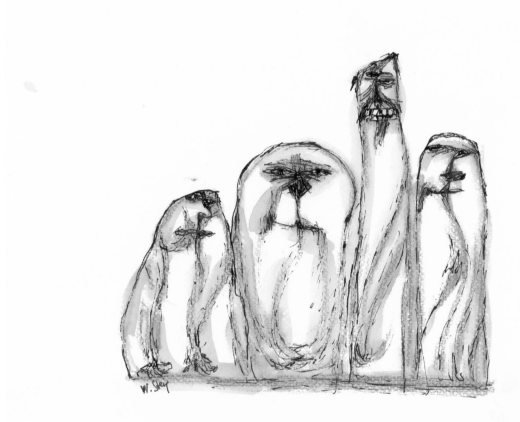

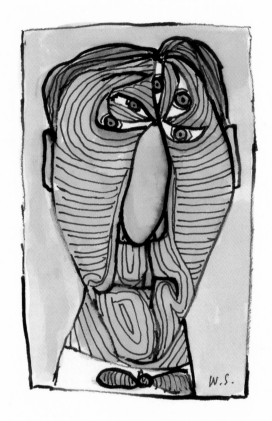

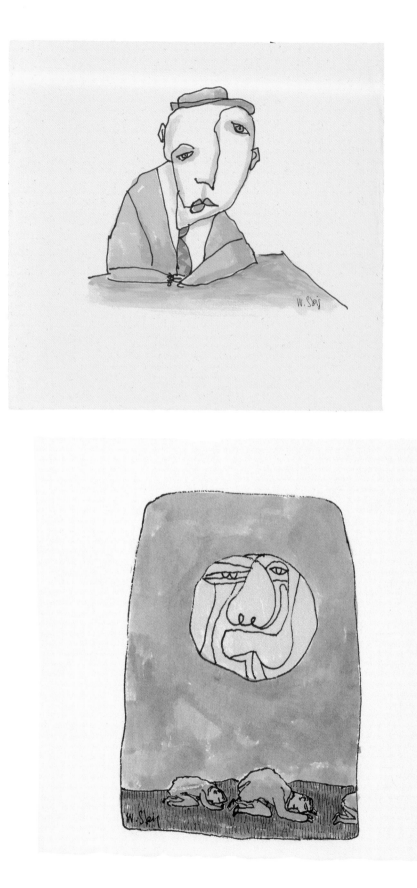

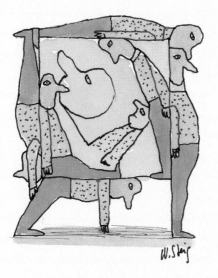

CONSTRUCTION

above: Construction

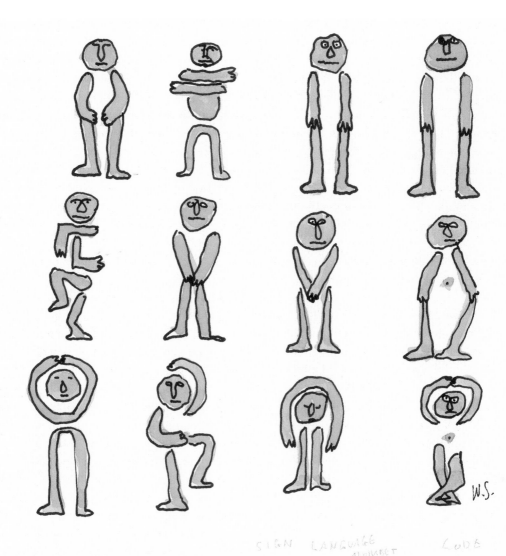

SIGN LANGUAGE CODE
ALPHABET

above: Sign Language Alphabet (Code)

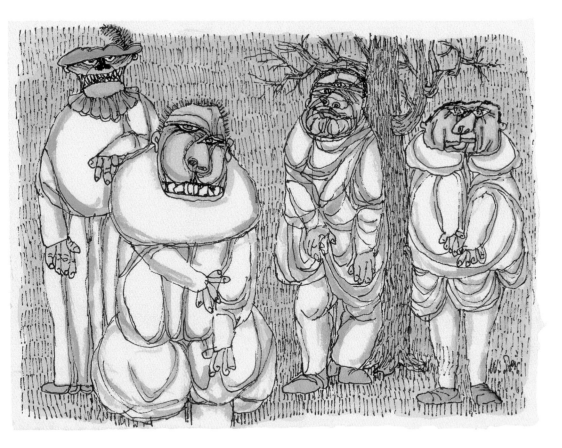

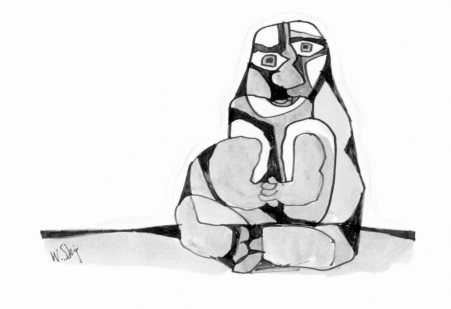

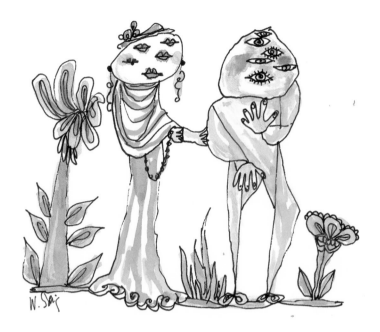

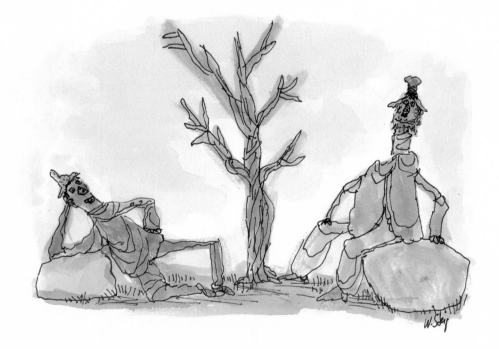

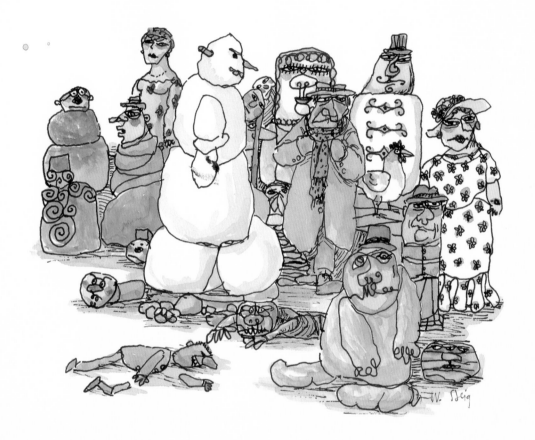

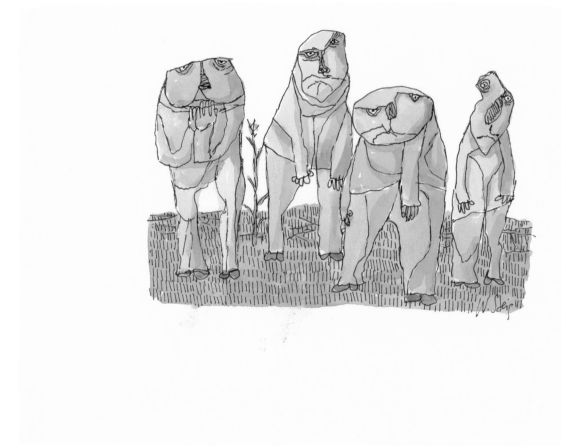

opposite, bottom: Sneak Preview

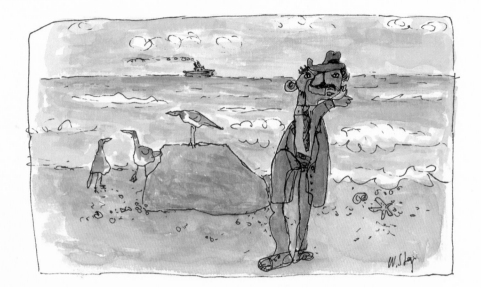

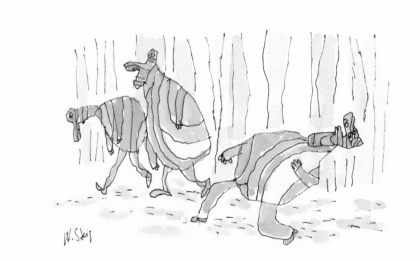

SNEAK PREVIEW

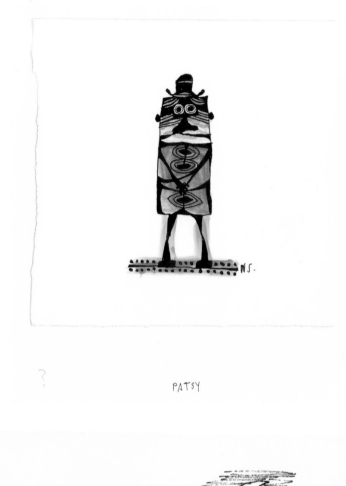

PATSY

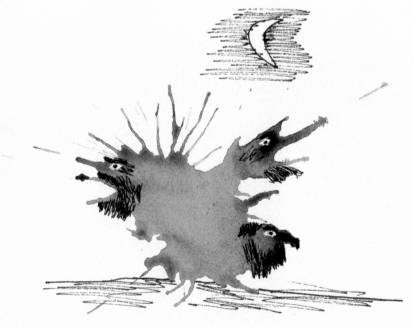

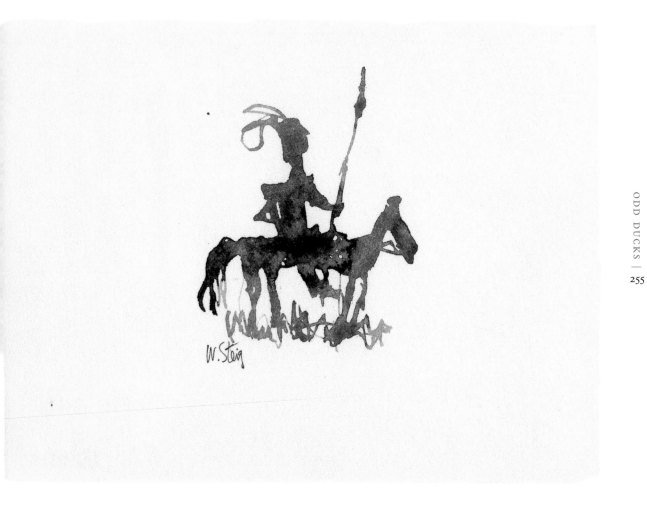

opposite, top: Patsy

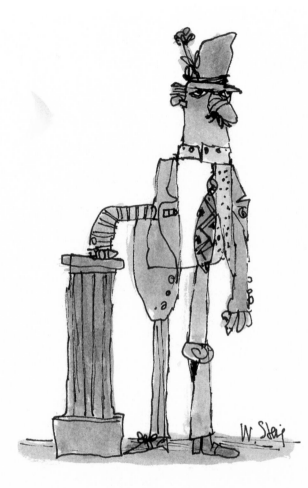

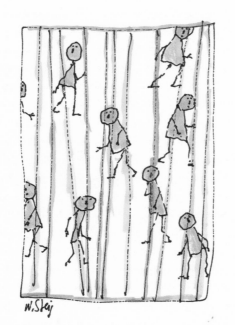

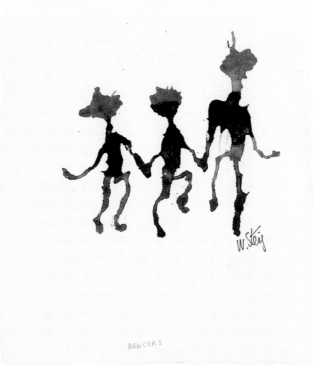

DANCERS

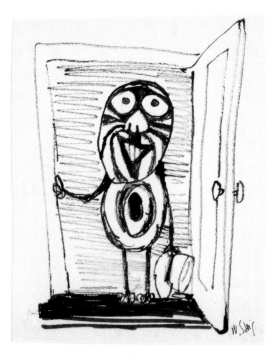

THE UNINVITED GUEST

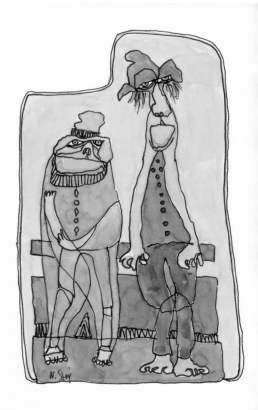

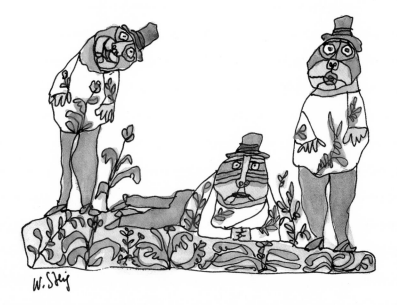

BEWITCHED, BOTHERED, AND BEWILDERED.

opposite, left: The Uninvited Guest

above: Bewitched, Bothered, and Bewildered

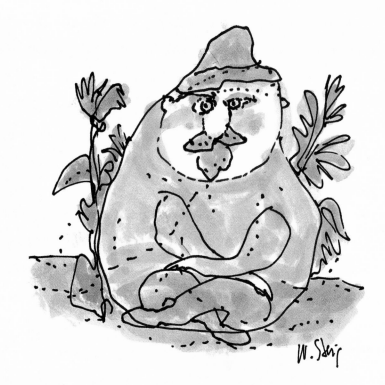

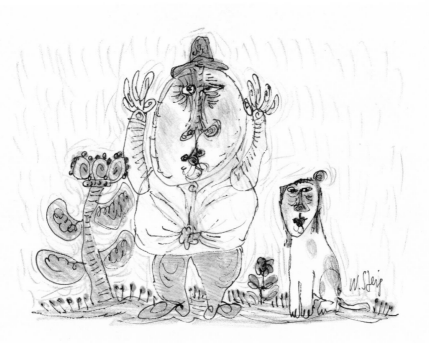

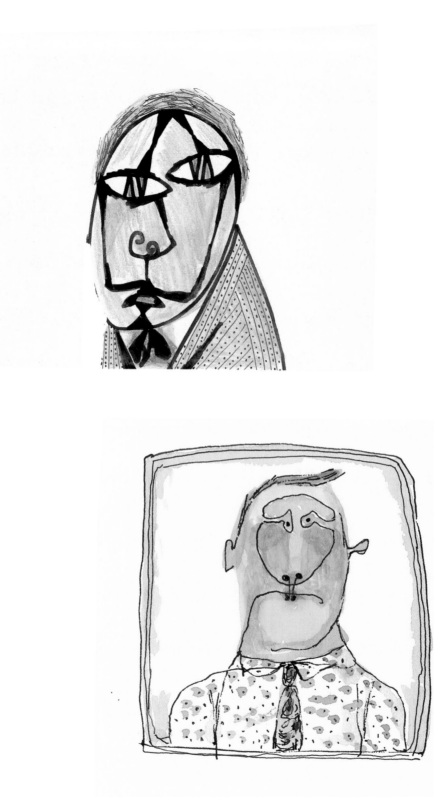

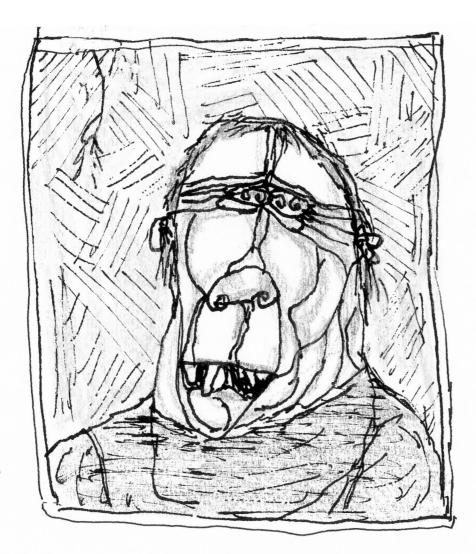

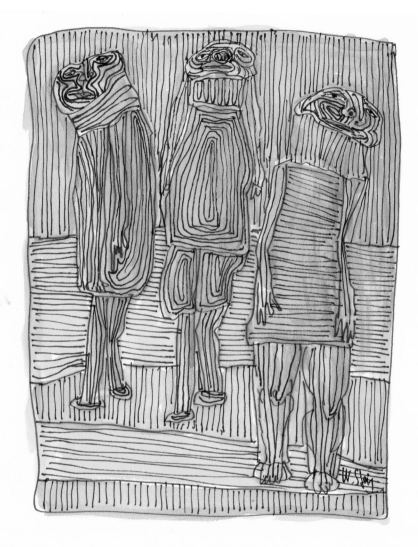

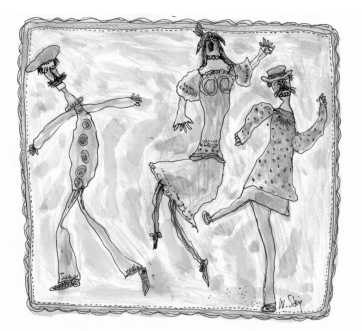

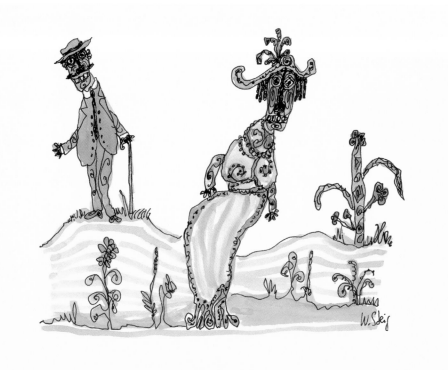

FORMER SWEETHEARTS IT MIGHT HAVE BEEN

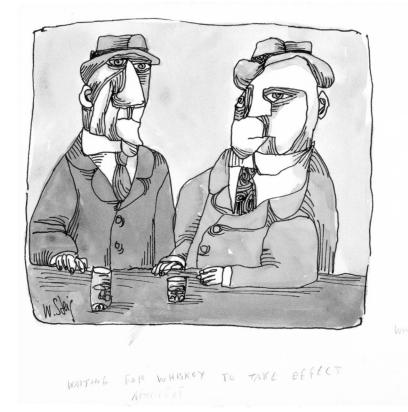

WAITING FOR WHISKEY TO TAKE EFFECT

opposite, top: Former Sweethearts (It Might Have Been)

opposite, bottom: Waiting for Whiskey to Take Effect (Aperitif)

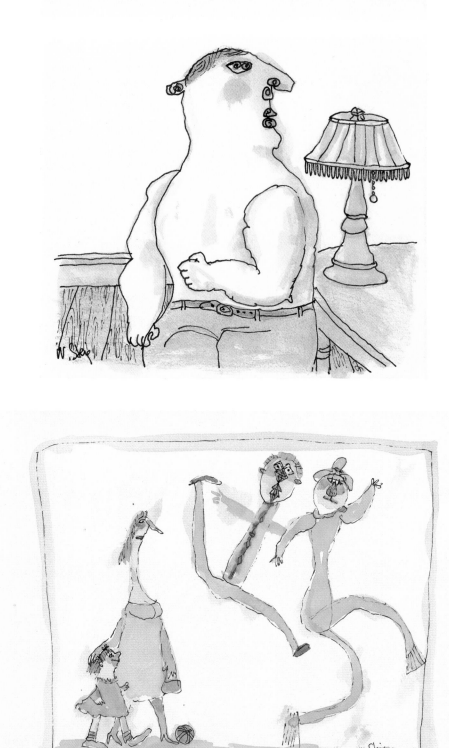

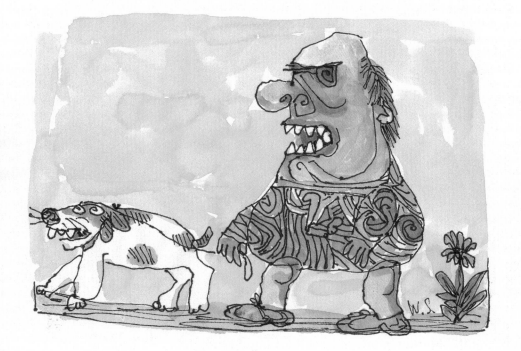

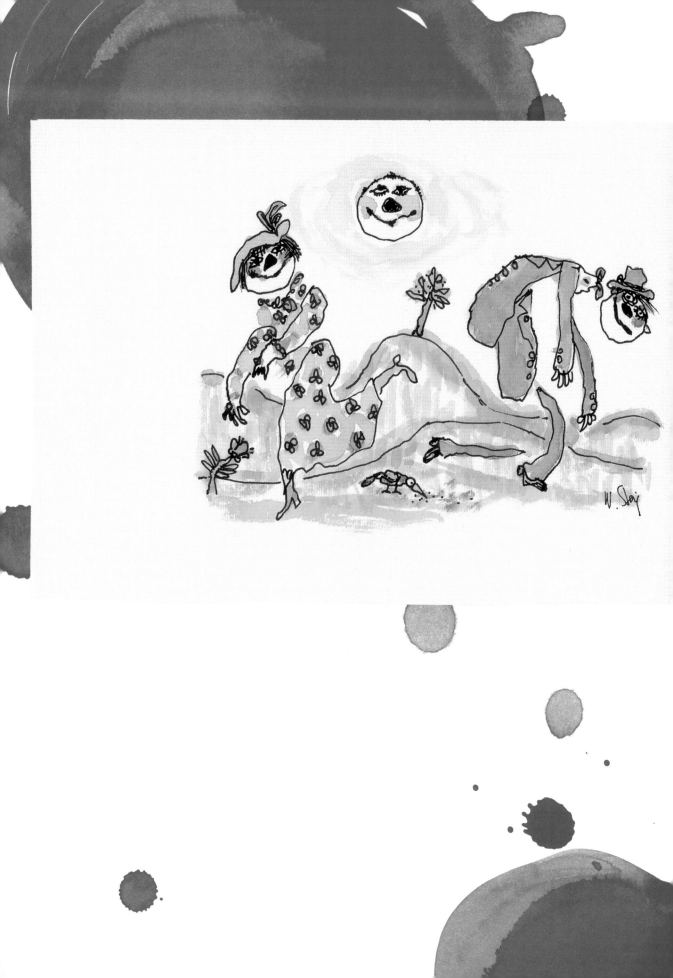

NINNIES & CLOWNS

Thousands of grown-ups quiver with fear at the sight of a clown. There are so many of them, with a horror so fierce that no publisher was ever persuaded to put forth a book of Bill's clowns. The very editors themselves were queasy.

Bill's clowns are mostly another story. His circus performers are having a lovely time of it; nothing scary about them. More often than not his clowns are either cowboys, neighbors, or backyard gossips: whole clown families, folks in the park or strolling the boulevards, some with their clown-dogs trotting along by their sides. Everyday clowns at their everyday business. You know they are clowns because of their noses and because they are clearly delighted with life. There are sad clowns as well: they are human, and subject to fits of dejection. There are clowns in trouble, and even troublesome clowns, but mostly they're joyfully roving the countryside, sometimes as Pierrots, sometimes as jesters and fools, all busy at keeping their kings in touch with reality. Bill favored fools over kings.

Clowns and fools are disarming creatures. "Who, me?" they wonder. "I'm harmless!" Nevertheless, they will tell you the truth when you don't want to hear it. Bill was truthful, and Bill was helpful. One of his friends complained that his psychiatrist wasn't making much progress with him. "I'll tell you what," said Bill, generously. "We'll see him together, and I can explain exactly what's wrong with you." The friend declined and decided it best to go it alone. Bill found that difficult to understand.

I don't want to imply that our friends were clowns, much less fools, but there were a number of people Bill never got tired of.

Good friends who knew how to horse around. Two of them, fine and respectable citizens, exchanged pants once under a restaurant tablecloth. No reason whatever to do it; it just seemed right at the time. Once, we all made large noses of bread and wore them until they fell off. Clown noses of a kind. It wasn't a theme, it simply took hold.

Bill maintained on his desk a small collection of gaudy talismans: pins and rings of decidedly dubious taste. He would don them, sometimes, for inspiration. He never wore them seriously; they were just for clowning round. He was not wearing them when we first met at a costume party in Brooklyn Heights back in 1968. Bill had a serious mission—"to meet girls"—and he appeared in his "formal" tweed jacket and one of his all-purpose ratty knit ties. I was wearing a haphazard getup, and had no mission to speak of. It was a gala affair. Not my sort of thing, and even less Bill's. As outcasts will do, we fell into conversation, and found ourselves in the best company after all. We clowned around. We touched on serious matters. And while Bill felt I lived a little too far uptown (ten blocks), and I felt that he was decidedly loony, we promised to meet again. As it turned out, I was right on the money, and so was he. A year later I moved a bit farther downtown.

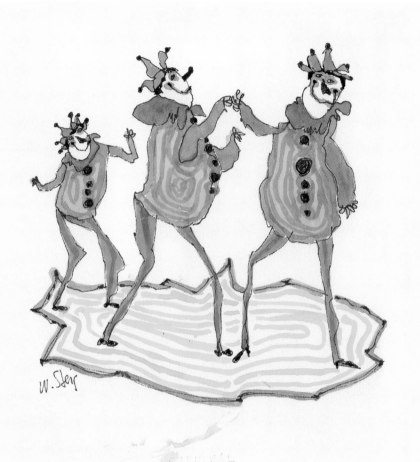

above: Carnival

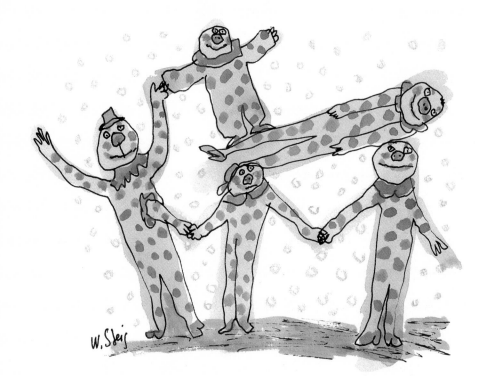

above: Tableau Vivant

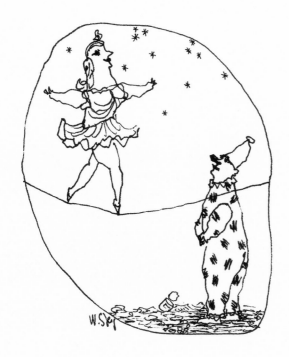

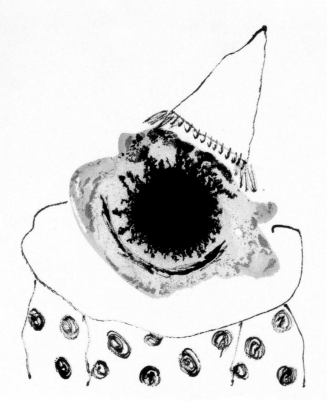

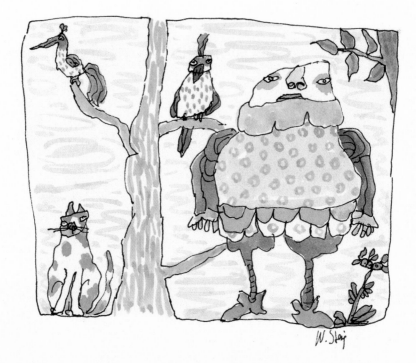

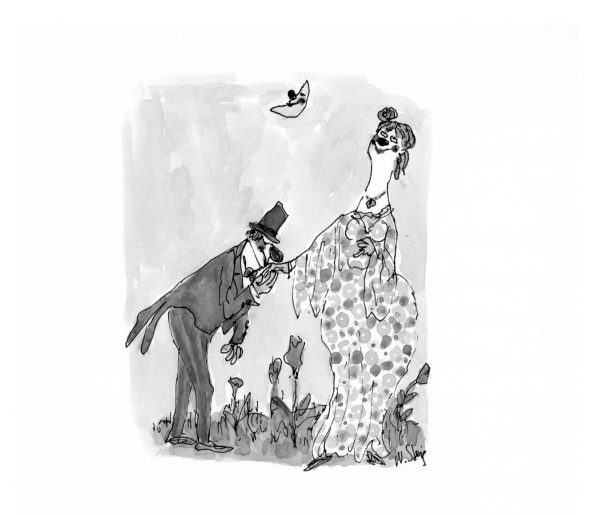

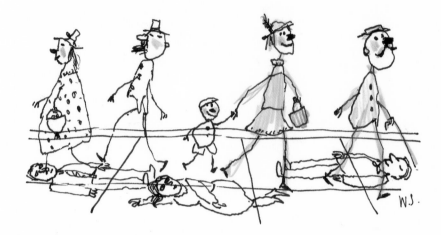

opposite, top: Dirt

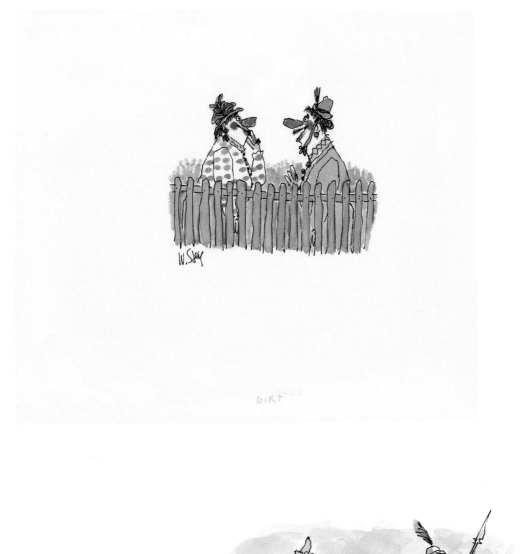

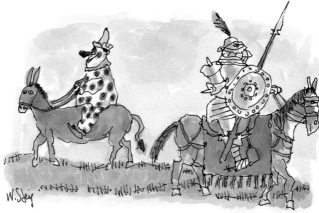

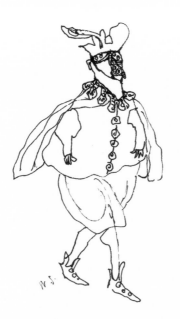

(Mummies)

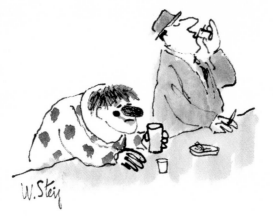

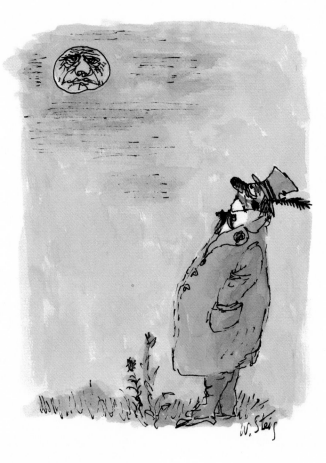

opposite, top: Mummer

above: Blue Moon

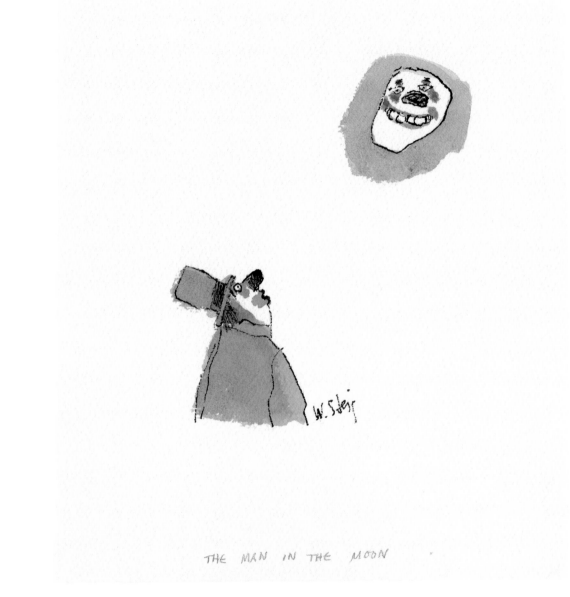

THE MAN IN THE MOON

above: The Man in the Moon

opposite, top: Man with a Job (Is Employed, Has Employment, Has a Job)

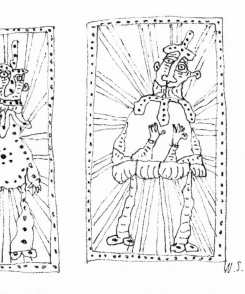

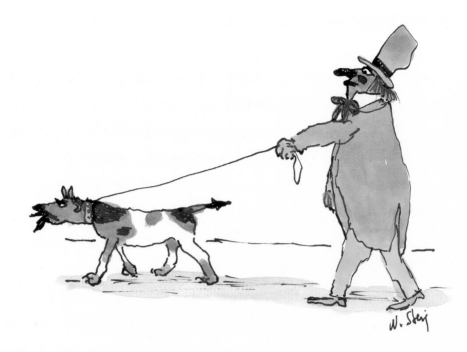

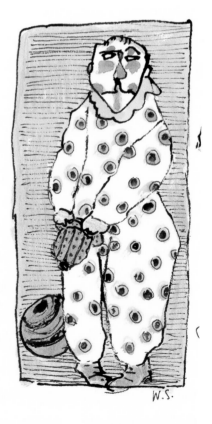

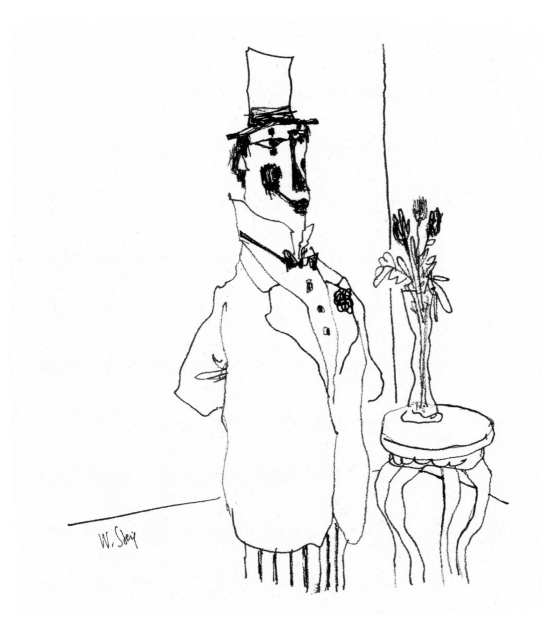

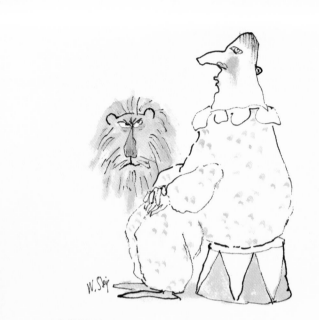

GUILTY CONSCIENCE

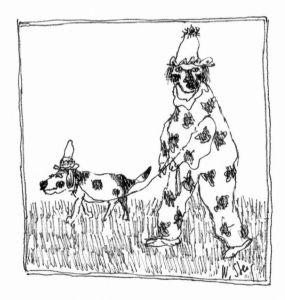

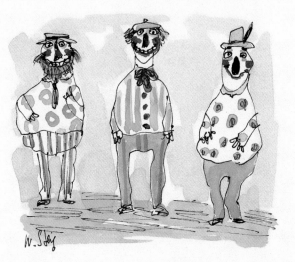

THREE SILLIES

opposite, top: Guilty Conscience

above: Three Sillies

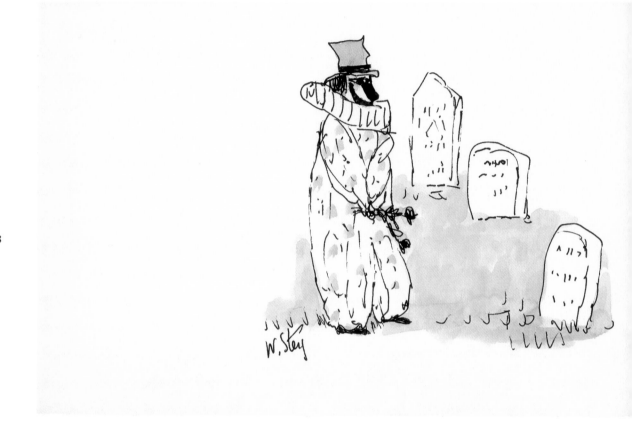

W. Stey

opposite, top: Spread—Some Times It's the Way It Seems

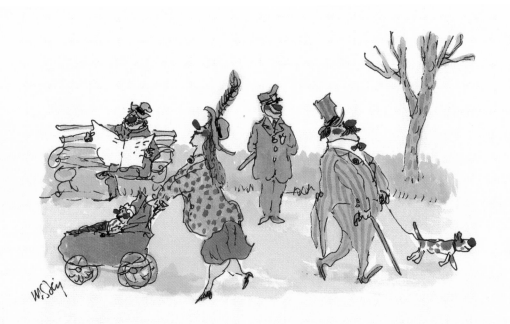

SPREAD — *Sometime that's the way it seems*

N.S.

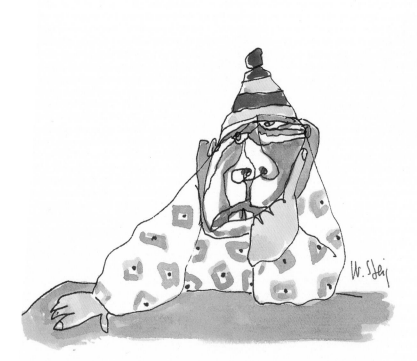

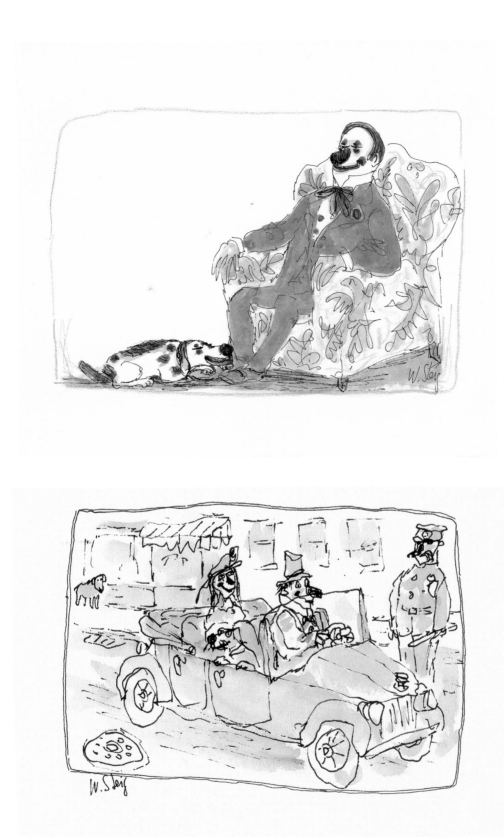

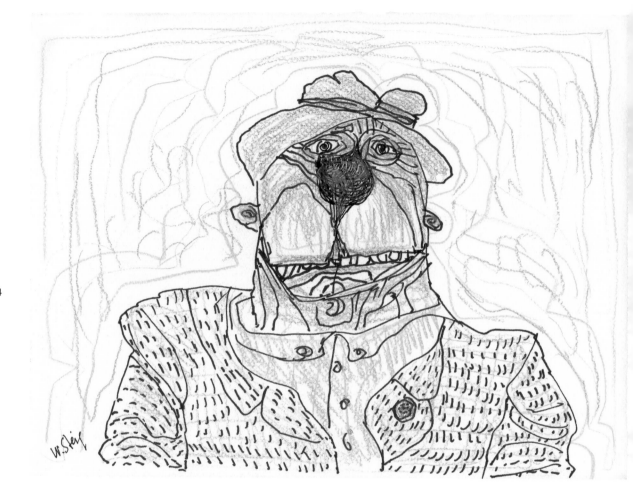

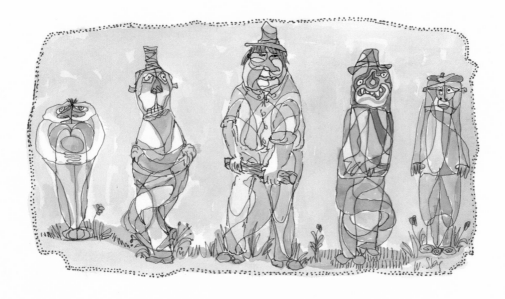

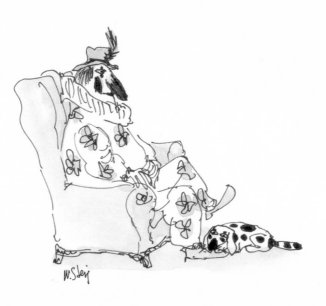

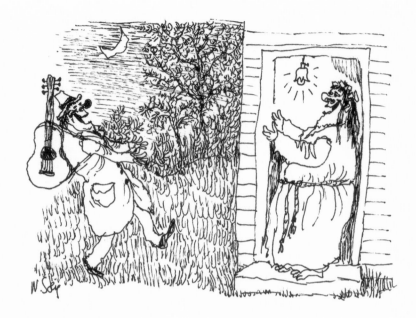

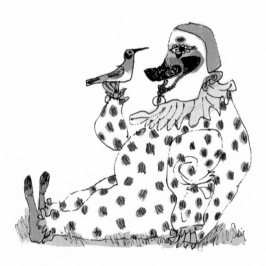

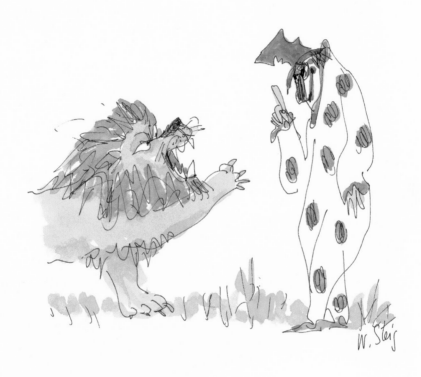

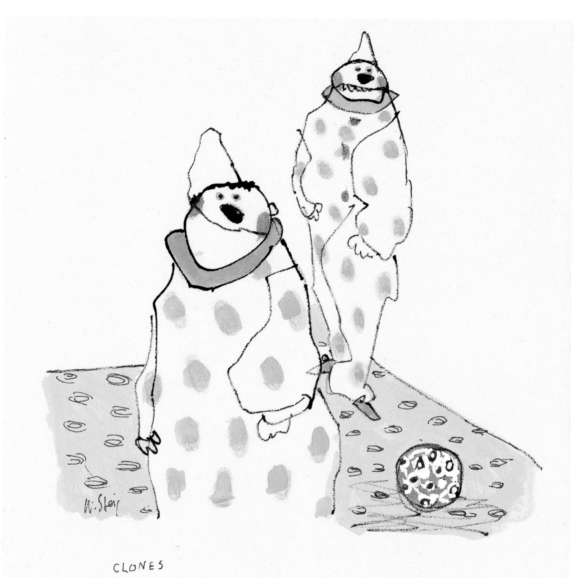

CLONES

above: Clones

opposite, top: Hence, Loathed, Melancholy

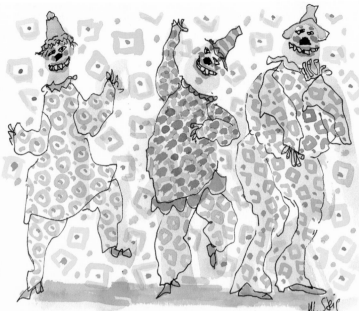

HENCE, LOATHED MELANCHOLY

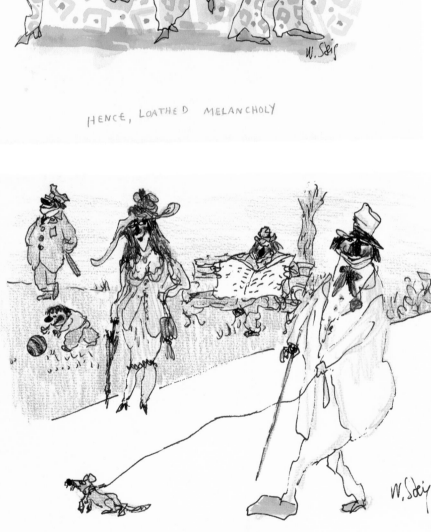

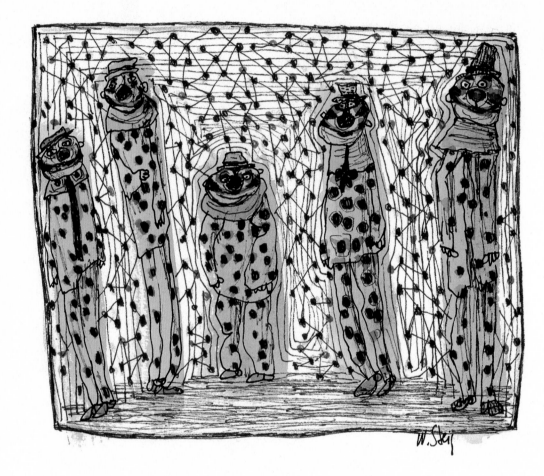

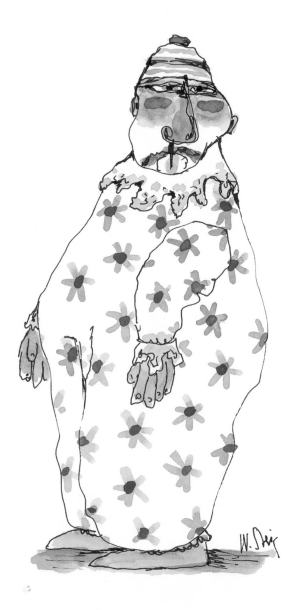

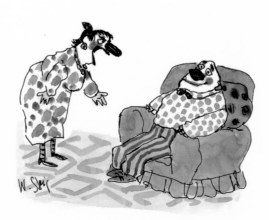

"Must I always yell at you?"

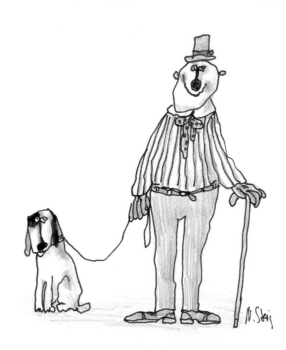

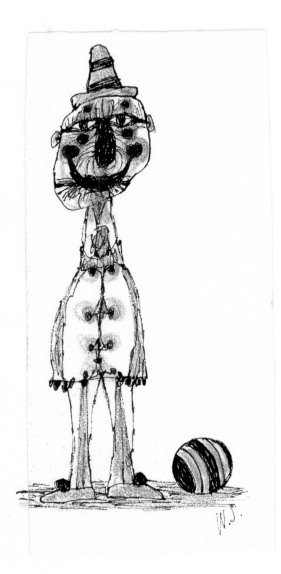

opposite, top: "Must I always yell at you?"

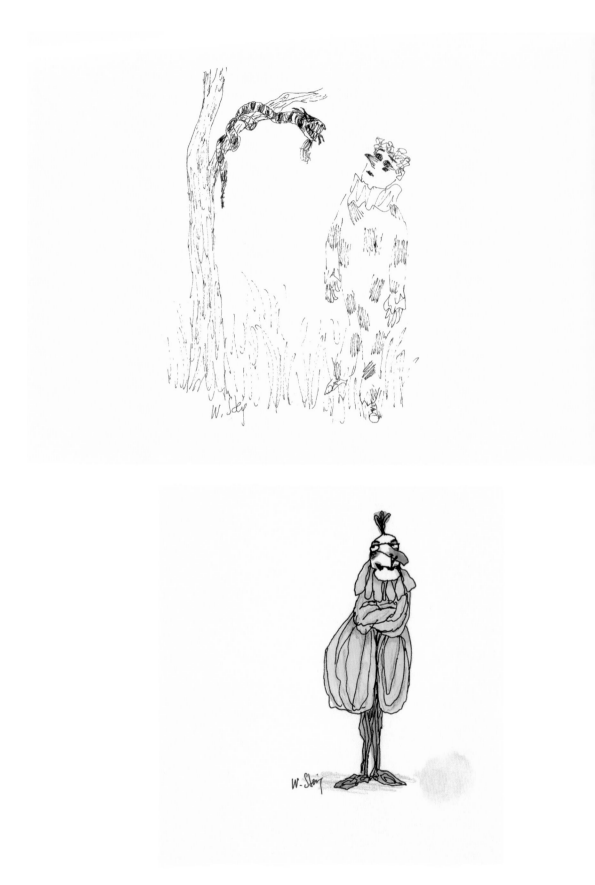

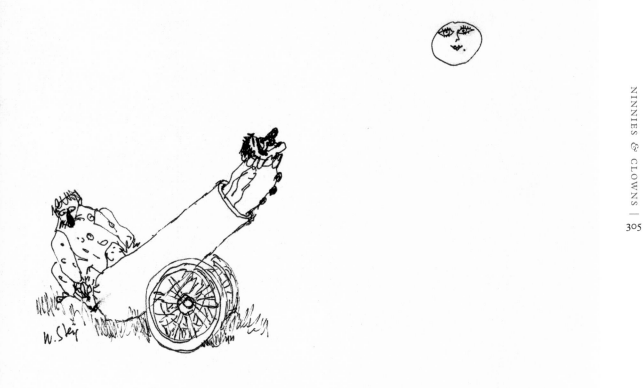

opposite, top: "Be serious!"

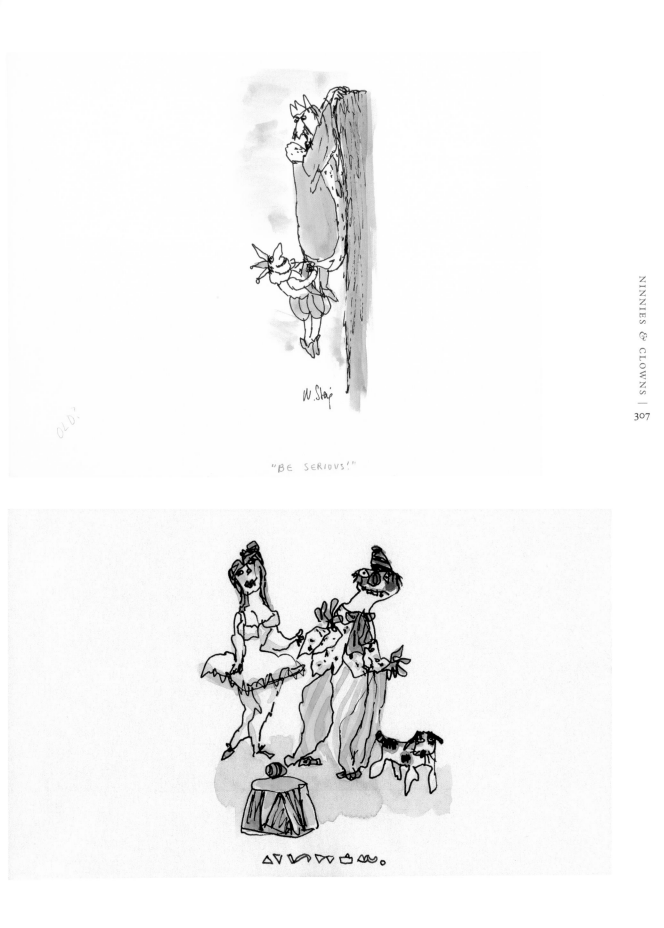

"BE SERIOUS!"

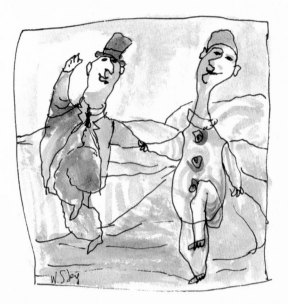

FREE SPIRITS

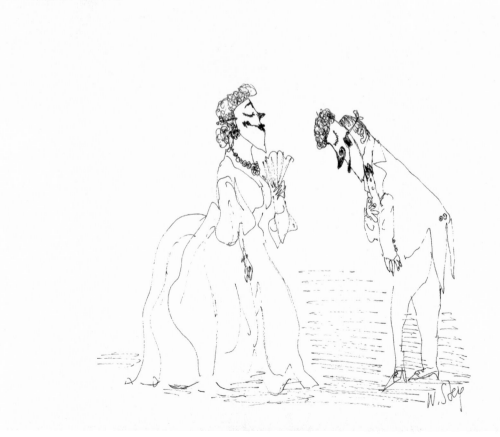

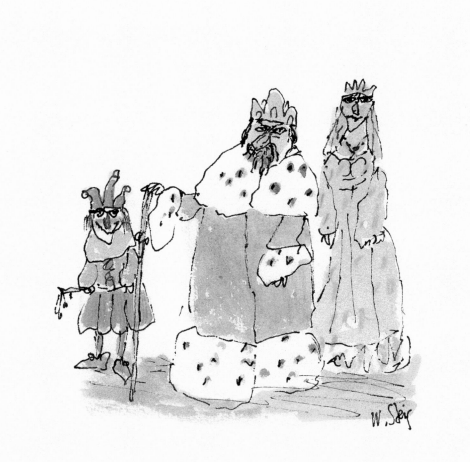

opposite, top: Free Spirits

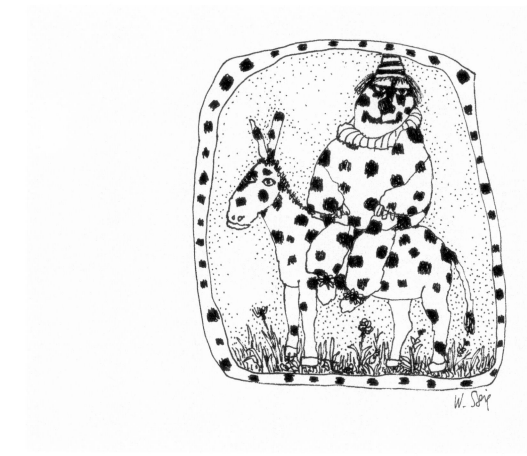

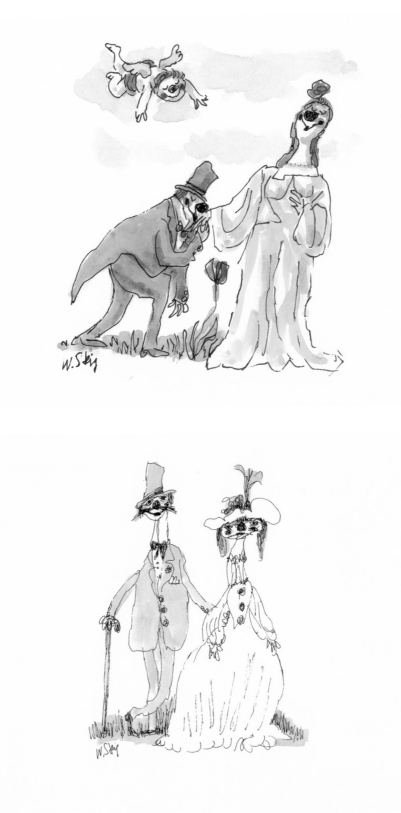

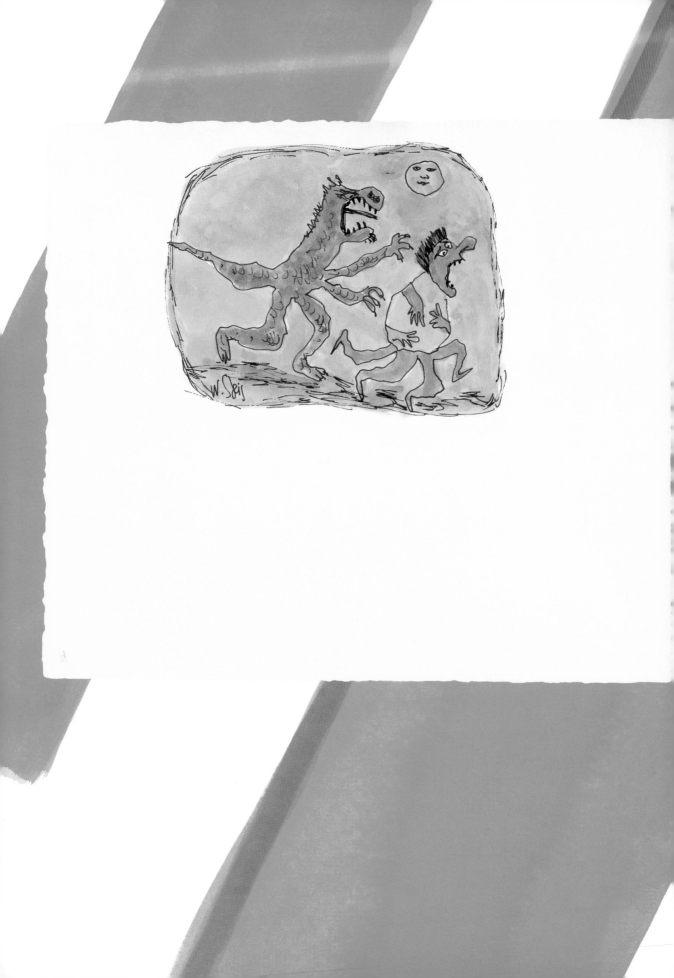

BODILY HARM

When the Nixon Watergate hearings were broadcast in 1973, Bill had to attend to them. What he loathed beyond anything was a corrupt politician. A generally peaceable man, Bill claimed that if he knew he was going to die in the next couple of days, he would murder the worst ones. And he practiced nightly, using the various techniques that appealed to him. Just before falling asleep, he'd go after one: I'd feel an elbow assailing my ribs and know he had fatally throttled, shot, or clobbered a senator. Now that the world was a cozier place, we could settle in for a good night's rest and, presumably, peaceful dreams.

It was hard for Bill not to be at his desk for a long stretch, except for a football or basketball game with a New York team featured. "If I had some burlap," he said during this politically desperate period, "I'd do some embroidering." He'd never taken his hand to stitchery, but fate, or perhaps his "spirits," stepped in. A friend had sent me a bundle of "trash," including a first-class piece of burlap. It arrived that morning. There was plenty of yarn around too, and Bill got to work on it immediately. His subject was a pair of lovers seated on the grass, with a thuggish old chaperone keeping her eye on them. Neither Bill nor I realized till many years later that she looked exactly like Richard Nixon.

There was a dark side to Bill's character. You can't have a good look at human nature without an awareness of its defects, and there was nothing hypocritical about Bill. If he saw it, he'd mention

it. Every morning he'd look at the *New York Times* and check off the headlines. "Yep," he'd say, "there's the murder, there's the corruption, there is the bigotry, and there's the mayhem." He would shake his head sadly, and turn in relief to the crossword puzzle.

This sometime dissatisfaction with his fellow beings is duly reflected in his work. There is the murder, there is at least the threat of assault, and there are those scary, unidentified threats of disaster that haunt us all.

The work is funny. Whatever Bill drew was funny, if for no other reason than his wonderful line. But Bill also *meant* what he did. He *felt* it. Bill called himself a depressive. You didn't much see that in his behavior, however. He was cheerful and equable most of the time. It seemed to reveal itself in a reflective act—a kind of questioning. "What's it all about?" he would frequently wonder. He never expected an answer, and would wave it off if someone offered.

Questions mattered, answers were somehow beside the point. "Wonder," he said in his Caldecott speech, "is a respect for life."

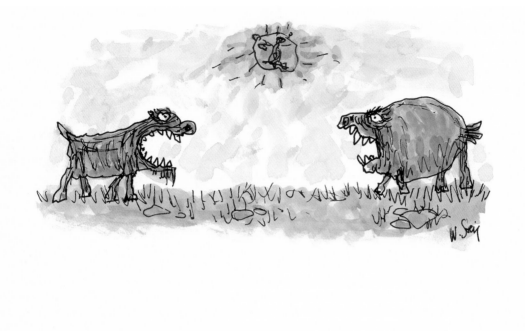

above: "Sez you!"

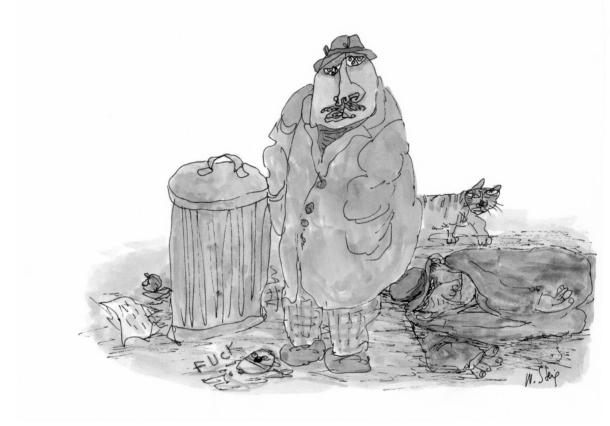

above: Man Astray in the Big City

opposite, top: Self-contempt

opposite, bottom: Doctor's Waiting Room

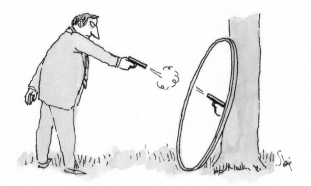

SELF - CONTEMPT

DOCTOR'S WAITING ROOM

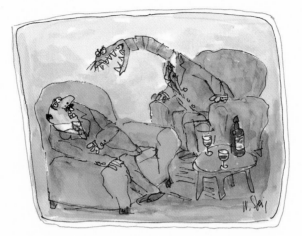

THE CONVERSATION TAKES A NASTY TURN

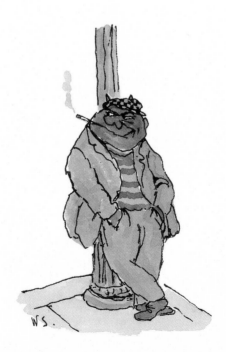

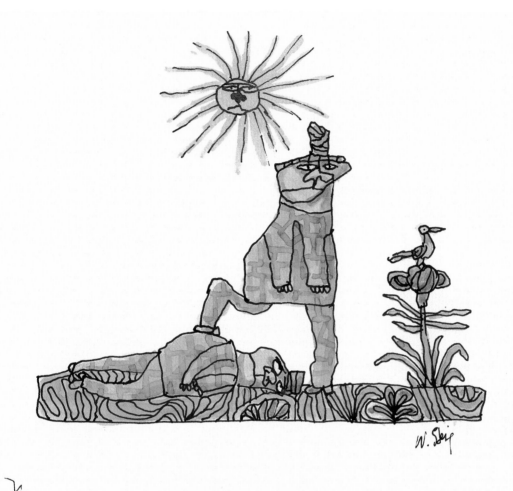

opposite, top: The Conversation Takes a Nasty Turn

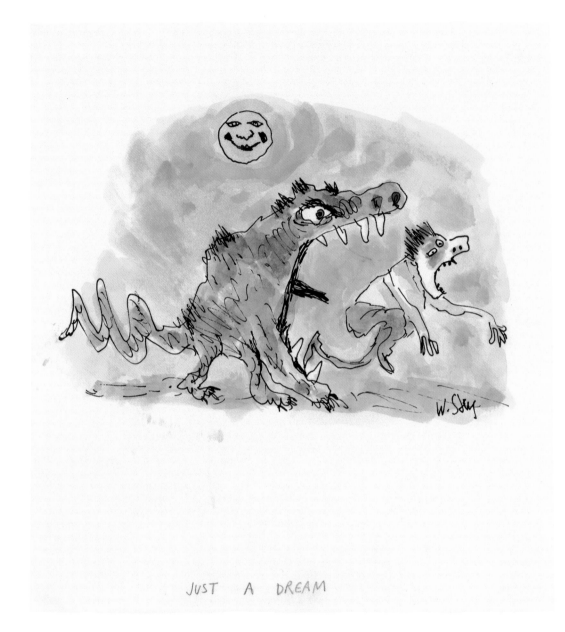

JUST A DREAM

above: Just a Dream

opposite, bottom: Passing Through

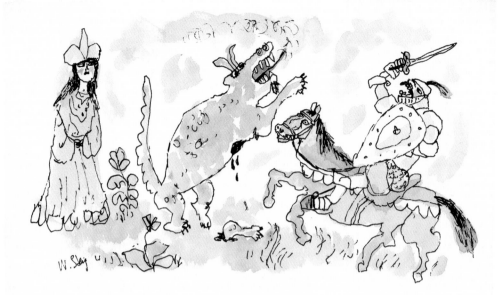

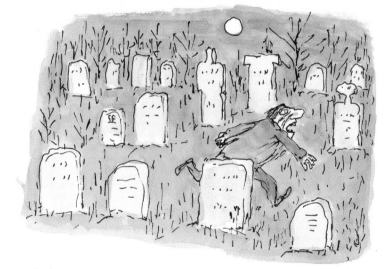

PASSING THROUGH

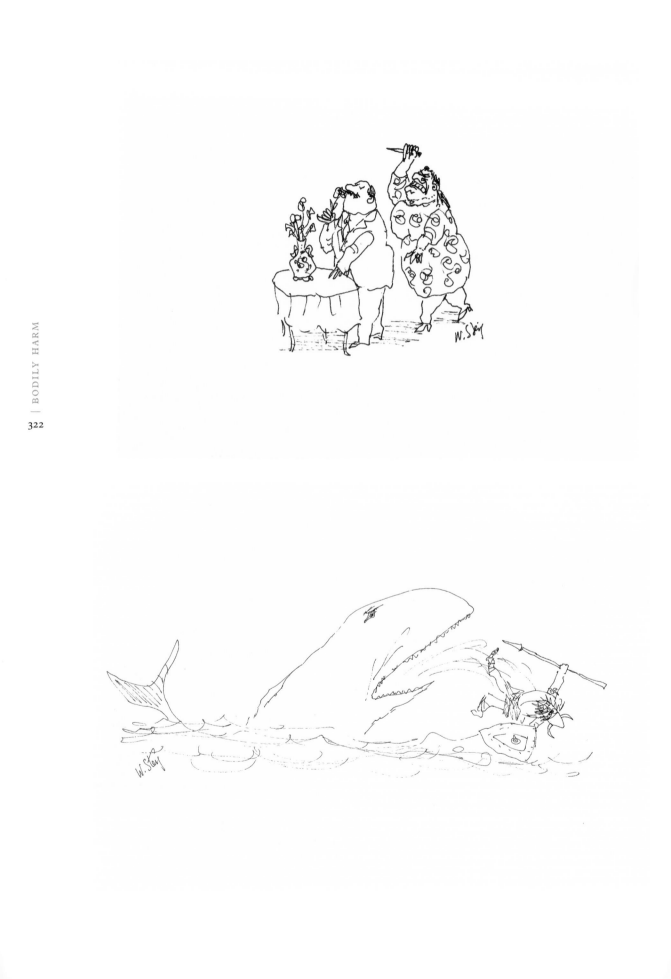

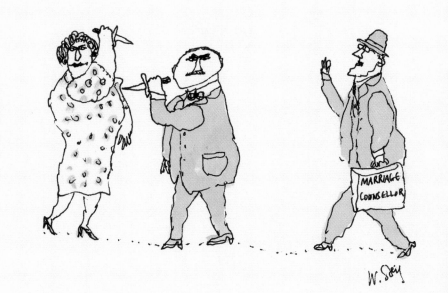

"HOLD IT!"

above: "Hold it!"

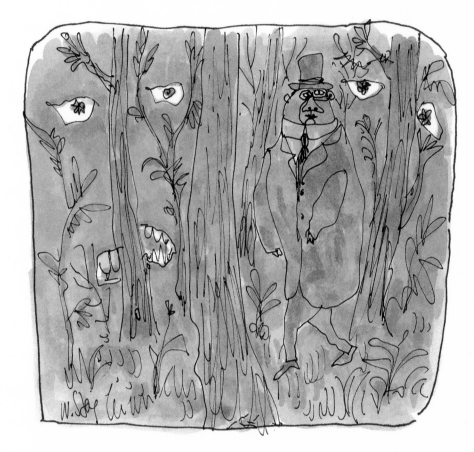

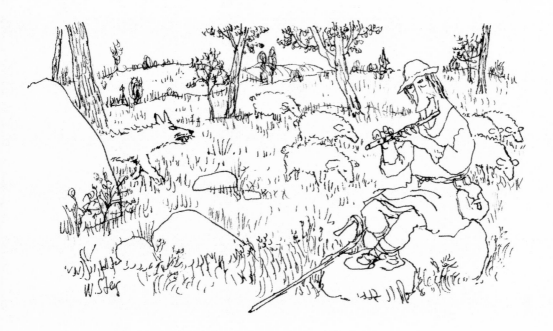

SHEPHERD

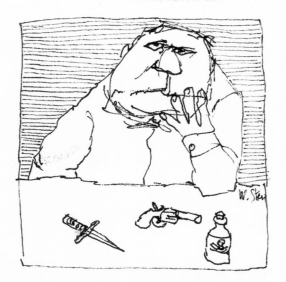

WHICH

"What would offend him the most?"

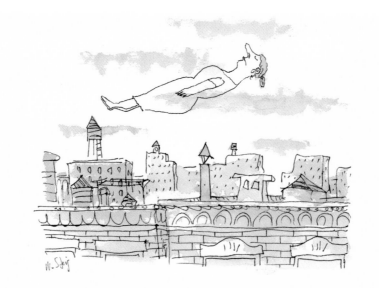

A SOUL RISING TO HEAVEN

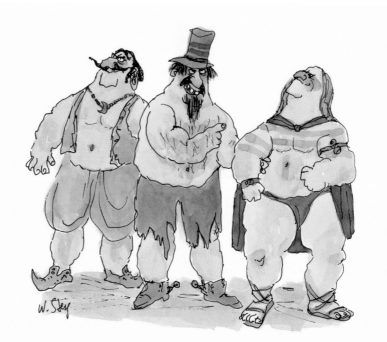

GLADIATORS

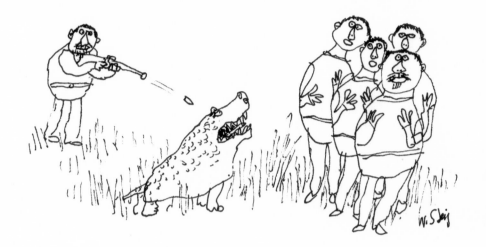

THE NICK OF TIME

opposite, top: A Soul Rising to Heaven

opposite, bottom: Gladiators

above: The Nick of Time

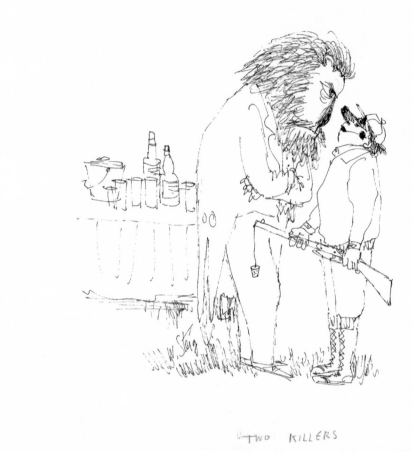

TWO KILLERS

above: Two Killers

opposite, top: Endangered Species

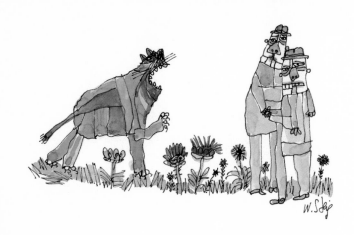

ENDANGERED SPECIES

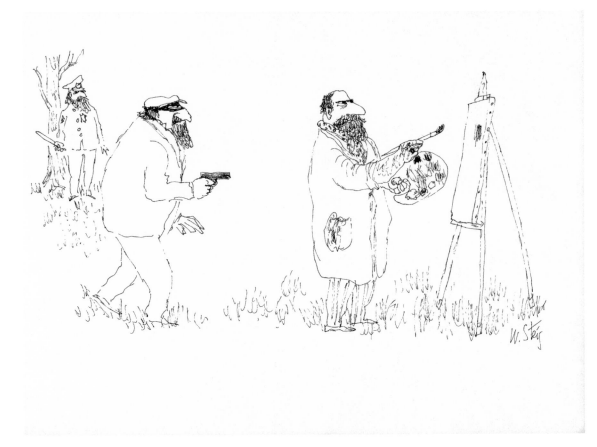

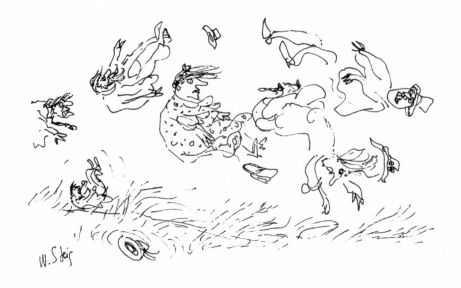

MARCH

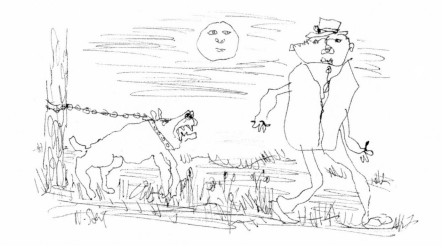

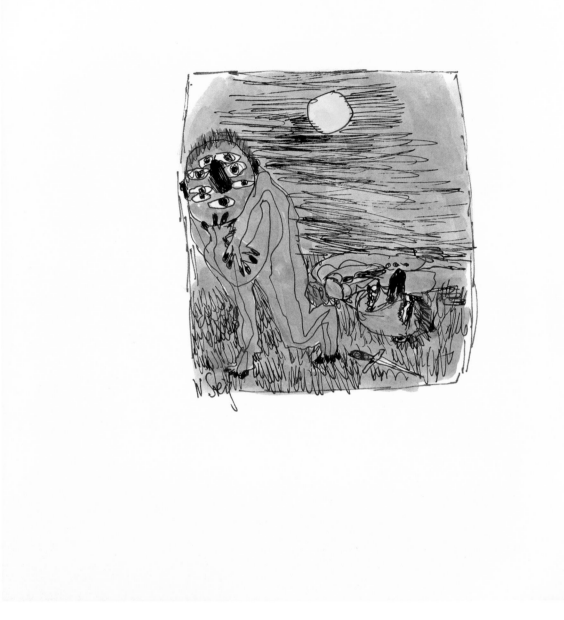

opposite, top: March

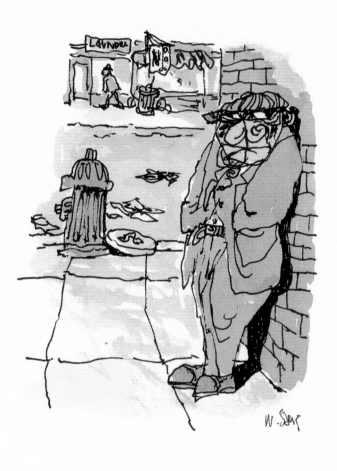

opposite, top: Jealous Husband

opposite, bottom: Caught in the Act

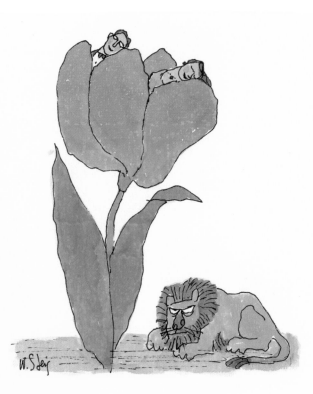

JEALOUS HUSBAND

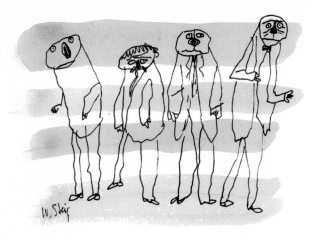

CAUGHT IN THE ACT

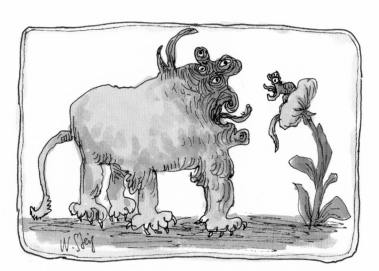

CONFRONTATION

above: Confrontation

opposite, top: "I told you not to aggravate me!"

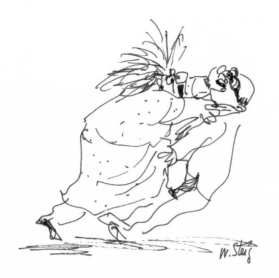

"I told you not to aggravate me!"

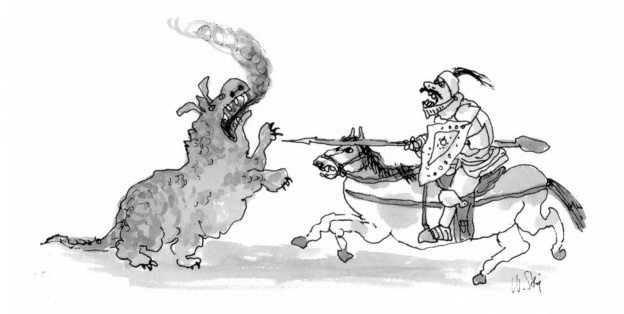

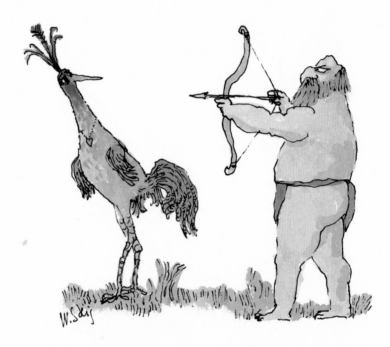

BECAUSE IT'S THERE.

above: Because It's There

opposite, top: Indifferent Group

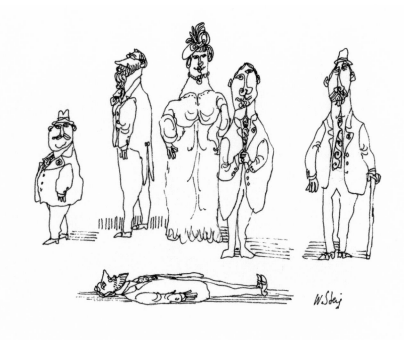

INDIFFERENT GROUP

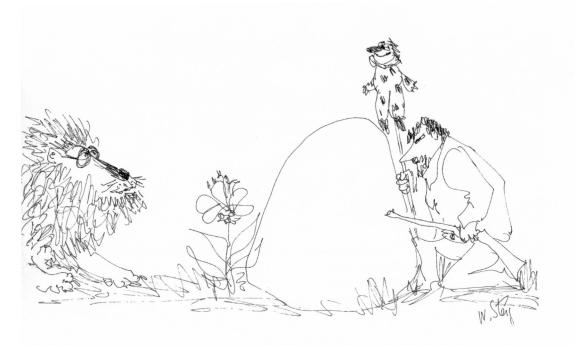

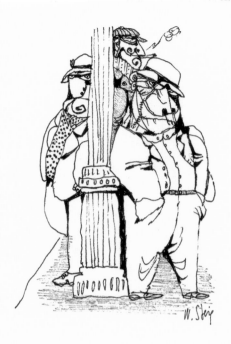

STREETCORNER

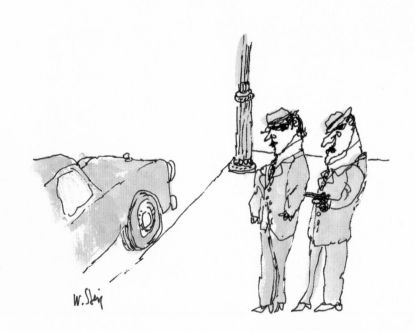

"Stick them up."

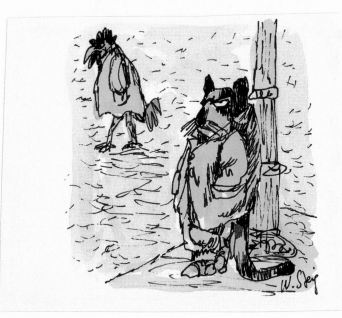

TOUGH NEIGHBORHOOD

opposite, top: Street Corner

opposite, bottom: "Stick them up." (All I Want Is Your Money)

above: Tough Neighborhood

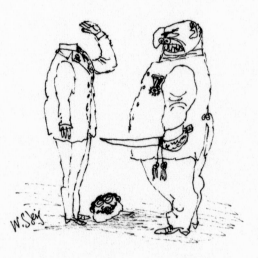

"THAT'S MORE LIKE IT!"

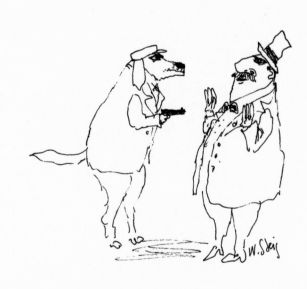

"Why me?"

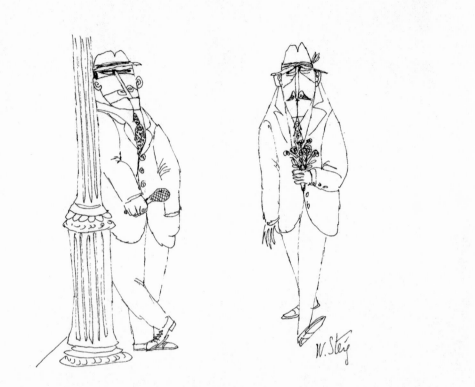

opposite, top: "That's more like it!"

opposite, bottom: "Why me?"

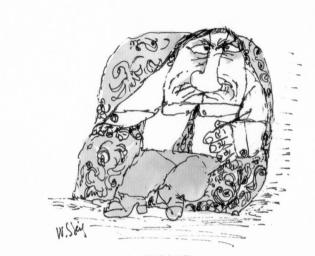

INTRANSIGENT

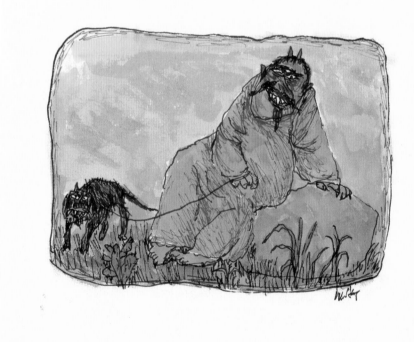

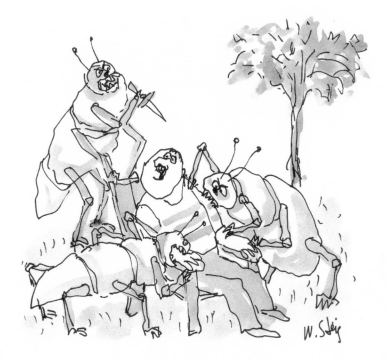

"THE BUGS OUT HERE ARE KILLING ME!"

opposite, top: Intransigent

above: "The bugs out here are killing me!"

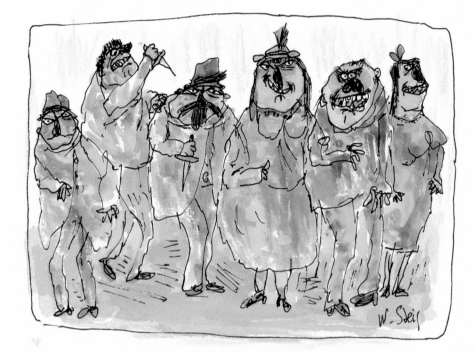

THE OPPOSITION

above: The Opposition

opposite, bottom: Bad Knight

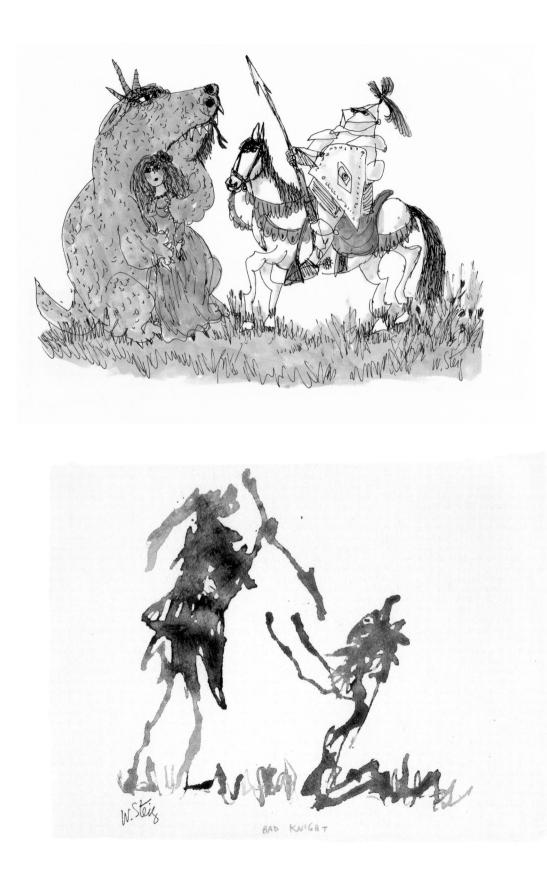

BAD KNIGHT

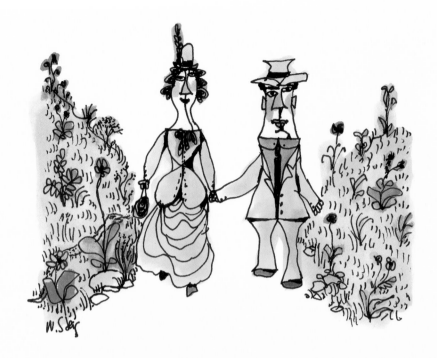

SNAKE IN THE GRASS

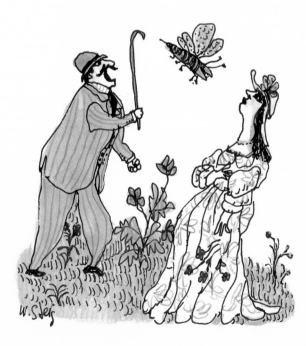

KNIGHT AND DRAGON

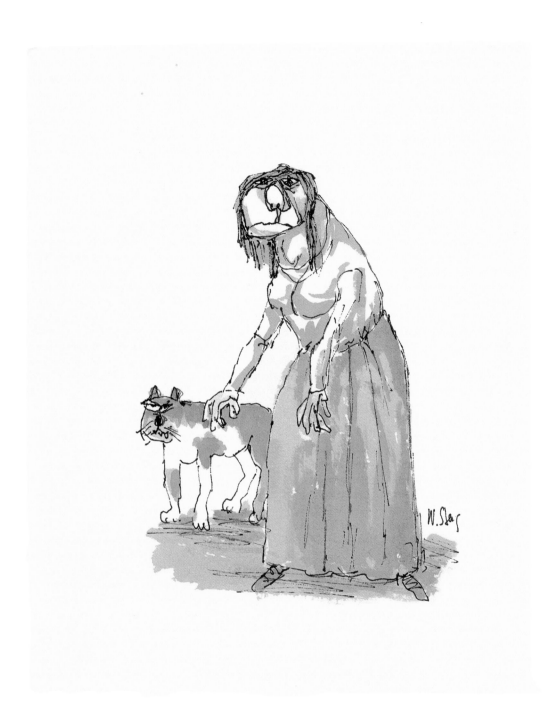

opposite, top: Snake in the Grass

opposite, bottom: Knight and Dragon

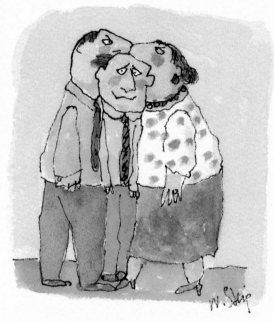

GO-BETWEEN

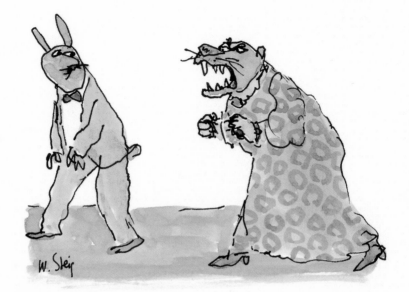

8 o'clock and all is hell.

W. Steig

opposite: Go-between

above: 8 O'Clock and All Is Hell

AFTERWORD

About a year ago, on my way back from a visit to the Eric Carle Museum of Picture Book Art in Amherst, Massachusetts, I suggested to the young friend who was doing the driving (the excellent children's book author-illustrator Nick Bruel) that we detour and visit the Norman Rockwell Museum in Stockbridge.

I grew up on Rockwell, loved his *Saturday Evening Post* covers, and, like every other American of my generation (and my parents'), saw his work as the personification of pre-war and World War II America presented at its mythic MGM best.

Rockwell drew and painted like a dream a post-Leyendecker nation of charm, wit, and style that passed for realism but was, in truth, as fantasy laden as Oz.

And these fantasies, in place on the museum walls (Rockwell's very own!), looked every bit as splendid as I remembered them. And except for a truly unfortunate stroke of institutional self-sabotage, Nick Bruel and I would have walked out of the Norman Rockwell Museum thinking and talking about Norman Rockwell. But no. The stroke of self-sabotage was the coupling of the permanent Rockwell installation with a special exhibition of the drawings, designs, cartoons, doodles, and whatnots of William Steig.

Steig could not draw or paint nearly as well as Rockwell, but looking at the often tiny compositions of old folks, quarreling couples, self-righteous women, self-mortified men, and endless parades of dogs and cats exhibiting more human traits than their owners, not to overlook trees, flowers, foliage, and ferns resplendent with attitude, I realized we are all part of some grand scheme that is not working out in our favor.

On these museum walls hung a cornucopia of Steig's more imaginative, more symbolic art: inquisitive, unsettling, evocative, insightful, and revealing. And not a hint of the soft-focus American gloss that was part and parcel of Rockwell's and everyone else's commercial art of the period.

When I walked out of the Norman Rockwell Museum with Nick, it was Steig we talked about. Poor Rockwell was outclassed and out-arted in the very museum that was his home. And by, of all people, a cartoonist!

Steig, by the mid-1940s, following his early success at the *New Yorker* with his *Small Fry* panels and other cartoons of lower-class and working-class family life, seemed to grow tired of being fixed in the very genre he had created.

Who knows what made him break out? Maybe it was the combined influence of Picasso and other abstractionists, the escalating inroads of psychoanalysis (Freud, Jung, and Reich, Steig's personal favorite), or the shock of World War II and the persecution of the Jews. Whatever it was that drove him to go beyond that boundary where other cartoonists feared to tread, Steig (with his equally experimental colleague, Saul Steinberg) broke ranks with the rest of the cartoon pack and moved on into uncharted territory.

One cannot overstate the momentous shift in cartoon sensibility. From the man who gave us the children of *Small Fry* and made us chuckle in recognition, Steig reinvented himself into the cartoonist who gave us *The Agony in the Kindergarten*, whose children made us cringe with insight.

And then onward. Further and always onward. Passionate, playful, pessimistic, perplexing—Steig's self-styled new universe.

To him, my blessing and my thanks. He gave me the career I ended up with. Without Steig showing me the way, I might, at this moment, be ghosting *Dennis the Menace*.

Jules Feiffer
New York City
February 2011

Jules Feiffer's latest book is a memoir, *Backing into Forward*.

EDITORS: Charles Kochman and Sofia Gutiérrez
DESIGNER: Neil Egan
PRODUCTION MANAGER: Anet Sirna-Bruder

Library of Congress Cataloging-in-Publication Data:

Steig, Jeanne.
 The lost art of William Steig : cats, dogs, men, women, ninnies & clowns/
 by Jeanne Steig; with illustrations by William Steig.
 p. cm.
 ISBN 978-0-8109-9577-2 (alk. paper)
 1. Steig, William, 1907–2003—Themes, motives. 2. American wit and humor,
 Pictorial. I. Steig, William, 1907–2003. II. Title. III. Title: Cats, dogs,
 men, women, ninnies & clowns.

NC1429.S583A4 2011
741.5'973—dc22

 2010041853

Printed and bound in China
10 9 8 7 6 5 4 3 2 1

Abrams ComicArts books are available at special discounts when purchased in quantity
for premiums and promotions as well as fundraising or educational use. Special editions
can also be created to specification. For details, contact specialsales@abramsbooks.com
or the address below.

ABRAMS
THE ART OF BOOKS SINCE 1949

115 West 18th Street
New York, NY 10011
www.abramsbooks.com